Sky-High

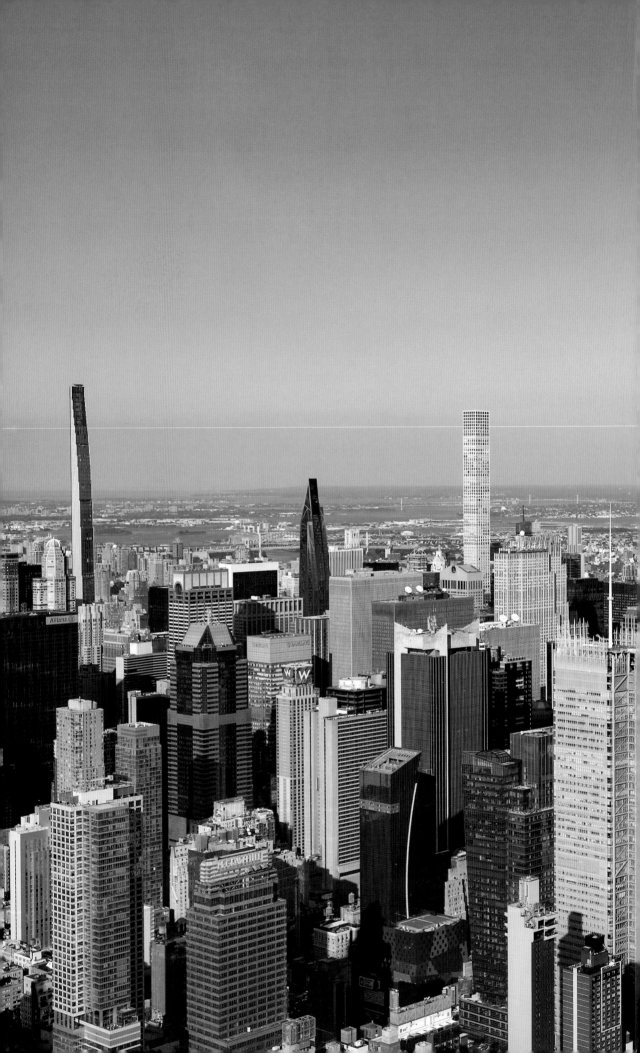

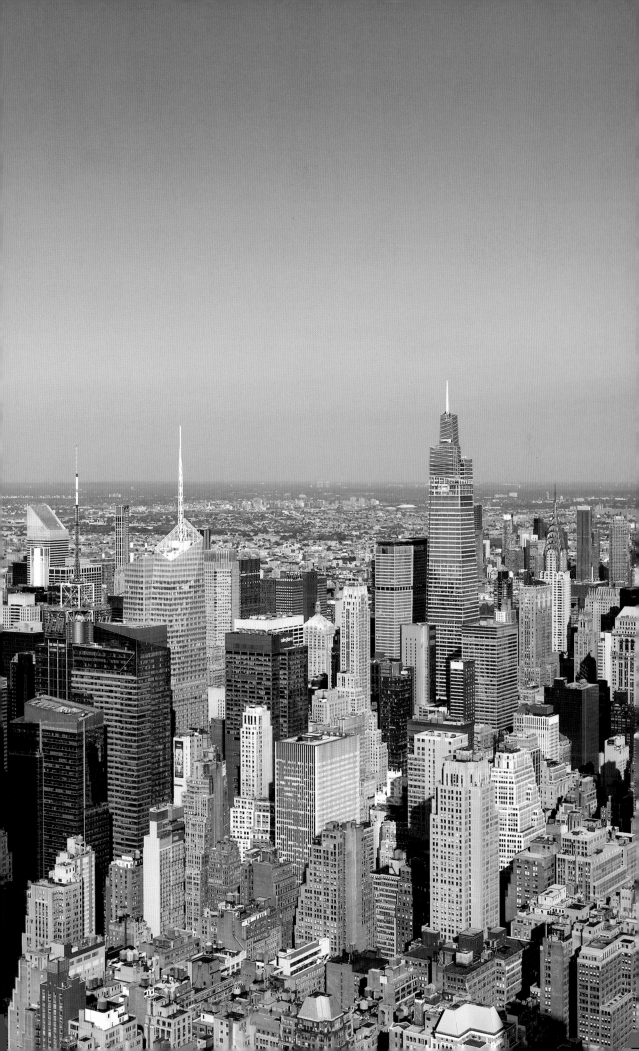

Sky-High

A Critique of NYC's Supertall Towers from Top to Bottom

Eric P. Nash

Photography by Bruce Katz

PA PRESS

PRINCETON ARCHITECTURAL PRESS
NEW YORK

Published by
Princeton Architectural Press
A division of Chronicle Books LLC
70 West 36th Street
New York, NY 10018
www.papress.com

Editor: Abby Bussel and Holly La Due
Designer: Benjamin English
Cover design: Paul Wagner

Library of Congress Cataloging-in-Publication Data
Names: Nash, Eric Peter, author. | Katz, Bruce,
 1958– photographer.
Title: Sky-high : a critique of NYC's supertall towers
 from top to bottom / Eric P. Nash ; photography
 by Bruce Katz.
Description: First edition. | New York : Princeton
 Architectural Press, [2023] | Includes bibliographical
 references. | Summary: "Part architectural guidebook
 and part critique, *Sky-High* documents the supertall
 towers that are transforming New York City's skyline
 as well as its streets" — Provided by publisher.
Identifiers: LCCN 2022042531 | ISBN 9781797222547
 (hardcover) | ISBN 9781797224206 (ebook)
Subjects: LCSH: Supertall buildings—New York (State)—
 New York. | Street life—New York (State)—New York.
 | Manhattan (New York, N.Y.)—Buildings, structures,
 etc. | New York (N.Y.)—Buildings, structures, etc.
Classification: LCC NA6233.N5 N38 2023 |
 DDC 720/.483097471—dc23/eng/20221014
LC record available at https://lccn.loc.gov/2022042531

Contents

Acknowledgments

To Kevin Lippert, a gentleman, and a scholar, taken from us too soon, who gave me my first break at Princeton Architectural Press; my sister, Laura, who has always been my north star, and who led me to audit a class with Carol Willis, founding director of the Skyscraper Museum, when she was teaching at Parsons School of Design and inspired me to take up architectural criticism as a career; the team at Princeton Architectural Press who made this book happen—Abby Bussel for the groundbreaking concept and Holly La Due for topping it off; my comrade in arms, intrepid lensman Bruce Katz, who always helped me keep focus and perspective; Apple Mike Abdalla, the best Mac troubleshooter in the biz, who picked me off the ceiling more than once; and sharp-eyed copy editor Magda Wojcek for proofreading the footnotes. And lastly, my nephews, Theodore and Lionel, who keep me informed and amused. —Eric P. Nash

To Eric P. Nash for bringing me along on this project— and for his generosity and good humor along the way; to our editors, Abby Bussel and Holly La Due; and to my wife, Jessica, for allowing me to perch precariously atop buildings in NYC without complaint. —Bruce Katz

List of Buildings

	Architect	Floors	Height	Year
One World Trade Center The Freedom Tower	David Childs of Skidmore, Owings & Merrill (SOM)	104	1,776 ft 541 m	2014
One57 157 West 57th Street	Christian de Portzamparc	75	1,004 ft 306 m	2014
432 Park Avenue	Rafael Viñoly Architects	87	1,397 ft 426 m	2015
3 World Trade Center	Rogers Stirk Harbour + Partners	69	1,079 ft 329 m	2018
One Manhattan West	Skidmore, Owings & Merrill (SOM)	67	995 ft 303 m	2019
30 Hudson Yards	William Pedersen of Kohn Pedersen Fox Associates (KPF)	73	1,270 ft 387 m	2020
35 Hudson Yards	David Childs of Skidmore, Owings & Merrill (SOM)	71	1,009 ft 308 m	2020
111 West 57th Street Steinway Tower	SHoP Architects	91	1,428 ft 435 m	2020
One Vanderbilt	James von Klemperer of Kohn Pedersen Fox Associates (KPF)	67	1,401 ft 427 m	2020
53W53 53 West 53rd Street	Jean Nouvel	77	1,050 ft 320 m	2021
Central Park Tower 217 West 57th Street	Adrian Smith + Gordon Gill Architecture	131	1,550 ft 472 m	2021
9 DeKalb The Brooklyn Tower	SHoP Architects	93	1,066 ft 325 m	2022

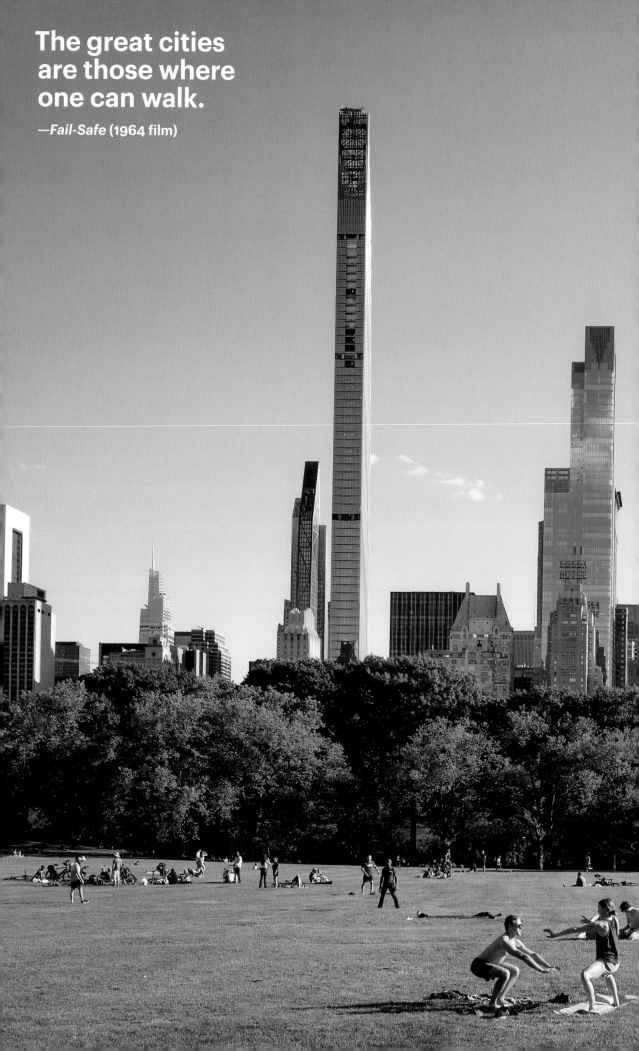

The great cities are those where one can walk.

—*Fail-Safe* (1964 film)

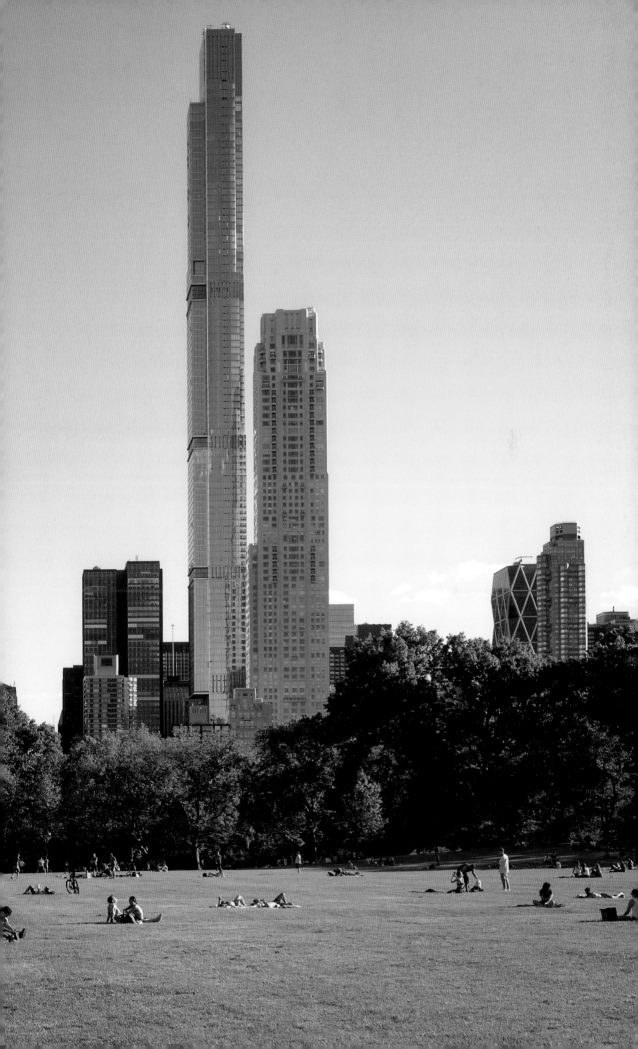

Part I
A Short History
of the Tall Building
in New York City

Part I
Introduction

In the second decade of the twenty-first century, architects and developers have set their sights on skyscrapers of an unprecedented scale: the supertall, a new skyscraper for the new millennium. According to the Council on Tall Buildings and Urban Habitat (CTBUH), the worldwide nonprofit organization that tracks skyscraper data, a supertall is any building that measures 984 feet or higher—an ungainly marker in the imperial system, but a cool 300 meters in the metric system.[1] The standard was set in 1889 by the Eiffel Tower, 1,083 feet / 330 meters from the base to the tip of its antenna.[2]

The onset of the COVID-19 pandemic in 2020 forced architects, city planners, developers, and policy makers around the world to rethink almost everything about the urban center as we know it, from crowded office buildings and elevators to mass transit and remote work.[3] Epidemiologists warn that COVID is just a foretaste of more virulent pandemics as civilization encroaches on the wild habitats of Asia and the Amazon.[4]

Climate change, perhaps already past anthropogenic reversal, may affect the world's great port cities, from the greater New York area to Hong Kong and Vancouver, as sea levels rise due to melting ice caps and warming temperatures.[5] Climatologists predict that sea levels may rise 4 to 8 feet / 1 to 2 meters by the end of the century.[6]

Meanwhile, we have a snapshot of how the future was *supposed* to look, (at least before the office rethink and concerns about future pandemics and drowning) with the dozen supertalls in this volume, largely residential and extremely expensive to build and live in. New York holds the record for the city with the most supertalls in the world, seventeen at this count, with a score or so underway or in proposal, including 2 World Trade Center by Sir Norman Foster, a fifth supertall for Billionaire's Row at 41 West 57th Street to be designed by the office of Rem Koolhaas, and another supertall for Phase II of Hudson Yards.[7] Chicago ranks next, with six supertalls. A handful of others are

scattered across the country like strewn toy jacks, from Los Angeles to San Francisco, Philadelphia, Atlanta, and Houston.[8]

China will soon have the most supertalls in the world, with more than two dozen completed and more than a hundred under construction.[9] Even Mexico City, whose financial underpinnings are shakier than the earthquake-prone lake-bed substratum upon which it is built, is digging foundations for two supertalls on a single downtown street.[10]

Chicago-based Adrian Smith + Gordon Gill Architecture was commissioned to build the jagged, thornlike Jeddah Tower in Saudi Arabia—a megatall, which the CTBUH defines as 1,989 feet / 600 meters, twice the height of a supertall.[11] The Jeddah has been mothballed for years due to financial issues and corruption by its backers (a group of financiers, including a Saudi prince, were temporarily detained).[12]

The Jeddah was meant to be the world's first kilometer-high skyscraper: 170 stories; 3,281 feet / 1,000 meters tall.[13] As of this writing, it is framed out at about seventy stories (42 percent of its height), but construction ground to a halt at the beginning of the pandemic in 2020.[14] It was also supposed to be the tentpole of a thriving commercial center, Jeddah City, but as of now it stands isolated in "the lone and level sands" like an augury from Shelley's "Ozymandias."[15]

For nationalistic pride, its developers hope the Jeddah will someday outstrip the current record holder for height, the 2,723-foot / 830-meter Burj Khalifa in Dubai, designed by the same firm in 2009.[16] Only 163 of its 200 floors are actually inhabitable; the remaining floors are what architects mock as "vanity height"—tiny, often useless floor plates (sometimes used for technical equipment and storage) designed to jack up the height of a building to achieve a world record—the architectural equivalent of shoe lifts.

There is an elite club of architects and engineers capable of designing supertalls, and they collaborate.[17] Adrian Smith + Gordon Gill Architecture also designed Central Park Tower—to date the world's tallest residential building and

the tallest of the New York supertalls documented in this volume—on West 57th Street, nicknamed Billionaire's Row for the wealth of its residents and the supertalls lined along it like sentries.[18]

The stats on Central Park Tower have been fudged by the developer for marketing superlatives. Extell lays claim to the world's highest roofline for a residential building, at 1,550 feet / 472 meters above grade (even though, strictly speaking, it's a mixed-use building). Extell also vaunts the world's highest habitable residential floor at 1,417 feet / 432 meters, 98 floors (oddly, listed as 137 floors—Extell conveniently lost count), which includes three underground floors.[19] No matter how you tote it up, residents of Central Park Tower's triplex penthouse live up there with King Kong.[20]

In late 2014, as supertalls including Christian de Portzamparc's One57 started to sprout on Billionaire's Row, activists bearing black umbrellas gathered to protest the impact of supershadows cast on Central Park that stretched three-quarters of a mile across the baseball fields up to the zoo.[21] Such concerns turned out to be exaggerated, except during the darkest days of fall.[22] In most seasons, the pencil towers cast no more shadow than a gnomon on a sundial.

What distinguishes many supertalls is not just their height but their slenderness ratio: a measure of width—or footprint—compared with its tallness.[23] A building is considered slender if it has a ratio greater than 1:7, which, curiously, corresponds to the ratio of a classically proportioned Renaissance human figure (seven and a half heads tall).[24] In comparison, the supertall is a supermodel, a Giacometti, an attenuated cruet of the old cartoon character Olive Oyl. The slenderest building in the world is the feathery, wafer-thin, eighty-four-floor, 1,428-foot / 435-meter Steinway Tower on Billionaire's Row, designed by SHoP Architects, with a ratio of 1:24—the visual equivalent of two school rulers stacked one atop the other.[25]

There is a superabundance of ways to measure a building's height, primarily for the purpose of record setting,

the most common of which is from the ground, or what architects call "grade level," to the top of the building's highest permanent architectural feature. But there is room to equivocate even there.

The illuminated barbershop pole atop One World Trade, a disproportionate third of the building's height, reaches the desired symbolic height of 1,776 feet / 541 meters in commemoration of the nation's year of independence, even though the roof level is only 1,368 feet / 417 meters, a couple of floors higher than the Empire State Building.[26] Completed in 2014, One World Trade, designed by David Childs of Skidmore, Owings & Merrill (SOM), is the tallest building in the country—but only by a technicality.[27]

What qualifies as a spire—a piece of "functional-technical equipment," as opposed to an antenna, a flagpole, or signage (which generally do not count)—is a subject of hot debate.[28] Officials at CTBUH subjectively deemed the unit atop the Freedom Tower a spire because it tapers, thus making it a permanent feature of the building, unlike the antenna—taller at 1,729 feet / 527 meters, also permanent, but nontapering— of the Willis Tower (forever known to Chicagoans as the Sears Tower) of 1974.[29] Call it Second City Syndrome.

1
The Eclectic Era

Skyscrapers would not have been possible without the advent of the passenger elevator.[1] Construction elevators have been in use since the time of Archimedes.[2] In the first century BC, the Roman architect Vitruvius employed simple hoists—little more than a rope, a raised pulley, and a platform—to raise loads of brick and stone. The unsecured cargo as often as not tumbled out, causing a dusty uproar, but transporting humans was another matter entirely.[3]

In 1854, Elisha Graves Otis demonstrated his invention of an automatic safety catch for passenger elevators with great aplomb at the World's Fair in New York, whose impresario was none other than America's showman, P. T. Barnum. Hourly, a top-hatted Otis would ride up on a creaky, heavily laden hoist, then dramatically order a workman to sever the sole supporting rope with a saber. The lift would fall just a few inches before stopping with a jolt.[4] Skyscraper speculators did not fail to recognize the possibilities, and tall commercial buildings with elevators began to crop up everywhere.

Amazingly, the shaft (but not the inner workings) of the world's first safety passenger elevator still exists, in the Venetian palazzo–style E. V. Haughwout Building (five floors; 79 feet / 24 meters) in New York's SoHo neighborhood, built by John P. Gaynor in 1857.[5] The word ELEVATOR stamped in cast iron can still be seen on the north end of the building's facade at 488-492 Broadway.

Ladies' Mile, an irregularly bordered historic district centered around Fifth and Sixth Avenues from Union Square to West 23rd Street, featuring 440 vast cast-iron structures that were once mainly fashionable department stores catering to the "carriage trade," is a forerunner to the modern skyscraper.[6] The district was also significant as an engendered space for women in the late nineteenth century, because it was considered safe enough that females, at least those of the upper classes, could consort without male companionship, a rare liberty in Victorian society. Radical notions like women's rights, suffrage, and temperance found fertile soil

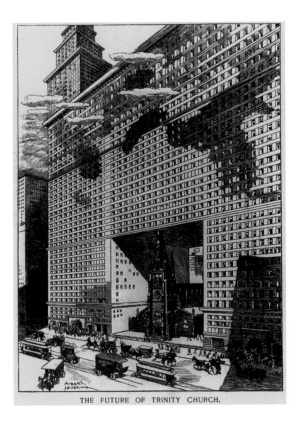

THE FUTURE OF TRINITY CHURCH.

Even in the early twentieth century, New Yorkers were alarmed that the city was growing too tall (left). At 281 feet / 86 meters, the spire of Trinity Church (Richard Upjohn, 1846, right) lorded over the city for forty-four years.

and were disseminated to the general population in spaces where women were allowed to talk freely without the disapproving gaze of mustachioed males.[7]

New York took its own idiosyncratic route to the skyscraper with cast-iron construction in the mid- to latter nineteenth century. Cast iron, a building material that dates back to Chinese temples of the Tang dynasty (618 to 907 AD), had been used to great effect to build "cathedrals of steam"[8] in bridges and railway stations in Victorian England as well as France and other European nations.[9]

New York foundry owner Daniel D. Badger and architect, inventor, and foundry owner James Bogardus were instrumental in the modular fabrication and application of cast iron in the United States.[10] They discovered that cast iron, when rolled into columns, made a remarkably compact, sturdy building material, able to bear far more weight than its brick or stone counterparts, without taking up the equivalent space. Ornate, relatively lightweight iron facades could be cast into historical styles (anything from French Second Empire to Venetian Gothic and Neo-Grec) and bolted to the supporting columns, thus eliding the need for skilled workmen.[11] Cast-iron construction presaged the curtain walls and modular bays that typify the modern skyscraper.[12]

With 250 to 300 cast-iron buildings still extant, Manhattan has the greatest concentration in the country.[13] Rare foundry marks of Badger and Bogardus can still be seen on some column bases. Rear walls and party walls were of ordinary brick, to add structural heft. It was fashionable at

The Eclectic Era

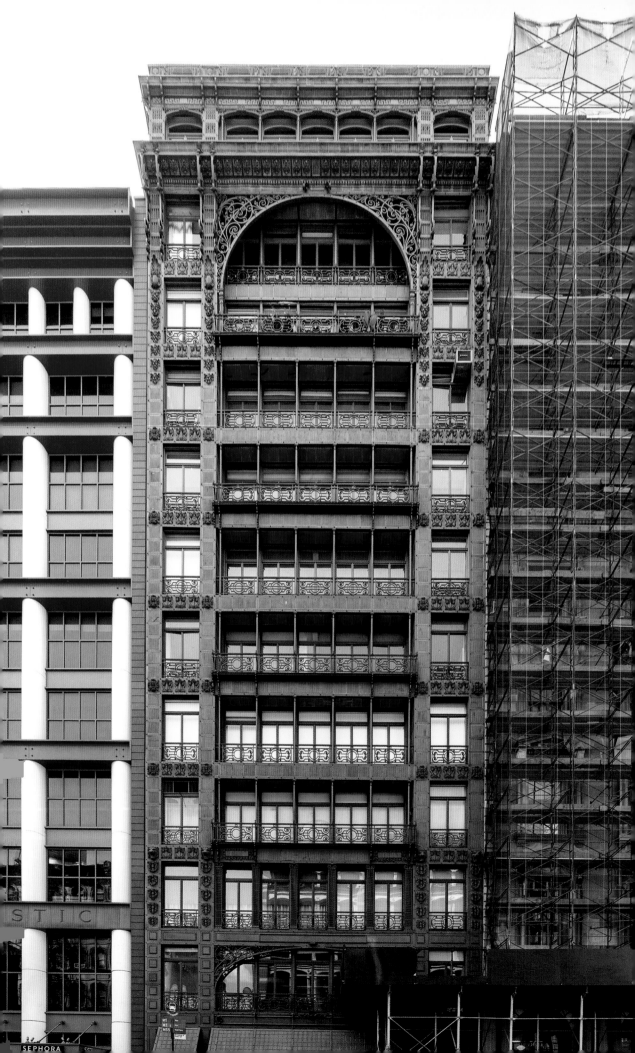

the time to paint the facades to resemble stone.[14] The trompe l'oeil effect can be startling. Cast iron hunters carry a pocket magnet, just to be certain.

Cast iron created a new sense of openness, both on the facade and in the interior, because buildings required far less support at the base. Street-level shopfronts became glass-filled and airy, like those that still stand in SoHo today. The term "window shopping " became fashionable among New York's smart set. Interior space opened up as thin cast-iron columns replaced blocky masonry columns that took up floor space.[15]

Cast iron, though strong in compression and able to support heavy loads like New York City subway ceilings (many of the original round cast-iron columns are still in place), is extremely brittle, snapping in suspension (that is, in supporting horizontal loads), because of impurities in the iron.[16]

Another drawback of cast iron is that it melts when subjected to high temperatures. Without the protection of insulating fireproofing material, a later feature, it puddled in the heat of a fire, whether from within the structure or an adjacent building.[17] Early fire-safety precautions were nil— flammable materials like hemp and kerosene were commonly stored side by side. Wooden joists, girders, and flooring ignited like so much kindling.[18] Even as late as the 1950s, the city's fire commissioner referred to the cast iron district as "Hell's Hundred Acres."[19]

While cast iron flourished in New York, Chicago architect and engineer William Le Baron Jenney created something new under the sun in 1884 when he built the ten-story, masonry, glass, and steel Home Insurance Building in Chicago's Loop—considered the first modern skyscraper (demolished in 1931).[20] At 138 feet / 42 meters, the Home Insurance staked its claim not because of its height, but because Jenney, more of an engineer than an aesthetician, built an internal framework of iron and steel embedded in the masonry walls to help support the building's weight.[21]

The glassy facade of Ernest Flagg's "Little" Singer Building (1904), made possible by a precociously wide span between steel columns, anticipated the modern glass curtain wall.

There are no clear-cut answers as to which was truly the first skyscraper, because there are no clear-cut definitions, but Jenney's imprint on the modern skyscraper is ineluctable. His apprentices included Louis H. Sullivan, designer of New York's highly decorative, thirteen-story Bayard-Condict Building (162 feet / 49 meters) of 1899 on Bleecker Street, and Daniel H. Burnham, architect of the proud Flatiron Building (twenty-one floors; 285 feet / 87 meters) of 1902, imposingly sited on a truncated triangular block just south of Madison Square Park.[22] Though Sullivan's and Burnham's buildings are not tall, even by the standards of their day, they remain impressive and are significant in the development of skyscraper style. The Flatiron, dramatically clad in seemingly weightless neoclassical terra-cotta, was one of the first buildings in New York with an all-steel skeleton.[23]

The technology was now in place for a skyscraper, but few architects had any inkling of what one should look like. Newer, taller buildings were plainly vertical, but hidebound architects insisted on squashing them into the tripartite, horizontal form of Renaissance palazzi or Beaux-Arts châteaus, which made the buildings look squat rather than soaring.

The so-called Eclectic Era of skyscraper design overlapped with the Gilded Age. Eclectic Era buildings never fail to entertain; the whole architectural grammar might as well have been written in Jabberwocky. All sorts of curiosities abounded, from sham Moorish styling to Roman columns on the facades, not supporting weight as they are meant to but merely providing visual decoration on high. Limestone and terra-cotta gorgons, gargoyles, goblins, grotesques, goat gods, and Gothic gewgaws, some quite ingeniously wrought, cavort at heights unseen by man.[24] Congestion was a concern even in the late 1880s.

Louis Sullivan formulated the essential grammar of the tall building in his brief 1896 manifesto, "The Tall Office Building Artistically Considered." He declared that

the skyscraper "must be tall, every inch of it tall....It must be every inch a proud and soaring thing, rising in sheer exaltation that from bottom to top it is a unit without a single dissenting line."[25]

Refinements in steelmaking at the turn of the twentieth century were the next significant step in skyscraper evolution.[26] Iron is smelted with alloys to produce steel, which has greater tensile strength, making it stronger and more flexible in bearing both horizontal and vertical loads. Like Superman, the proverbial Man of Steel, the admixture is nearly impervious to impact and does not shatter.[27] The final piece of the skyscraper puzzle, so to speak, was the development of riveting steel columns to beams to form a springy steel inner cage.

The Bayard-Condict Building (1898) is New York's only building by the great skyscraper theorist Louis Sullivan, who realized that the essence of a skyscraper is its verticality.

The Eclectic Era

2
Ever Upward

New York State's motto is "Excelsior" ("Ever upward")
and a hit parade of the world's tallest buildings followed
the development of the steel structural skeleton.[1] One
of the earliest, the twin-cupolaed Park Row Building (thirty
floors; 391 feet / 119 meters), the tallest office building of its
time, was completed by R. H. Robertson in 1899.[2] It still
stands, dwarfed by its neighbors, near City Hall at 15 Park
Row—once known as "Newspaper Row" because of its
concentration of daily newspaper publishers.

The next record holder was Napoleon LeBrun & Sons'
Metropolitan Life Insurance Company Tower (fifty stories;
700 feet / 213 meters), built in 1909, east of Madison Square
Park.[3] Though a true skyscraper, it was modeled after the
Campanile in Venice's Piazza San Marco (323 feet / 98
meters)—tall, yes, but only by the standards of a sixteenth-
century city.[4] The problem with faithfully copying a
historical building is that the mind's eye inevitably shrinks
it down to the scale of the original.

In 1913, Cass Gilbert sagaciously chose the vertically
oriented Flamboyant Gothic style for his world's tallest
building, the creamy, terra-cotta-faced Woolworth Building
(fifty-eight floors, including mechanical floors; 792 feet / 241
meters), near City Hall.[5] The F. W. Woolworth Company
was a chain of retail stores, originating the concept of five-
and-dimes (selling all items for ten cents or less), and evolved
into a multimillion-dollar worldwide corporation.[6] Dubbed
the "Cathedral of Commerce," the Woolworth was as
world-renowned in its day as the Empire State, and reigned
supreme as the world's tallest building for seventeen years.[7]
Remarkably, the entire construction cost of more than $13
million was paid in cash, without a mortgage, presumably
in Frank Woolworth's nickels and dimes.[8]

The next spurt of skyscraper creativity was brought
about by something as seemingly innocuous as a change in
a zoning code. Office buildings in Lower Manhattan had
been growing not only in height but also in bulk. At the end
of the nineteenth century, block-wide, forty-story behemoths

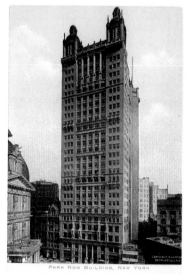

PARK ROW BUILDING, NEW YORK

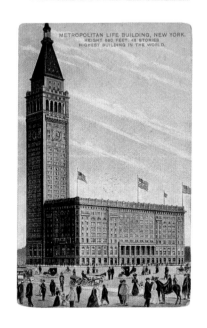

A Short History of the Tall Building in New York City

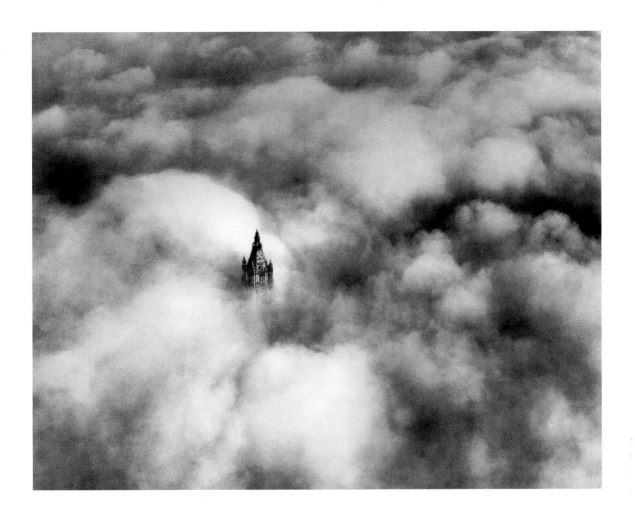

stretched to the horizon, like in Winsor McCay's *Little Nemo in Slumberland*, a popular Sunday funnies page in the *New York Herald*.[9]

Historians identify the tipping point as the formidable Equitable Building, which occupies an entire block at 120 Broadway, rising straight up from the sidewalk without a single setback (thirty-eight floors; 555 feet / 169 meters).[10] Designed by Ernest R. Graham in 1915, the world's largest office building of its day packed a whopping 1.2 million square feet / 111,484 square meters of rental space onto a footprint of slightly less than an acre, or thirty times the area of its site.[11] The Equitable cast a shadow six times its size over the neighborhood, devaluing surrounding properties, which relied on natural light.[12] Even today, one feels mouselike entering its cavernous lobby. Plainly, something had to be done to curb the city's overgrowth.

(opposite top) At the time it was built, R. H. Robertson's eclectic twin-cupolaed Park Row Building (1899) was the world's tallest office building. The Met Life Tower (1909, opposite bottom) is yet another in New York's series of world's tallest buildings.

(above) The pyramidal, copper-clad, 125-foot / 38-meter-tall roof of Cass Gilbert's fifty-five-story Woolworth Building (1913) pokes through the cloud cover, demonstrating the meaning of the word *skyscraper*. The Woolworth reigned as the world's tallest building for seventeen years and was as universally recognized as the Empire State Building.

3
Art Deco Days
(and Nights)

In response, the city passed the Building Zone Resolution
in 1916, the first comprehensive zoning code in the nation,
which mandated that building floors must be set back at
certain heights according to a prescribed formula from the
plot line where the building meets the sidewalk, to allow
much-needed sunlight and air circulation to penetrate to the
street.[1] Zoning codes may seem like a dry topic, but the new
school of architects in the 1920s responded with tremendous
zeal, giving rise to New York's romantic, sawtooth art deco
skyline, associated with F. Scott Fitzgerald's Jazz Age.

What is considered the first fully realized setback
skyscraper stands on the downtown border of Bryant Park:
the American Radiator Building (twenty-three floors;
338 feet / 103 meters), designed by Raymond Hood in 1924.[2]
Restored to its former glory, the Radiator is constructed
with black brick setbacks and gold-tipped finials in an
architecture parlante style, expressing the company business
of making glowing, coal-fired radiators.

Though deco is characterized by its setback silhouettes,
architects reached as far and wide as those in the Eclectic
Era did for stylistic reference points. The sixteenth-century
Renaissance-style apartment building aptly named the
Ritz Tower by luxe architects Emery Roth and Carrère &
Hastings (forty-one floors; 541 feet / 165 meters), at the
corner of Park Avenue and East 57th Street, was the world's
tallest residential building in 1926.[3] Today, it stands knee-
high to the steroidal supertalls of Billionaire's Row, but it
is the lineal ancestor of the exclusive residential supertall
because it featured duplex apartments with 18-foot / 5-meter
ceilings that extended 40 feet / 12 meters, with simultaneous
views of the Hudson and East Rivers.[4]

The phantasmagorical Fred F. French Building of 1927
(thirty-eight floors; 429 feet / 131 meters) at 551 Fifth
Avenue was built as the headquarters of the eponymous
real estate developer by architects H. Douglas Ives and
Sloan & Robertson.[5] The lobby is patterned after the Ishtar
Gate (originally in Babylon's inner city, now partially

reconstructed in the Pergamon Museum in Berlin, thanks
to German archaeological bandits).[6] The crown of the French
Building is graced by a spectacular polychromatic faïence
panel of paired Assyrian griffins facing a sunrise.[7] Back then,
it was not considered outré for a Manhattan developer to
compare himself to Nebuchadnezzar II.

Another over-the-top example of art deco design is the
original RCA Victor Building, now known as the General
Electric Building (seventy floors; 643 feet / 196 meters), at
570 Lexington Avenue, designed by Cross & Cross in 1931,
whose latticework crown of arcane architectural masks and
zigzagging airwaves can only be interpreted as evoking the
primitive "gods" of a new technology.[8] Never again would
American corporations be so dizzyingly romantic. The spire-
like upper shaft (forty stories; 570 feet / 174 meters), with
floor plates far too narrow to accommodate the floorspace
required for modern office suites, has much in common
with today's superskinny, supertall residences.[9]

One of the purest art deco showcases is the Chanin
Building, built by Sloan & Robertson in 1929 (fifty-six
floors; 649 feet / 198 meters).[10] Although it was the first
major art deco skyscraper in the Grand Central district,
it is overshadowed by its peacock neighbor, the Chrysler
Building, across East 42nd Street.[11] The slablike Chanin, on
a corner site, rises in a series of shallow setbacks. Its stunning
ornamental lobby features intact original entryways, beige
Botticino marble walls, sculpted grille covers, chandeliers,
bronze elevator doors, and metalwork by deco artist Rene
Paul Chambellan and Chanin's in-house architect Jacques
Delamarre—an art deco museum for enthusiasts.[12]

Starrett & Van Vleck's former Downtown Athletic
Club of 1930 near the Battery on West Street (thirty-five
floors plus four attic stories; 542 feet / 165 meters)—now
shuttered, with a possibility of condo conversion—was once
a celebration of what architect and critic Rem Koolhaas
retroactively labeled "Manhattanism," or the "culture of
congestion."[13] Floors of the men's club were dedicated to

different programs: a boxing ring, complete with oyster bar, where gentlemen in the nude could slurp oysters on the half shell; an Olympic-sized pool on the twelfth floor, where they could float above the city lights in solitary splendor like today's billionaires on the Row; even at one time a golfing green with a "real" running brook (a miniature golf–type sham of an artificial streamlet with a verdantly disguised tap and drain—but still, it kept the old boys amused).[14]

In his over-the-top paean to congestion, *Delirious New York: A Retroactive Manifesto for Manhattan,* Koolhaas wrote, "Nature is now resurrected *inside* the Skyscraper as merely one of its infinite layers."[15] You might call the vertically stacked amenities of the club a supertall in embryo.

Schultze & Weaver's design of the limestone-clad, twin-pinnacled Waldorf-Astoria Hotel (forty-seven floors; 625 feet / 191 meters) of 1931, on Park Avenue between East 49th and East 50th Streets, also reflected Manhattanism's mania for putting everything under one roof, a city-within-a-city on a single block. Amenities included a bank, a bakery, a barbershop, and a triple-height ballroom, the largest in the world at the time.[16] The ground-floor parking garage was designed to accommodate the turning radius of a Rolls-Royce Corniche.[17]

The race to be the world's tallest building culminated in a madcap chase among the Chrysler Building, the Empire State Building, and 40 Wall Street.[18] Like poker players, the architects of the three buildings bet on what would qualify as the world's tallest. In April 1929, six months before the stock market crash, the team of H. Craig Severance and Yasuo Matsui, with consulting architects Shreve & Lamb, gambled on 927 feet / 283 meters for 40 Wall's height.[19]

But in a stunt straight out of a Keystone Kops silent comedy, architect William Van Alen secretly assembled a 125-foot / 38-meter spire he termed a "vertex" *inside* the seventy-seven-story frame of his Chrysler Building, hoisting it up from within to reveal a capping height of 1,046 feet / 319 meters, dwarfing 40 Wall.[20]

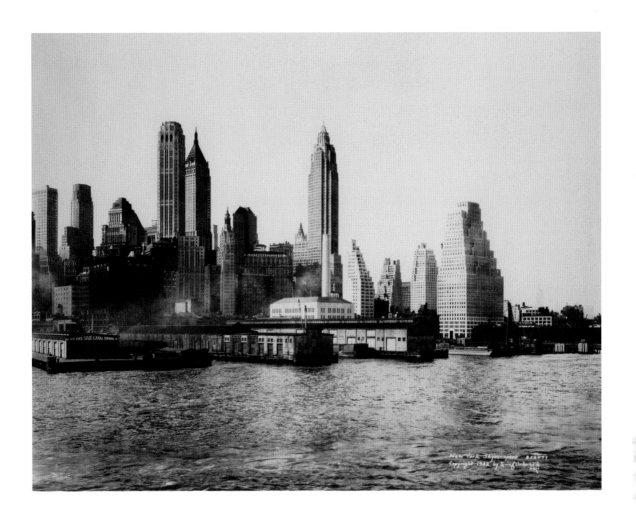

Renamed Shreve, Lamb & Harmon in 1929, the firm made the matter moot just thirteen months later, in 1931, with the completion of its 102-story, 1,250-foot / 381-meter Empire State Building (the addition of an FM radio antenna in 1965 brought it to 1,454 feet / 443 meters).[21] Instantly it became the world's tallest building and the first to top one hundred stories.[22] In today's era of ever-higher skyscrapers, the Empire State holds one record that will stand: the longest time as the world's tallest skyscraper, forty-three years.[23]

Like today's supertalls, the Chrysler Building met with mixed press when it opened. Many critics were dismissive: "no significance as serious design," opined highly regarded architectural critic George S. Chappell, writing under the pen name T-Square in the *New Yorker*, "distinctly a stunt design, to make the man in the street look up."[24] An unflattering comparison was made of the silver-crowned tower to an "up-ended swordfish."[25]

Nonetheless, influential architect and critic Kenneth Murchison, who personally liked Van Alen and was a fellow alum of the École des Beaux-Arts in Paris, liked the building's frankly commercial quality and admired "the astonishing plays of light which nature alone can furnish" upon its crown, declaring Van Alen "the Ziegfeld of his profession."[26]

Stone colossi arise from the bedrock of Lower Manhattan, dwarfing the scale of the old city, in this image captured in the 1930s. Once the street grid was filled in, there was nowhere to go but up.

29

Art Deco Days (and Nights)

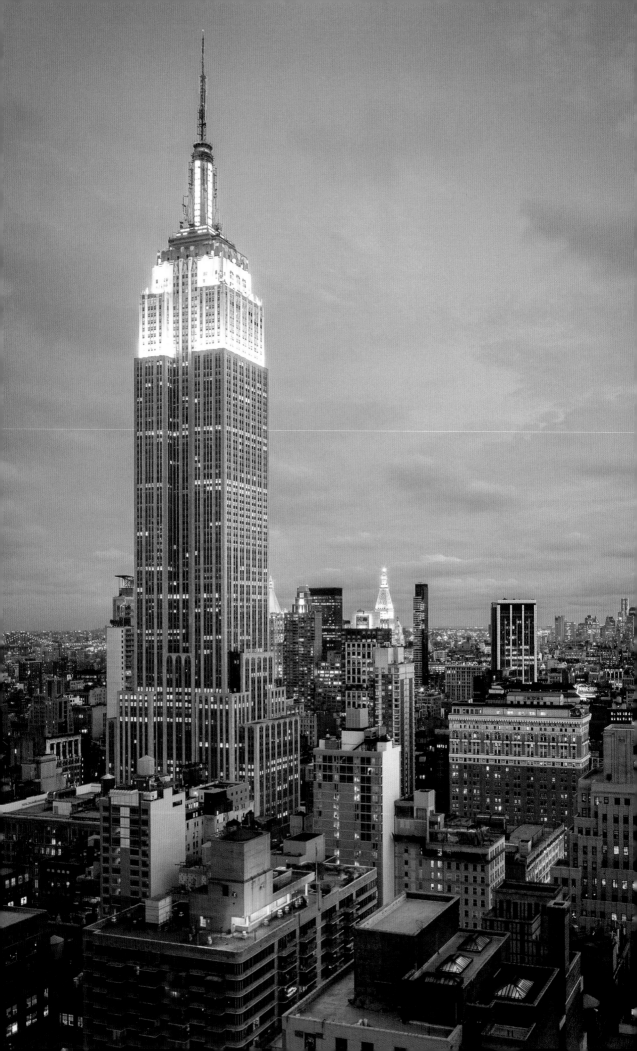

In contrast, the Empire State Building was designed with strict economic determinism in mind, as Skyscraper Museum director Carol Willis points out in *Form Follows Finance*.[27] Surprisingly, the famous skyscraper, reproduced on tchotchkes from key chains to coffee mugs, owes most of its silhouette to pragmatic business calculations: before the widespread use of fluorescent lighting and air-conditioning, the innermost walls of prime office space were typically located 25 to 30 feet (8 to 9 meters) from a window.[28] Any space beyond that point was unfit for office work, because it did not receive enough natural light or air circulation.[29] The Empire State Building's setbacks and long vertical shaft were largely determined by the grouping of the elevators.[30]

Its chief designer, William Lamb, offered a matter-of-fact description of the building's program:

> The logic of the plan is very simple. A certain amount of space in the center, arranged as compactly as possible, contains the vertical circulation, toilets, shafts, and corridors. Surrounding this is a perimeter of office space 28 feet [9 meters] deep. The sizes of the floors diminish as the elevators decrease in number.... The four groups of high-rise elevators are placed in the center of the building with low-rise groups adjoining on the east and west side so that, as these drop off, the building steps back from the long dimension of the property to approach the square form of the shaft, with the result that instead of being a tower set upon a series of diminishing setbacks prescribed by the zoning law, the building becomes all tower rising from a great five-story base.[31]

But oh, that glorious, impractical winged spire! A perch from which King Kong could fend off biplanes. "It's the nearest thing we have to heaven in New York!" exults Deborah Kerr's character to Cary Grant's character in *An Affair to Remember* (1957).

In contrast to the vertical thrust of Manhattanism, European architects like Le Corbusier, Walter Gropius,

The art deco crown of the Empire State Building (Shreve, Lamb & Harmon, 1931) was first illuminated in 1976, in honor of the nation's bicentennial.

Art Deco Days (and Nights)

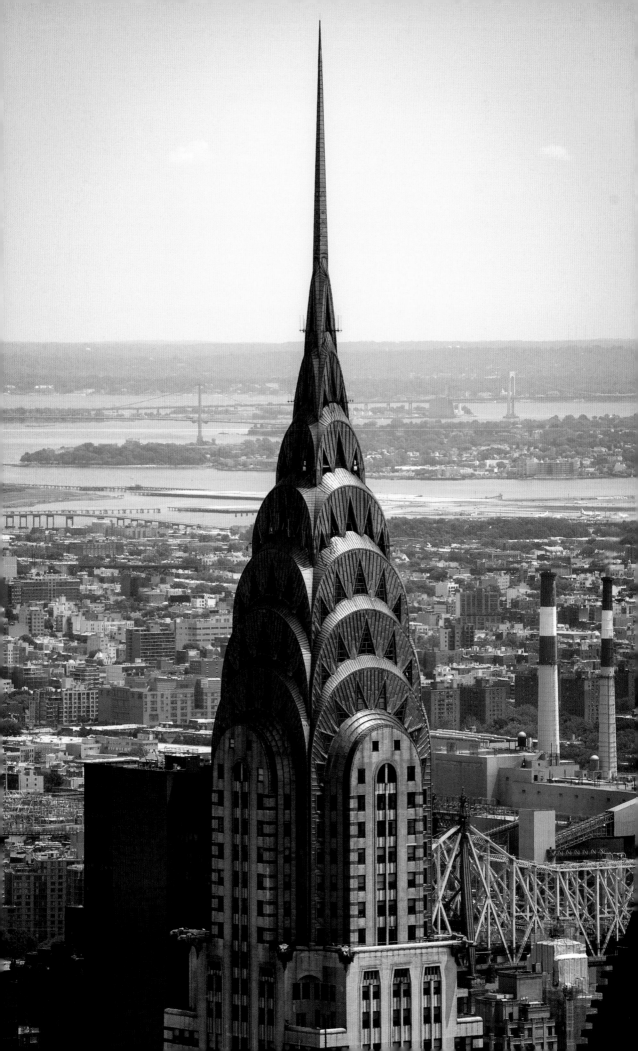

and Eero Saarinen, leading proponents of what came to be known as the International Style, were experimenting with more ground-hugging, slablike forms.[32] Raymond Hood, the last important prewar architect in New York, struggled throughout his brief, prolific career to reconcile the two.[33]

For the Daily News Building in 1930, Hood and partner John Mead Howells experimented by combining the setback and slab with white brick piers and spandrels of russet and black brick (thirty-six floors; 476 feet / 145 meters).[34] It is one of the earliest skyscrapers with a flat roofline and undecorated cornices—a fact so common today that it goes unnoticed, but a radical departure at the time, which gives the massive building an almost weightless mien.[35]

Again, in 1934, Hood melded the two styles in his blue-green, glazed tile McGraw-Hill Building (thirty-three floors; 485 feet / 148 meters) on far West 42nd Street. Looked at straight on from the sidewalk, it resembles a slab, but seen from either side, it reveals its distinct setback silhouette.[36] After Corbusier, it was modish to compare buildings to machines and means of transportation.[37] Hood's design recalls a luxury ocean liner, with porthole-like windows at street level, nautical brass handrails, and, originally, a trim lobby with deep emerald enamel walls and dadoes, before a ham-handed remodeling.

Hood was lead architect of the team that designed Rockefeller Center, the city's last major construction project during the Great Depression—made possible because it was privately funded by the Rockefeller family.[38] The centerpiece of the complex is the sharp cliff face of 30 Rockefeller Plaza (seventy stories; 850 feet / 259 meters) of 1933.[39] Originally called the RCA Building (later the General Electric Building, now the Comcast Building— not to be confused with the 1931 RCA Victor / General Electric Building described on page 27), it is a Janus-faced design that both looks back to the romance of art deco and ahead in its slablike parti to the clean-lined International Style that predominated the postwar era.[40]

Controversial in its time because of its secondary function as a flashy ad for Chrysler cars, William Van Alen's phantasmagoric Chrysler Building (1930) is now New Yorkers' favorite skyscraper.

Art Deco Days (and Nights)

4
Looking through a Glass Onion

After World War I, the entire course of Western civilization was viewed as a nightmare from which we needed to awaken. Modernists wanted to "start from zero," to build on a tabula rasa with no reference to all that cluttered historicism, like so much junk in the attic. The revolt against ornament was presaged at the turn of the twentieth century in the work of the idiosyncratic Czech-Viennese architect Adolf Loos and in the 1920s by the overlapping aesthetic movements of the Bauhaus, the Wiener Werkstätte, the Werkbund, and the Neue Sachlichkeit (the "New Objectivity") in Germany, all of which ended with hyperinflation and the rise of Hitler.[1]

After the interregnum of World War II, what became known as the International Style of clear lines and new, pure materials of steel and plate glass took over the globe. As much of an aphorist as Mies van der Rohe, Le Corbusier said of New York, "A hundred times have I thought New York is a catastrophe and fifty times: It is a beautiful catastrophe."[2] The sexagenarian Swiss-French architect petulantly seized upon the United Nations Secretariat as his personal mission, even though the team leader was an American, Wallace K. Harrison, the Rockefeller family's in-house architect.[3]

Going up in 1949, the freestanding steel slab of the Secretariat measured 544 feet / 166 meters tall, 287 feet / 87 meters wide, and only 74 feet / 23 meters deep.[4] The tower's final height was thirty-nine floors (506 feet / 154 meters).[5] Most important, when the Secretariat opened in 1952 it featured the first glass curtain wall in the world, so-called because the glass is attached much like a curtain or skin to the steel underpinning.[6]

The world's first all-glass curtain wall building is the dainty, asymmetrical green glass gem Lever House (twenty-one floors; 307 feet / 94 meters).[7] Poised on stainless-steel-clad columns above the sidewalks at the base of Park Avenue, it was designed in 1952 by the egoistic genius Gordon Bunshaft of SOM and his often unaccredited senior designer, Natalie Griffin de Blois.[8] Lever House is by no means a

Lever House (Skidmore, Owings & Merrill, Gordon Bunshaft, principal architect, 1952) ushered in the era of the all-glass curtain wall office building.

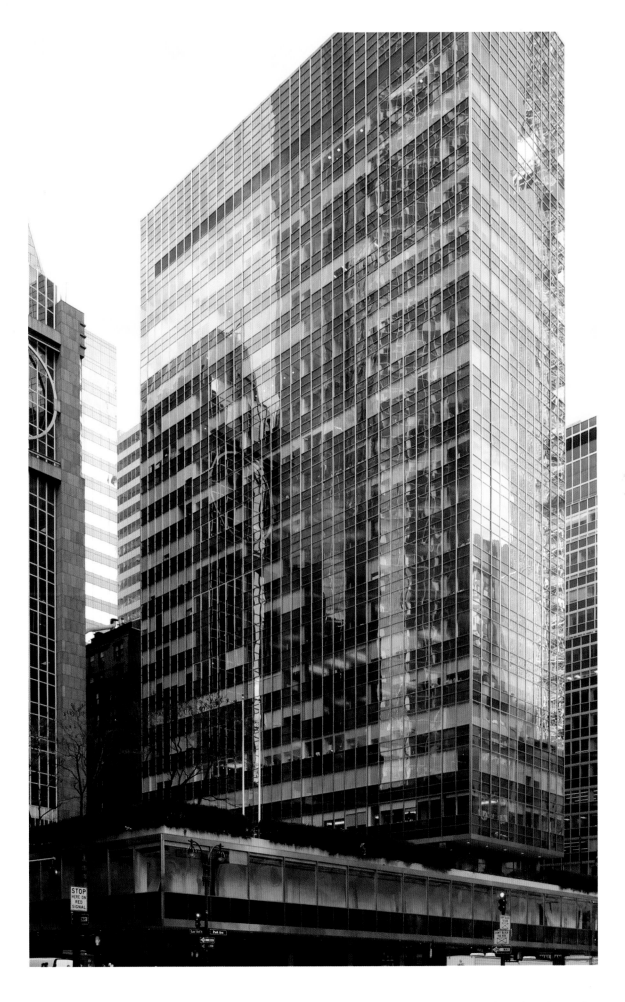

Looking through a Glass Onion

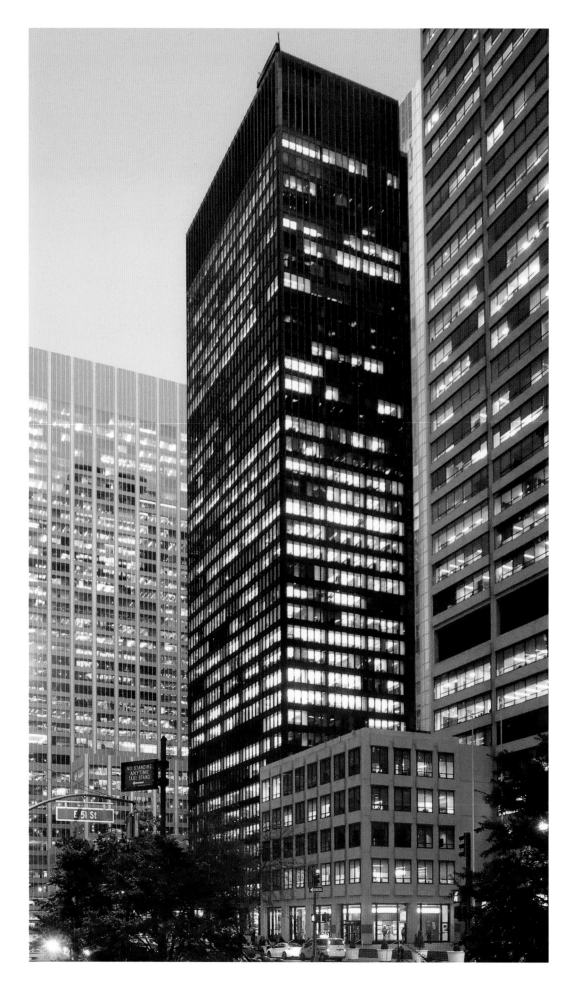

A Short History of the Tall Building in New York City

skyscraper, but its impact on the glass office buildings that line Park and Third Avenues in Midtown was monumental.

Catercorner to Lever House stands Mies van der Rohe's perfectly proportioned, 515-foot / 157-meter Seagram Building of 1958, the most celebrated postwar office tower in the city, and perhaps the world.[9] Mies reduced the skyscraper to its essence, a skin-and-bones, bronze-colored glass sheath on a steel skeleton floating atop bronze pilotis. (Reaching back to Corbu's radical Villa Savoye of 1931, modernists preferred the French-derived term *piloti*, perhaps because simply calling them columns seemed too bourgeois.)

Known for his aphorism "Less is more," Mies also remarked that he wanted his architecture to be "*beinahe nichts*" — German for "almost nothing."[10] In the Seagram, Mies fused the glory of Gothic architecture, the stained-glass window, with the serene proportions of a Greek temple in a stripped-down architecture for the ages. He also broke up the dense *rue corridor* of masonry fronts of Park Avenue with a refreshing, open plaza that would be much emulated.

The new zoning code of 1960–61 allowed many similar towers-in-a-plaza to replace the outdated setback style. Seemingly overnight, the all-masonry palazzos of Midtown Manhattan transformed into glass boxes.[11] Unfortunately, many of them lacked the proportionality and materiality of Mies's masterpiece. After the rackety, light-obscuring Third Avenue El train was torn down in the mid-1950s, sketchy walk-ups and low-rise dives as seen in the shot-on-location movie *The Lost Weekend* (1945) were demolished to be replaced with clone-like, mid-rise glass office buildings.[12]

The bronze-colored Seagram Building (1958), by Mies van der Rohe in association with Philip Johnson, is critically considered to be the pinnacle of twentieth-century skyscraper design.

Looking through a Glass Onion

5
Beyond Modernism

In succeeding decades, some architects and critics felt that
modernism had reached a terminal point and was ossifying
into "glass-box-itis,"[1] in the words of Philip Johnson. Just
when modernism seemed to have hit the doldrums, the
postmodern movement in architecture of the early 1980s
was buttressed by a *nouvelle vague* of French philosophers,
like Michel Foucault, Jacques Derrida, Gilles Deleuze,
Jean-François Lyotard, and Jacques Lacan, who introduced
concepts of power, deconstruction, poststructuralism, and
even psychoanalysis to architecture, producing, with a few
exceptions, more great literature than great buildings.[2]

In 1984, Philip Johnson, who along with architectural
historian Henry-Russell Hitchcock essentially defined the
International Style in their seminal exhibition in 1932 at the
Museum of Modern Art, turned court jester and abruptly
pronounced that historical references were not so bad after
all.[3] In an era of knockoff Miesian glass towers, Johnson
and his partner, John Burgee, audaciously adorned their
647-foot / 197-meter AT&T Building of 1984 (now the Sony
Building) at 550 Madison Avenue in *retardataire* pinkish
gray Stony Creek granite (popular in the era of Beaux-Arts
classicism), with an arched, seven-story entryway referencing
Milan's Galleria Vittorio Emanuele II and, most outrageously,
a whimsical, purely ornamental Chippendale-inspired
crown — a shockeroo to most critics.[4]

Johnson's tower has aged well over the decades, although
contemporary critical reception was mixed. Ada Louise
Huxtable of the *New York Times*, who was right about
so much else, dismissed it as a "pedestrian pastiche pulled
together by painstaking, polished details," getting carried
away with alliteration in her ennui, while her colleague Paul
Goldberger rightly recognized it as "postmodernism's major
monument."[5]

There is much else to cover in the story of the New York
City skyscraper, enough to fill whole libraries, but the first
part of this volume concludes with the tragedy of 9/11,
when the original 1 and 2 World Trade Center Buildings

by Minoru Yamasaki and Emery Roth & Sons, which eclipsed the Empire State Building in 1973 and 1974, respectively, as the world's tallest buildings, collapsed in a terrorist attack.[6]

The Twin Towers were not actual twins: they were both 110 floors, but 1 World Trade was 1,368 feet / 417 meters and its sister was slightly shorter at 1,362 feet / 415 meters.[7] In 1978, a fixed antenna added onto 1 World Trade brought its height to 1,728 feet / 527 meters.[8] Compared to today's supertalls, their slenderness ratio was a relatively chunky 1:6.5.[9]

After the attack, there were murmurings in the real estate community that out of a superabundance of caution, Manhattan should never again build above the Midtown average of fifty or so floors. But then again, New York's motto is "Ever upward."

**Part II
Supertalls**

Part II
Introduction

The mixed-use, sky-high supertall is *the* building typology of the twenty-first century.[1] Except for museum-building, which carries an aura of prestige, few hotshot architects are concentrating on anything else, like civic buildings or affordable low-rise housing, with the exception of Steven Holl, the hyperprolific Bjarke Ingels, beleaguered Santiago Calatrava (who spent fourteen years of his life and career mired in the Oculus downtown), and a handful of others.[2]

Rem Koolhaas has seemingly switched camps from iconoclast to ultimate insider—he is either cynical or concupiscent enough to participate in the game by planning a fifth supertall for Billionaire's Row, which tilts back like a party guest listening to an overbearing talker with bad breath, but at least he is self-aware enough to remark, "In the free market, architecture = real estate."[3]

It's not that the intellectual groundwork for attractive public housing hasn't been laid out, it's just that there is no fame or money in it for careerists. Holl wrote in an editorial in *Dezeen* that "in New York, architecture with a sense of social purpose has become increasingly rare."[4] He added about supertalls, "Many of these profane spires have been built with tax abatements from our once public-oriented city government."[5]

Whether these "profane spires" are sustainable remains to be seen, depending on indeterminable factors like the global economy and climate change. *Green* is the buzzword in architecture today, and there are even green supertalls, like Foster + Partners' humongous, massively buttressed, sixty-story supertall (1,388 feet / 423 meters) JP Morgan Chase at 270 Park Avenue, which promises to be 100 percent powered by renewable energy from a New York power plant.

The relatively new construction method of building a concrete core framed by steel-reinforced concrete beams and peripheral columns is to the twenty-first century what steel-cage construction was to the classic skyscrapers of the previous century.[6] Now, we are on the verge of megatalls, which the CTBUH defines as 1,968 feet / 600 meters, twice

Supertalls

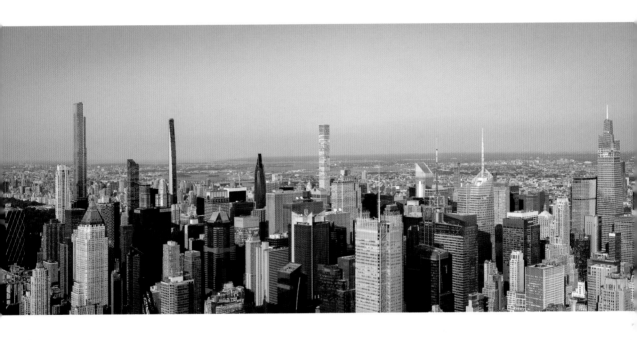

Supertalls are the logical
extension of the vertical
thrust of Manhattanism,
a new typology for a new
century.

Part II Introduction

the height of a supertall, some planned (perhaps wishfully) as far into the future as the 2030s.[7]

Admittedly, a megatall may serve no other purpose than vanity or nationalist pride. The Jeddah Tower remains as isolated as the US flag on the moon.[8] There is at times an unsavory side to their construction, with the use of imported, underpaid, unprotected labor. Saudi Arabia is the cheapest Middle Eastern country to build in, with little or no regard for worker safety, and even designer Adrian Smith confessed that cut-rate labor costs were a factor in meeting the Jeddah Tower's budget.[9]

Supertalls required a new science of structural engineering. In their aeolian realm, high winds are as much of a problem as the stress of gravity. Engineers must keep pace with the design of these slender beauties, finding innovative, lighter, stronger ways to brace them.

Any structure with a width-to-height ratio greater than 1:4 or 1:5 is at risk of swaying in high winds because of vortex shedding, a principle of fluid dynamics wherein air flowing past a bluff, vertical, sheer surface creates low-pressure vortices eddying from the sides. This produces uneven pulsations downwind, causing the building to rock from side to side like a palm tree buffeted in a storm.[10]

Supertalls are supersusceptible to this effect, especially older ones. In Chicago's externally X-braced, trapezoidal John Hancock Center (one hundred floors; 1,499 feet / 457 meters to tip), built in 1969 (now known by its address, 875 North Michigan Avenue), the penthouse chandeliers legendarily swayed up to a yard and the toilet water shimmied from vortices caused by the high winds of the Windy City.[11] Unnerving, to say the least. No wonder the Hancock Center was the perfect spooky locale for the fright-fest *Poltergeist III* (1988).[12]

Today, a technology called tuned mass dampers—computer-controlled concrete or steel blocks weighing tons—are used to counteract wind force. The dampers, located in the upper stories of a skyscraper, slow the velocity

Creative zigzagging exterior steel bracing on Jean Nouvel's 53W53 helps support and stiffen the supertall.

Supertalls

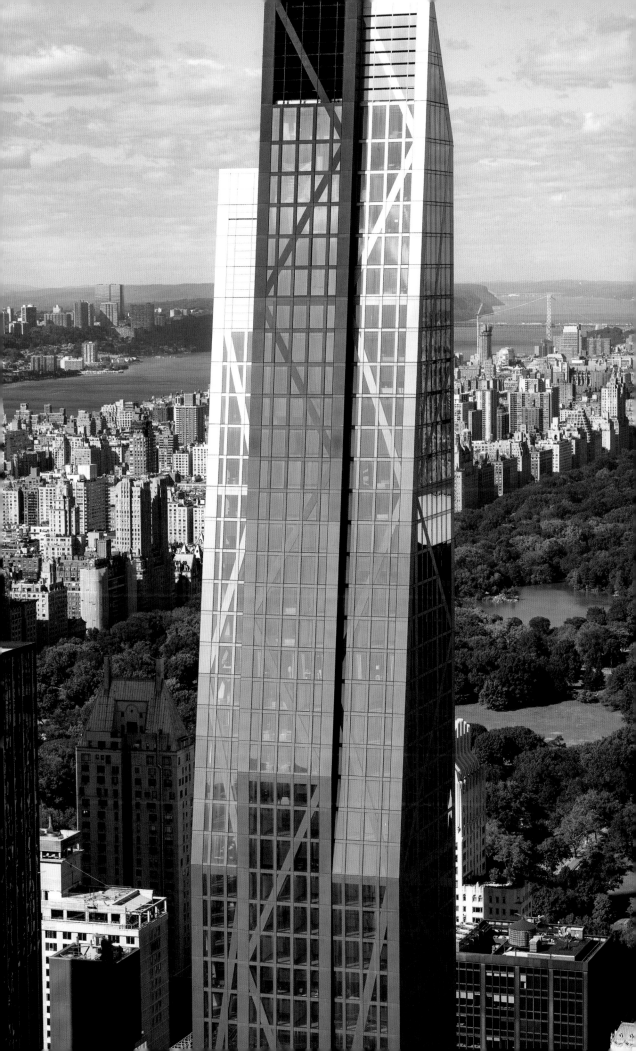

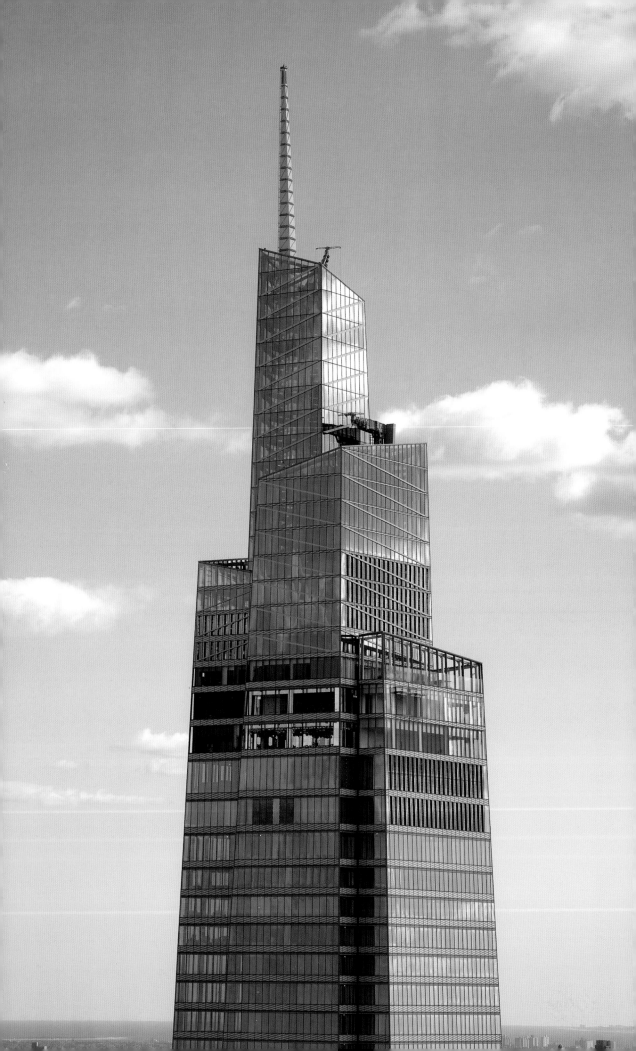

of acceleration by moving a mass that floats on a sheet of ball bearings in the direction of the wind to lessen its impact.[13] Like a rocking ship in rough waters, it is acceleration rather than the absolute degree of speed that is so alarming. Think of dinnerware flying off the table on a cruise ship in a storm—more frightening than dangerous. Tuned mass dampers keep the dinner plates on the table.

Bracing is another engineering challenge. Buildings must be rigid enough not to torque, or twist, in the wind or from their own sheer weight pulling them down. Despite their diverse appearances, the supertalls in this volume share one feature: each building is constructed around a concrete core that contains the elevators and mechanical services like plumbing and HVAC (heating, ventilation, and air-conditioning), with load-bearing columns pushed to the perimeter to provide column-free floor plates. Some, like 3 World Trade Center and 53W53, employ more conventional external steel bracing to stiffen their facades.[14]

In bulkier towers, like One World Trade or One Vanderbilt, the core is commonly placed in the center for optimum HVAC distribution and easy access to elevators. In superslender residential towers, the core can be located on the perimeter because elevator traffic is relatively low and the HVAC does not need to be as widely disbursed. Even in mid-rises, engineers are turning to steel-reinforced, poured-concrete columns and beams. Newer high-strength concrete dries rapidly, so engineers have learned to pour it in stages from external scaffolding.[15]

Sloping setbacks of
One Vanderbilt, by James
von Klemperer of Kohn
Pedersen Fox, recall the
setbacks of Midtown's
great art deco skyscrapers.

Part II Introduction

6
Phoenix from the Ashes

The saga of One World Trade Center, aka the Freedom Tower (2014), has all the ingredients of a Manhattan real-estate melodrama—greed, ambition, ego, and betrayal.

Our dramatis personae: predacious developer Larry Silverstein, who sought to score a double insurance profit by claiming the 9/11 terrorist attack was not one but two events; babe in the woods Polish-German starchitect Daniel Libeskind, who won the 2003 design competition for the site's master plan; David Childs, design principal at SOM, the city's go-to skyscraper man; and innovative Spanish architect Santiago Calatrava, who built the fossil-like, semisubterranean World Trade Center Transportation Hub (aka Oculus).[1]

Libeskind, who had never designed a skyscraper before, won out over a field of fascinating, at times bizarre, entries by major international architects—including Rafael Viñoly and Sir Norman Foster—with a bifurcated tower that recalled the contrapposto stance and upraised arm of the Statue of Liberty as well as the obelisk shape of the Washington Monument.[2] Later, a livid, table-pounding Silverstein, who held the ninety-nine-year lease on the site, demanded that Libeskind work with Childs, his personal choice, in what Libeskind bitterly called a "forced marriage" that compromised the design.[3]

One of the most visited sites in the city, One World Trade is powerful because of its association with heroism and loss.[4] People come to pause, reflect, and remember at the historic site and the adjacent memorial. One World Trade's distinctive, though slightly out of proportion, silhouette has become *the* symbol of the city's resilience, if not the nation's, and is almost as world recognized as the Empire State or the Statue of Liberty.

Eight massive isosceles triangles, four rising and four descending, define the tower's silhouette. Rising from a 200-foot by 200-foot / 19-meter by 19-meter square base, the gigantic triangular glass planes connect with the inverted triangles to from a cincture, or "waist," midway up the tower,

One World Trade Center, universally known as the Freedom Tower, is emblematic of the nation's indomitable spirit.

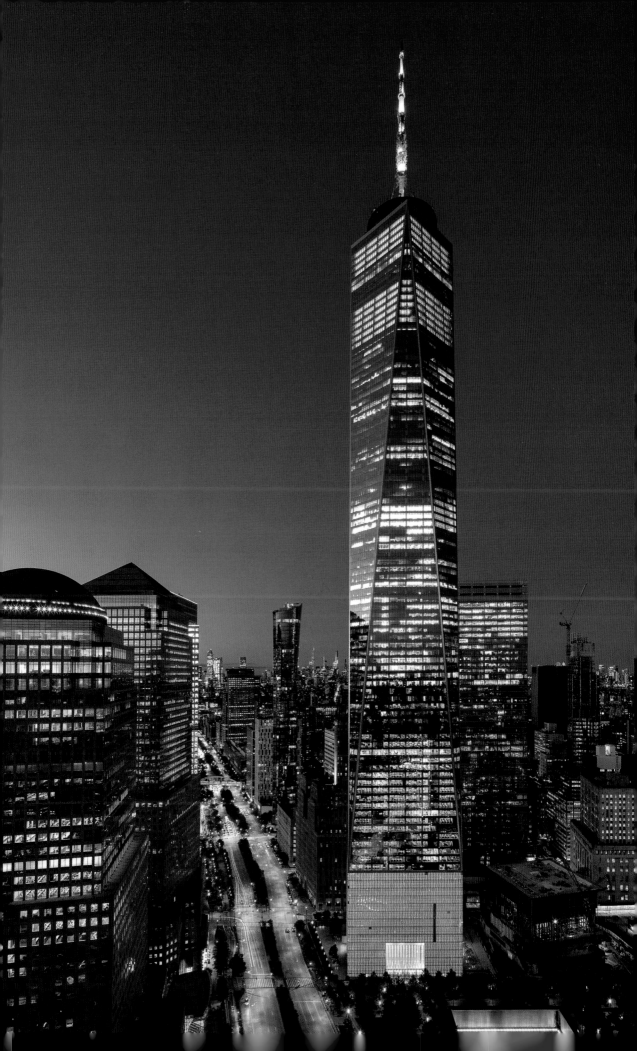

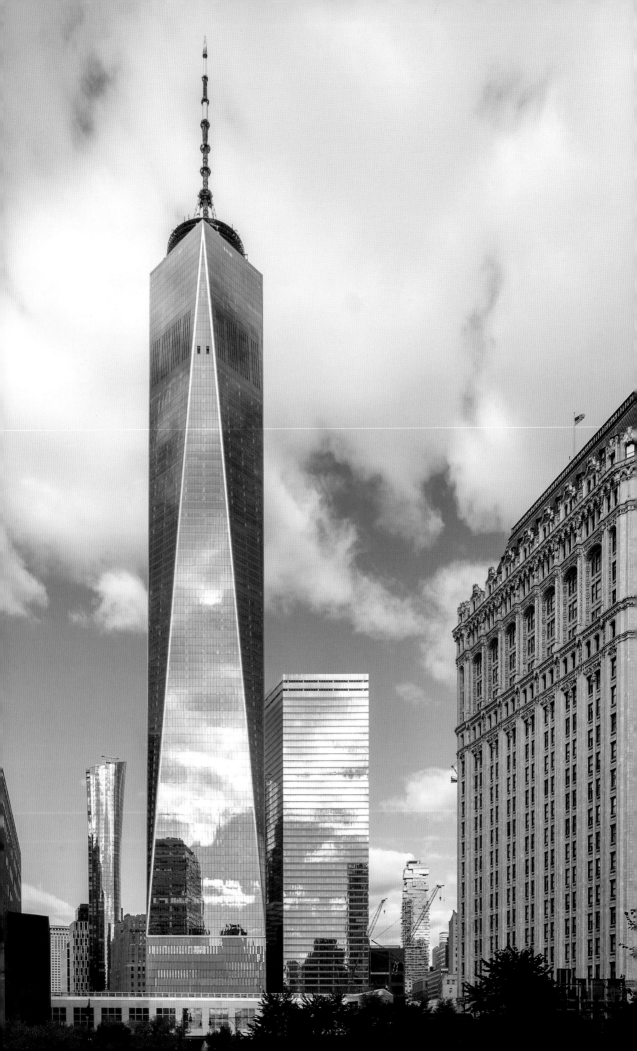

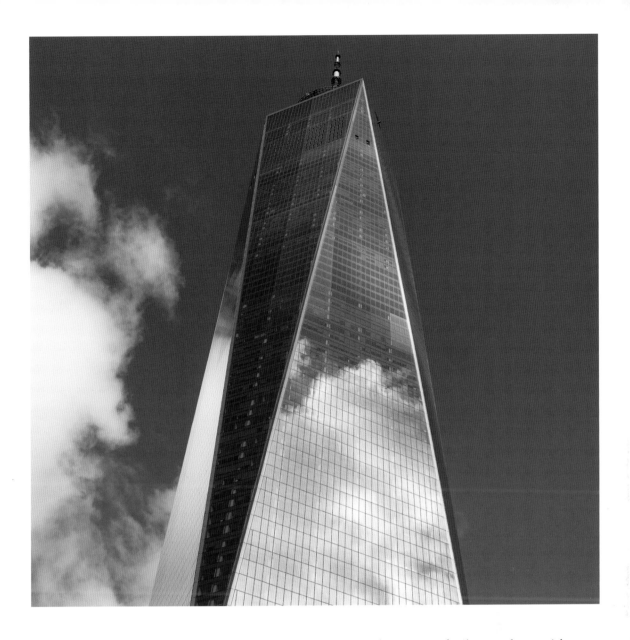

(opposite) Eight colossal, smooth-glass triangles form the Freedom Tower's monumental silhouette.

(above) The Freedom Tower's reflective glass surface interacts marvelously with atmospherics at all times of day.

a contextual allusion to the Statue of Liberty, along with the mast, a stand-in for Lady Liberty's raised arm. These symbolic gestures are almost all that remain of Libeskind's original design.[5] Childs says he was inspired by the simplicity and grandeur of the Washington Monument.[6] The structural engineer was the firm of WSP Cantor Seinuk, which also worked on the Steinway Tower.[7]

Sited on an open plaza, the structure can be taken in from top to bottom, much like the original Twin Towers. One World Trade Center's best effect is the location of its spandrels (horizontal supports)—beneath the glass facade, so that the tower seems to be sheathed in a single crystalline surface, which interacts spectacularly with the sky's atmospherics at different times of day, from dawn into the night, and in different moods of weather.

At ground level, adjacent to the tower, the 9/11 memorial *Reflecting Absence* by Israeli-American architect Michael Arad and landscape architect Peter Walker is especially

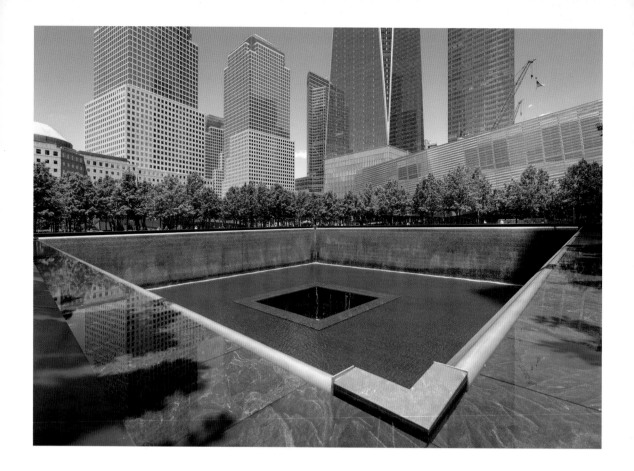

moving, with its iconic black granite voids set into the
footprints of the original towers. The fountains drain
silently into cisterns, as if perpetually weeping. It is here
where people appear at their most solemn, rather than on
the carnivalesque observation deck.[8]

The 1,079-foot / 329-meter supertall 3 World Trade
Center was completed in 2019 by the London-based firm
of Rogers Stirk Harbour + Partners, led by Pritzker Prize
winner Richard Rogers.[9] Massive, zigzagging external
steel K braces (shaped like the letter) are the tower's most
distinctive feature.[10] The sixty-nine-story tower features
a soaring triple-height lobby with a 64-foot / 20-meter-high
ceiling. The lobby of 3 World Trade connects seamlessly
underground with Santiago Calatrava's glorious, vacuous
Oculus, a transit hub-cum-luxe shopping mall.[11]

The problem with Oculus is that although the interior
space is vastly sculptural, it lacks interior focus, or even a
sense of meaning. It is literally and figuratively hollow—
a stunning space that lacks procession. It is what Rem
Koolhaas aptly terms "Junkspace."

"The built…product of modernization is not modern
architecture but Junkspace," he writes in *Junkspace with
Running Room.*[12] Lined with a miscellany of commercially
necessary but aesthetically distracting high-end shops, the
bone-white interior leads nowhere, unlike its grand Beaux-
Arts counterpart, Grand Central Terminal, which directs

(above) Perpetually
weeping cisterns of
the memorial *Reflecting
Absence*, set in the
footprints of the original
Twin Towers, are a moving
tribute to the victims
of the 9/11 tragedy.

(opposite) The new World
Trade Center complex
by a murderers' row
of starchitects is both
architecturally cohesive
and a popular tourist
destination.

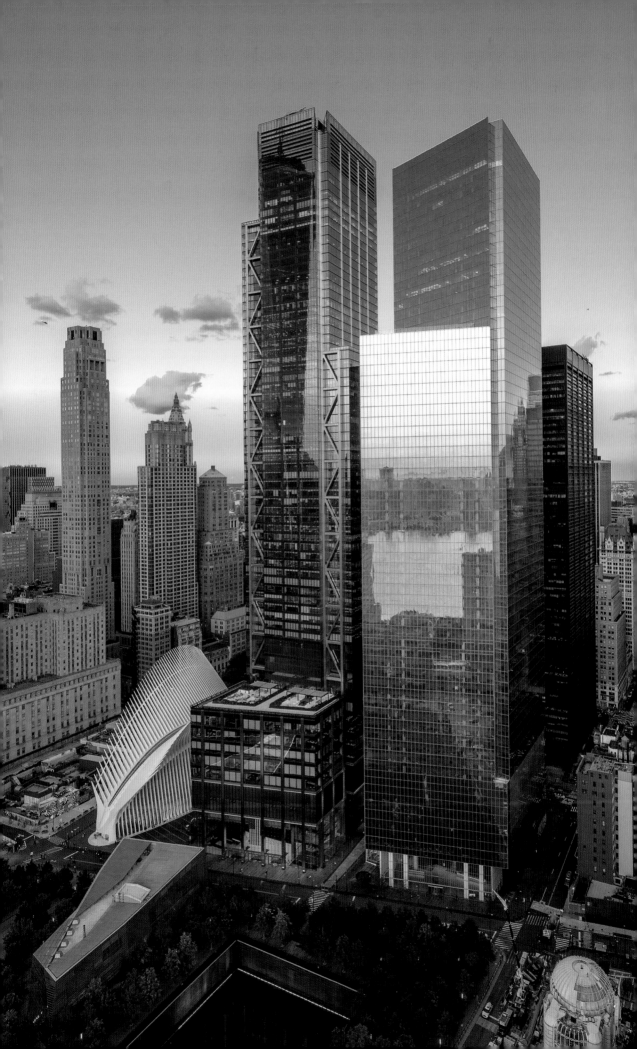

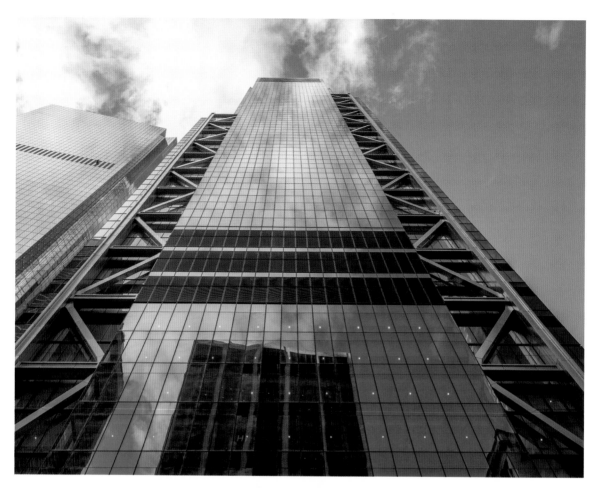

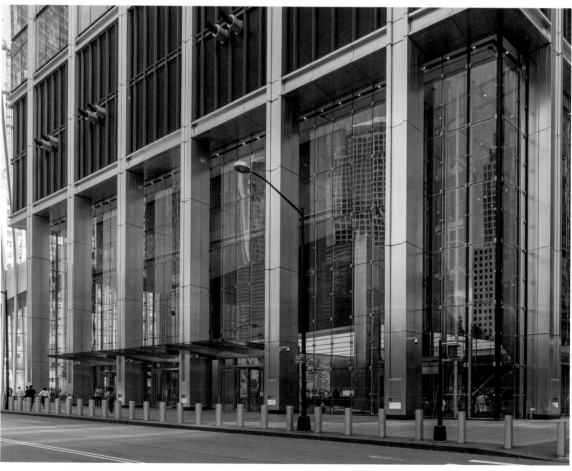

Supertalls

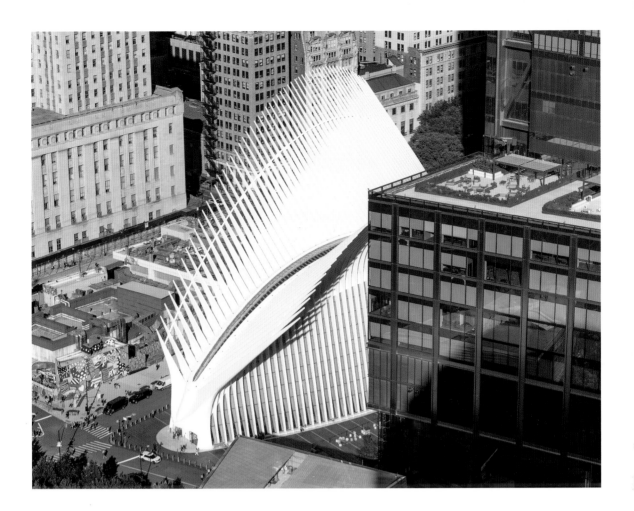

visitors in an unconscious procession and perception of space. Oculus's best feature is its central skylight, which allows daylight to filter in and match the level of light on the street. It is a little magical, bringing light underground.[13]

Oculus took more than a decade to build and landed with a bloated price tag of $4 billion, twice the original estimate.[14] Delays, engineering overruns, and the cost of fabricating customized parts overseas were ruinous.[15] Ultimately, Calatrava, a highly talented, successful, and well-meaning architect, dug the most expensive hole in the city's history.

(opposite top) Massive steel K braces reinforce the sides of Rogers Stirk Harbour + Partners' 3 World Trade Center.

(opposite bottom) Six giant steel columns both support 3 World Trade and create friendly, open space at street level.

(above) Santiago Calatrava's white-painted steel PATH transportation hub, Oculus, edges out like a porcupine amid the World Trade supertalls.

Phoenix from the Ashes

One World Trade Center
(The Freedom Tower)
104 floors
1,776 feet
541 meters

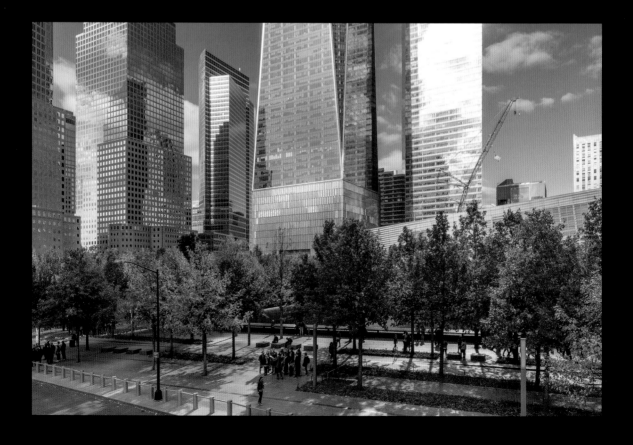

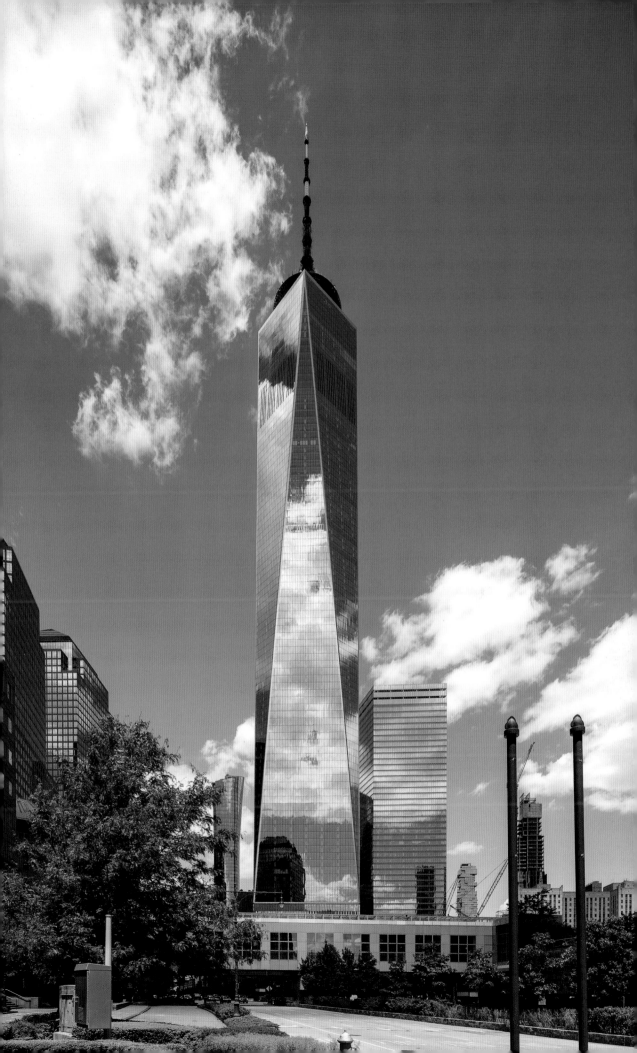

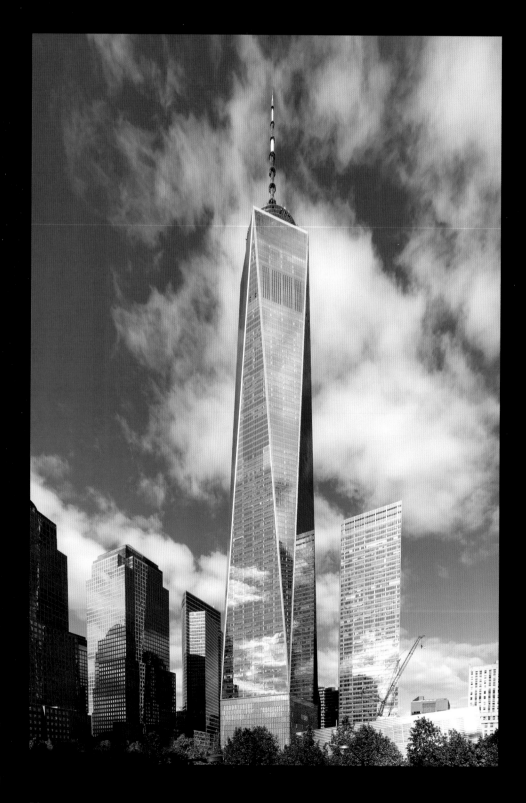

Supertalls

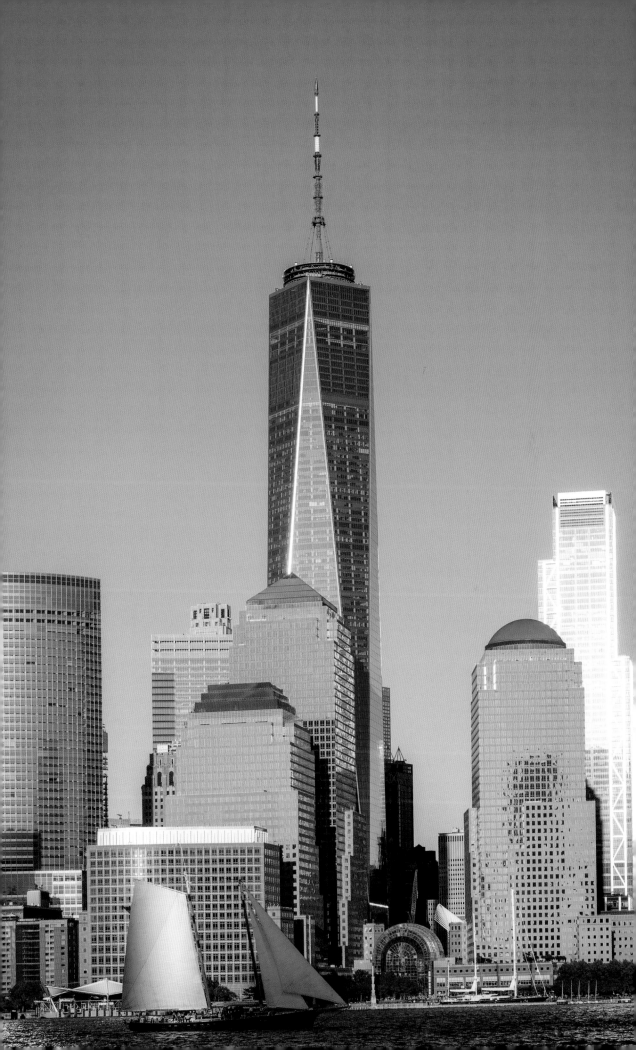

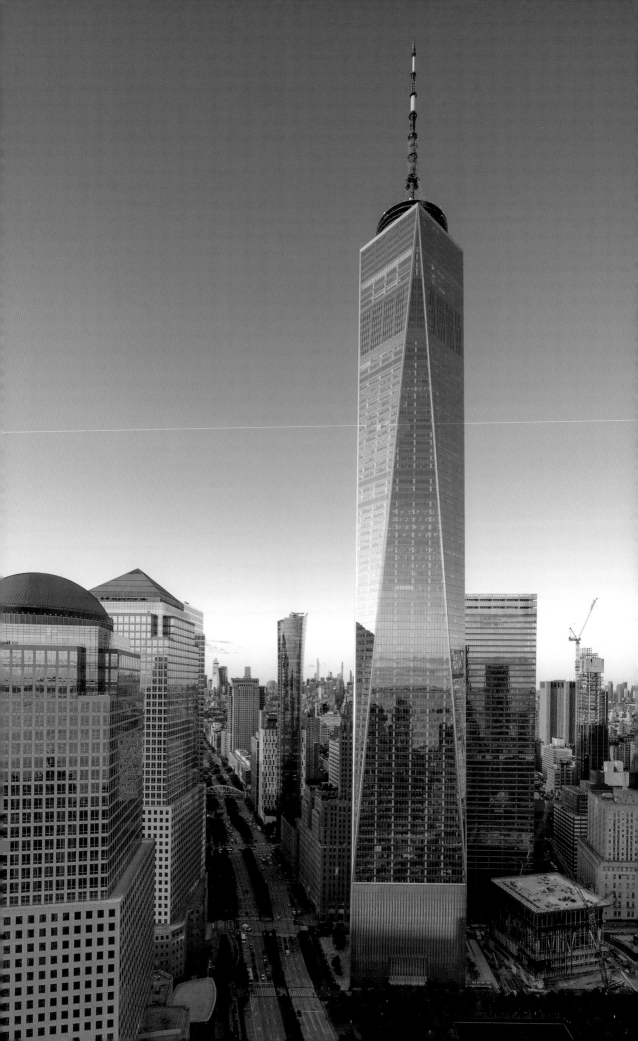

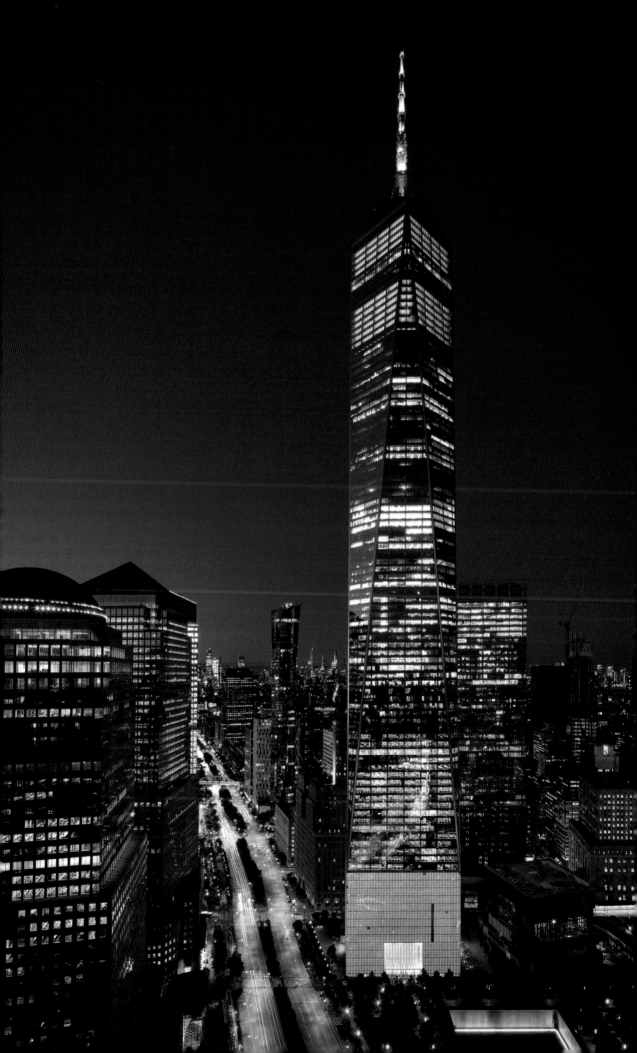

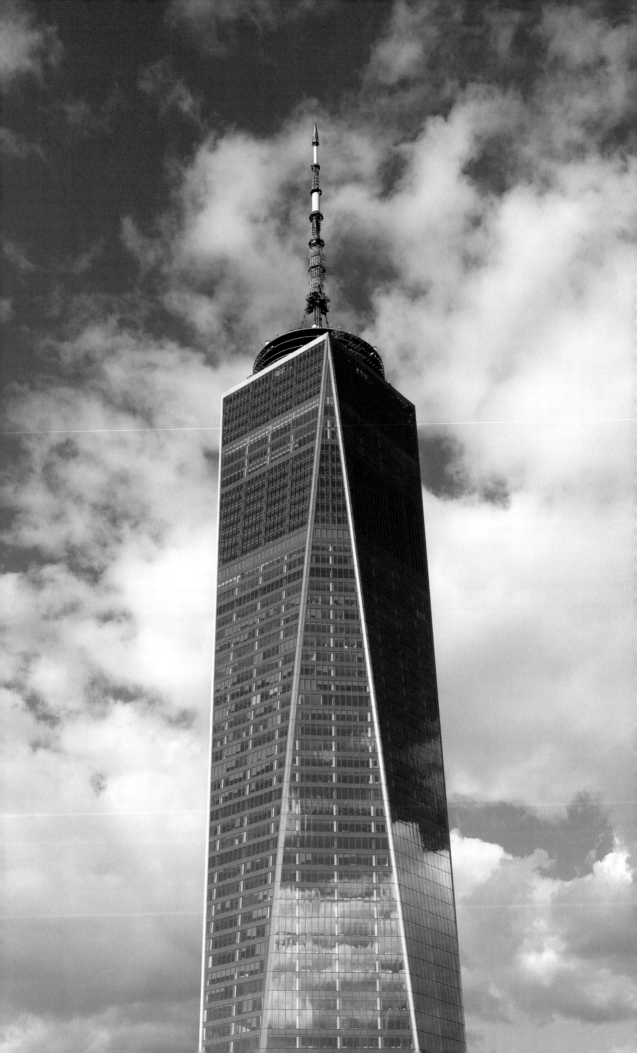

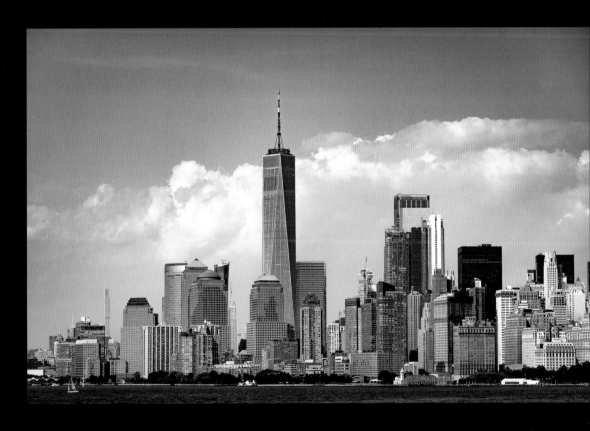

One World Trade Center

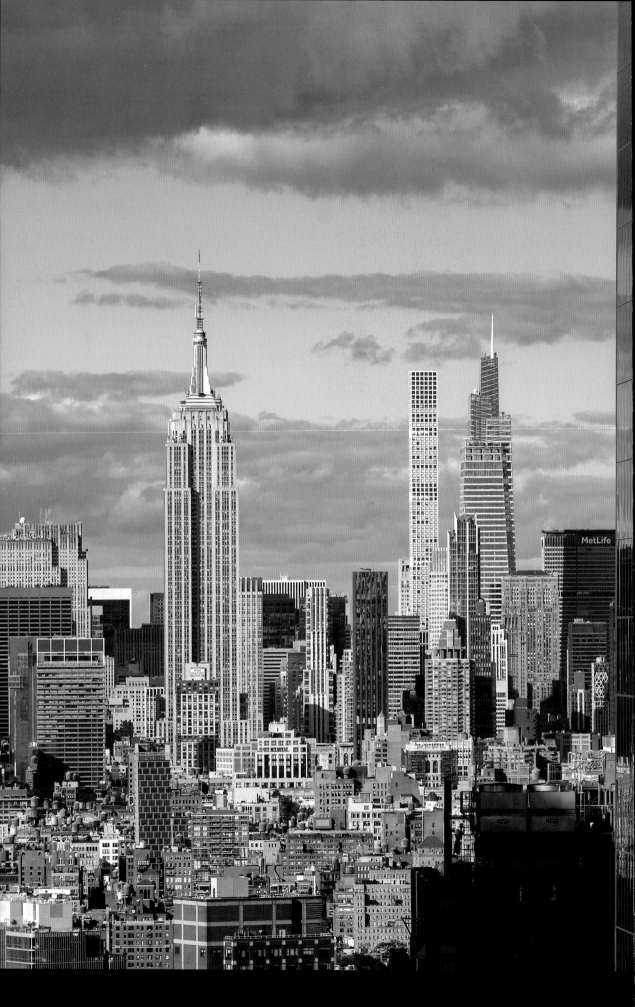

Supertalls

One World Trade Center

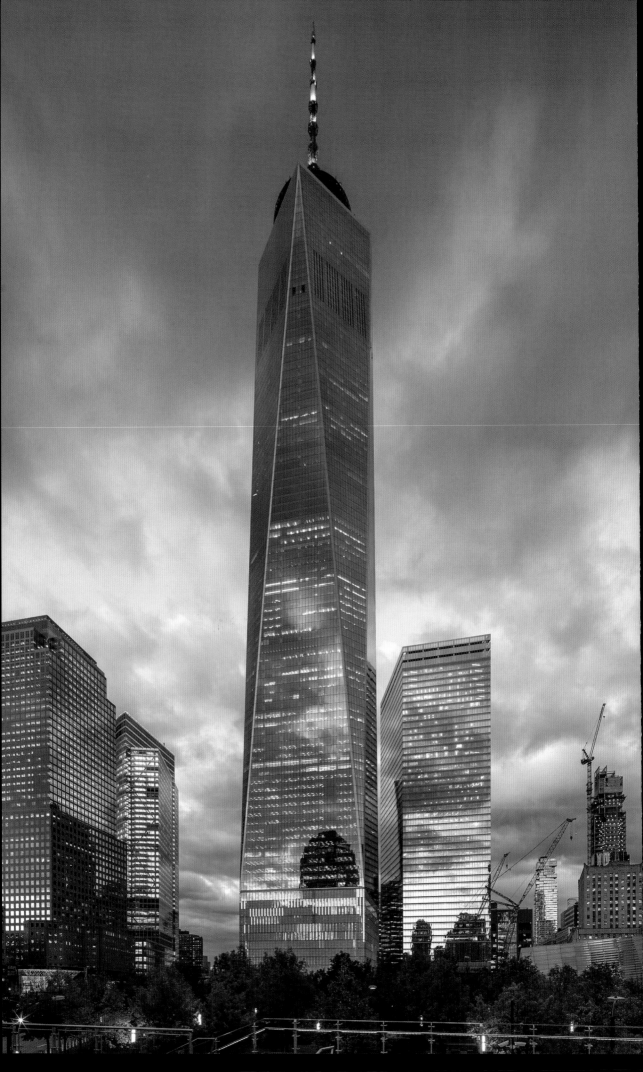

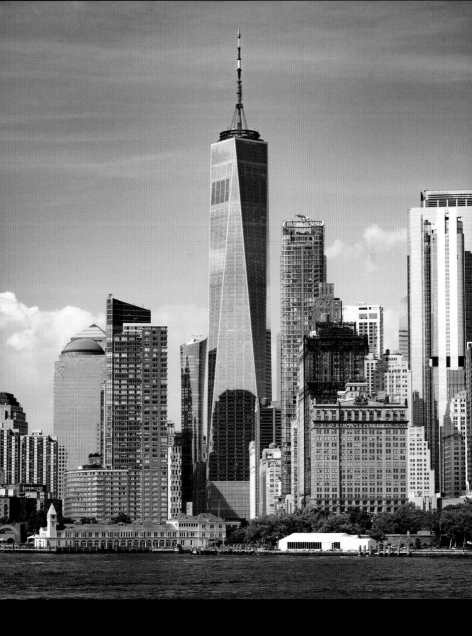

One World Trade Center

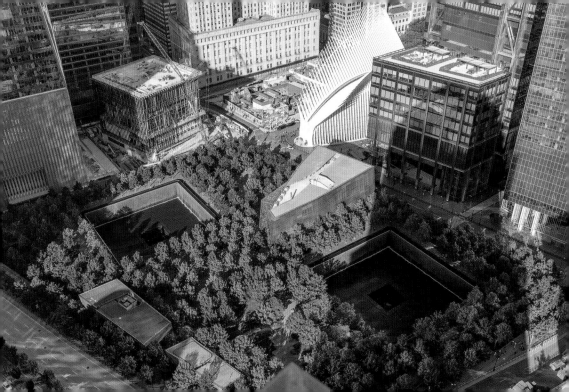

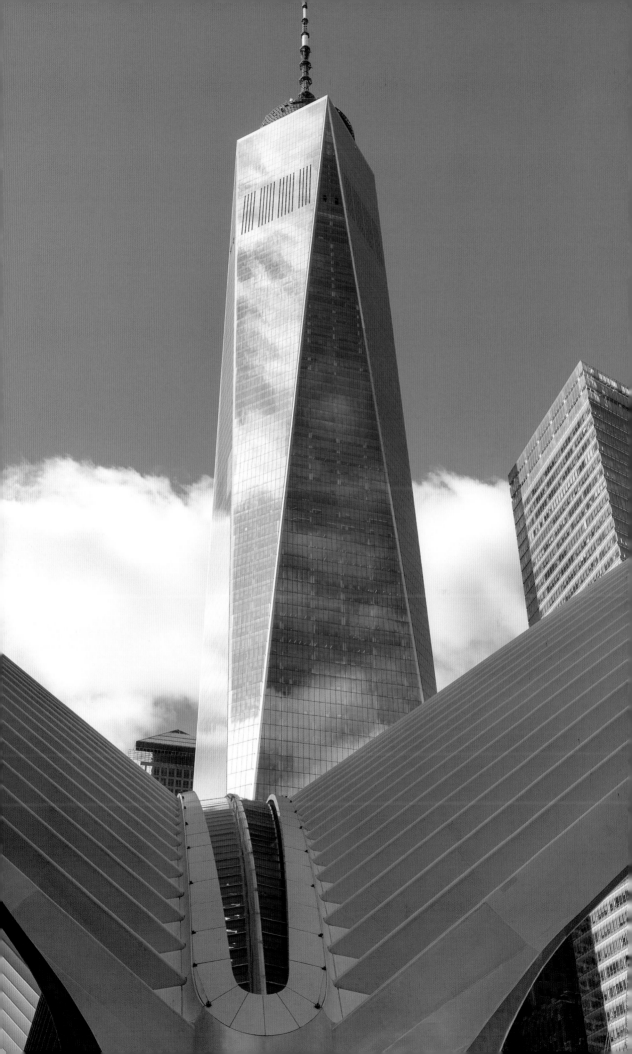

3 World Trade Center
69 floors
1,079 feet
329 meters

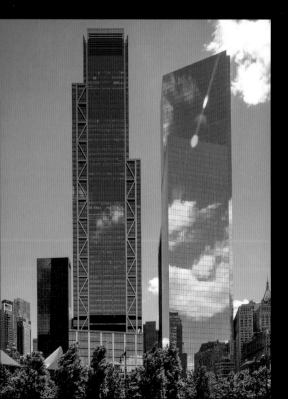
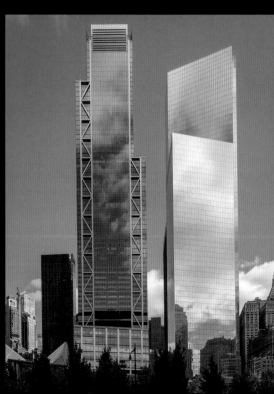

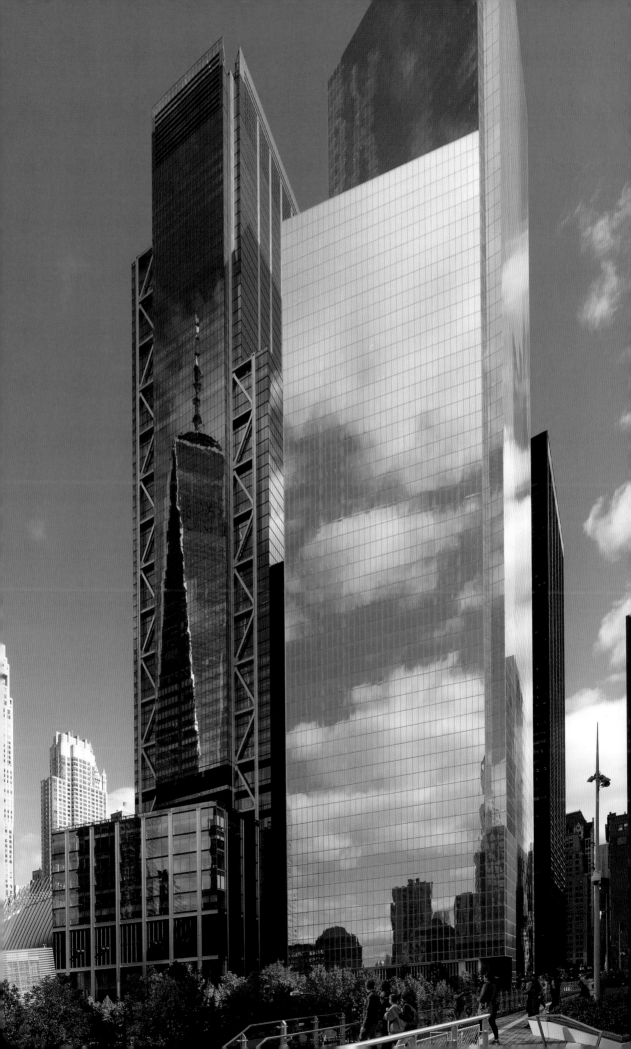

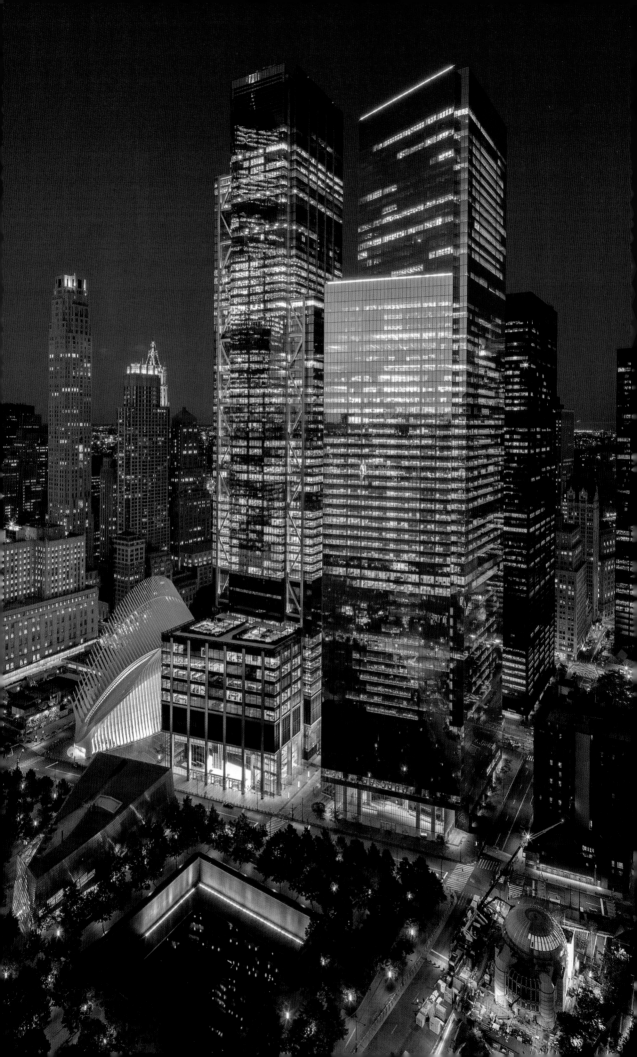

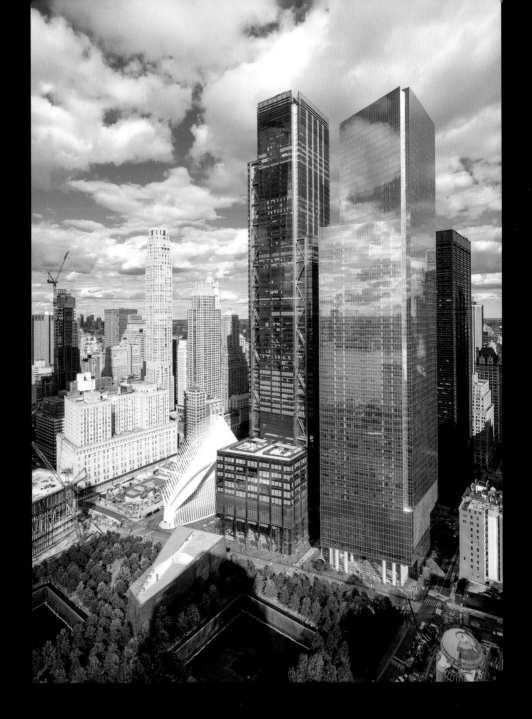

3 World Trade Center

3 World Trade Center

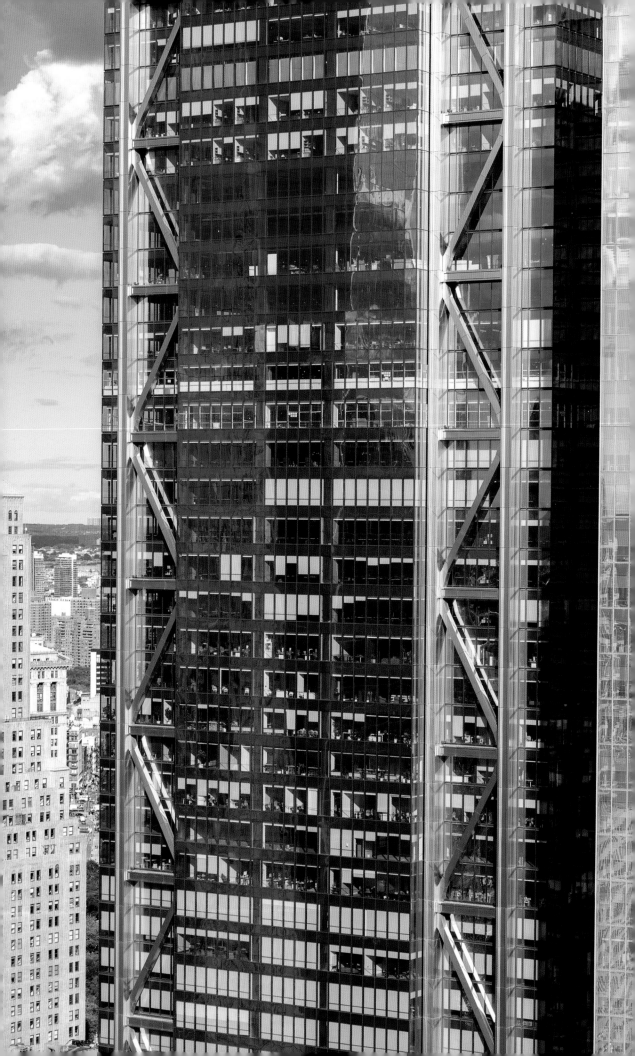

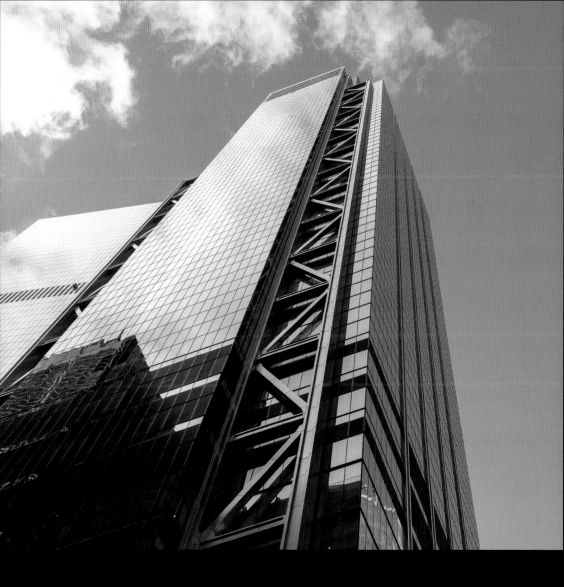

7
The Boulevard
of Billionaires

Initially, residents of Central Park West and Fifth Avenue were appalled by the sheer effrontery of sky-high supertalls popping up on the beloved southern edge of their Central Park, but as art critic Clement Greenberg once observed, "All profoundly original art looks ugly at first."[1]

Of course, supertalls are not new. Built for the 1889 World's Fair in Paris, the centenary of the French Revolution, the all-metal Eiffel Tower was a marvel—the tallest man-made structure on Earth (though technically not a skyscraper, because it is unoccupied).[2] Now the universally admired monument and the very emblem of France, from charm bracelets to perfume bottles, the tower was greeted with disdain by traditional Parisians, who loved their low-roofed city. With Parisian perversity, the author Guy de Maupassant lunched daily beneath the tower, because "inside the restaurant was one of the few places where I could sit and not actually see the Tower!"[3]

Despite the mollifying effect of memory and nostalgia, in the 1970s the public was up in arms over the uncompromising scale of the minimalist Twin Towers, believing they upset the balance of the Manhattan skyline. In its day, the World Trade Center was a transitional place for harried commuters to endure, rather than a destination in itself. Its plaza was windblown and nearly useless as a venue for public events. Its underground passageways held all the charm of the Port Authority Bus Terminal—grim, dirty, poorly lit, anonymous—spaces to scurry through rather than linger. Despite the famed wine cellar at Windows on the World, the restaurant at the top of 1 World Trade was strictly tourist fare, or for expensive dates, not for movers and shakers, whose watering hole was still the old Four Seasons in the Seagram Building.[4] But the public grew fond of the Towers as a civic symbol, especially after 9/11.[5]

Even the critical and public *furore* over superskinny towers is not new. Forty years ago, architectural critic Paul Goldberger wrote in the *New York Times*:

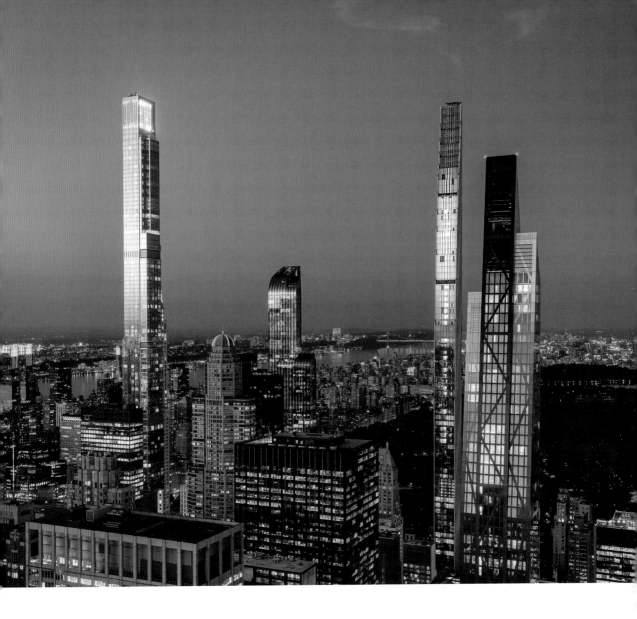

It is a new building type—a thin, narrow apartment tower, sometimes no bigger than a town house....They have become known as 'sliver,' or 'needle,' buildings....They usually contain no more than a single, tightly laid-out apartment per floor, and in some slivers the floors are so tiny that each apartment fills two levels. They are significant, however, not because of the living space they create on the inside, but because of the urban disruption they create on the outside.[6]

So-called slivers (the name never caught on, despite a cheesy Sharon Stone suspenser about them entitled *Sliver* in 1993) were slender, with street frontage of about 40 feet / 12 meters but only thirty or forty floors high, many containing a single unit per floor. Pedestrians now pass below them without even a second thought. In retrospect, the uproar seems like a precursor to today's anxiety about supertalls. Slivers were just another chapter in the history of hysteria over height.

Today's supertalls are distinguished by their combination of height and slenderness, made possible by radical advances

A new crop of supertalls now lines West 57th Street, nicknamed Billionaire's Row. At far left is Central Park Tower, the tallest (primarily) residential building in the world.

The Boulevard of Billionaires

in engineering, a new demand for aerial perches, and a surprisingly tenacious market for luxury residences, largely for investment purposes. The superrich just want a room with a really, really fantastic view. Traditionally, the wealthy preferred lots of room, like the famed Prewar Six apartment, overlooking a small patch of greenery, preferably on Park Avenue, rather than shoeboxes with helicopter views. But at the turn of the twenty-first century, developers discovered that part-time potentates and jetsetters were willing to plunk down seven figures for a 700-square-foot / 65-square-meter pied-à-terre in the clouds, in what amounts to a safe-deposit box in the sky, mostly with foreign equity in untraceable, nested shell companies. The supertall was born.

Christian de Portzamparc's seventy-five-story One57 of 2014, which stands 1,004 feet high / 306 meters, was the first supertall to rise on Billionaire's Row, looming over Central Park's iconic southern skyline.[7] Not coincidentally, the first supertall was greeted with brickbats by critics and the public alike—an outrageously tall, skinny, blue interloper on their sacrosanct skyline!

Some architects just do not have a feel for tall buildings; Pritzker Prize winner Portzamparc is one of them. His first building in New York, the diminutive, gemlike LVMH headquarters, down the street at 19 East 57th Street, was critically admired in 1999 for its origami-like, folded, variegated glass.[8] But One57 was lambasted: clumsy, clunky, gaudy, graceless, a "Vegas-style disaster of a design" were some of the kinder responses.[9] His tower culminates in a curved crown that leans yearningly toward the park, perhaps a nod to the Flash Gordon finials of Irwin S. Chanin's Century and Majestic Apartments on Central Park West, but it's a failed gesture, and looks more like a giant ventilator hood.

One57's curvy setbacks spill to the sidewalk in what the architect called "*les cascades*," by which he meant to suggest a waterfall topped by billowing clouds.[10] It doesn't help that Portzamparc sheathed One57 in vertically striated,

Supertall sentinels have forever altered the scale of Central Park South but make useful landmarks if you find yourself disoriented in the park, as landscape architect Frederick Law Olmsted intended.

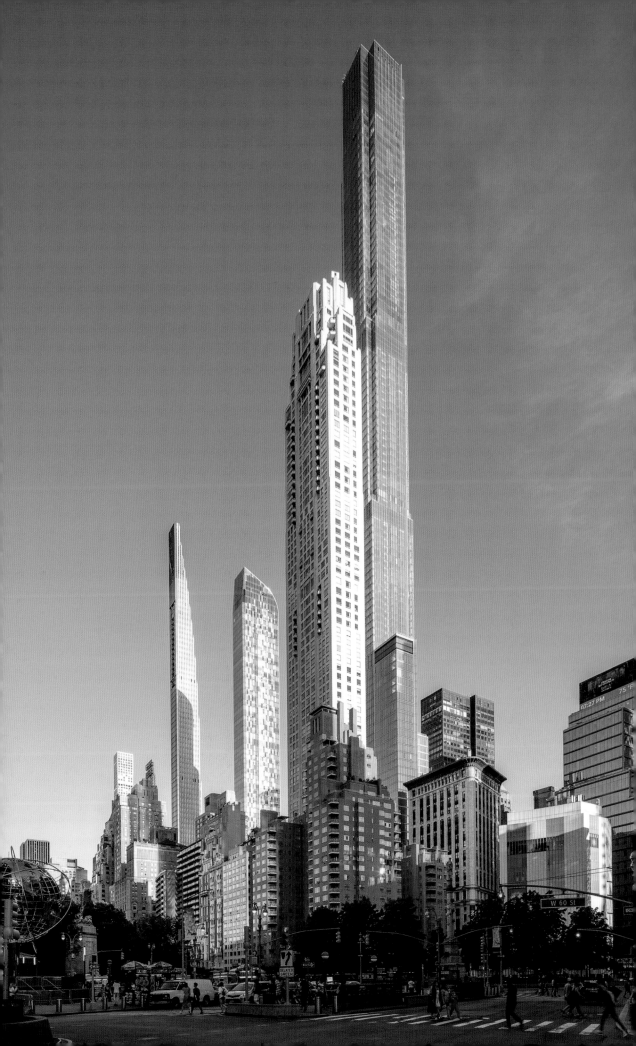

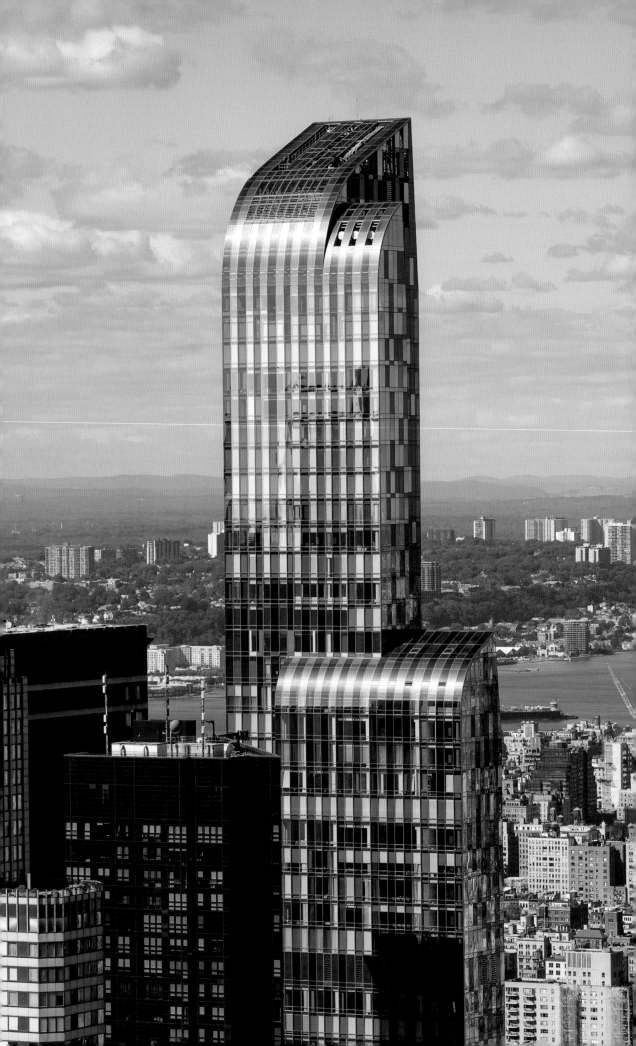

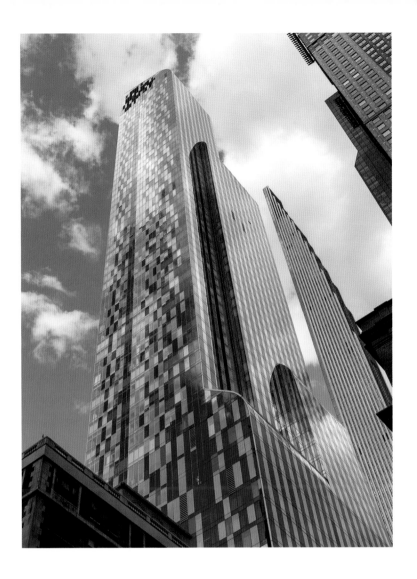

(opposite) Christian de Portzamparc's hooded One57 was the first supertall to sprout up on Billionaire's Row in 2014 and was a lightning rod for public and critical ire.

(above) Citizens banded together against the supertall upstarts, which they feared would cast deep shadows on their beloved park (a fear that did not in fact materialize).

blotchy panes of blue, gray, and pewter-colored glass for what he termed a "Klimt effect," after the tessellated paintings of the Secessionist painter.[11] Not only is the concept derivative, but also it has been done better elsewhere in the city, notably in Bernard Tschumi's pixelated glass cladding for his Blue Condominium of 2007 on the Lower East Side and Jean Nouvel's patchwork, glass-and-steel apartment building at 100 Eleventh Avenue.[12]

Poor Portzamparc cares very much about the materiality of his buildings, but Michael Kimmelman of the *New York Times* brought out his knife set: "The conceit is falling water. The effect: a heap of volumes, not liquid but stolid, chintzily embellished, clad in acres of eye-shadow-blue glass offset by a pox of tinted panes, like age spots."[13]

Architect Rafael Viñoly offered a rare public rebuke of a fellow architect's creation: "What is the name of that building by that French guy? It would have been better without all that glass. I think it is an absolutely horrendous building," he told the *New York Post* about One57.[14]

One reason the building took such heat was that even though developer Gary Barnett quietly plotted for a decade

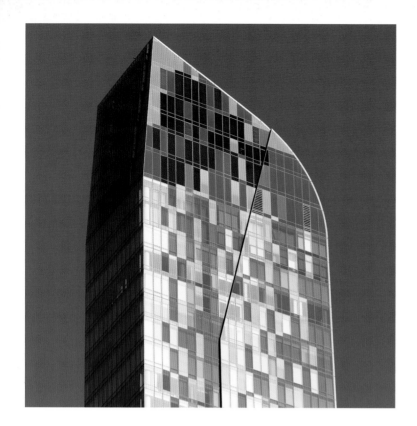

to cobble together a domino-like pattern of air rights for the site, One57 seemed to pop up overnight like a fiddlehead fern, without anybody's say-so.[15] The principle behind air rights (called "as-of-right" development, or AOR) is that the air rights of lower properties that do not fully utilize their height allowance can be sold on the free market to another developer to add height to a new building. It is a three-dimensional chess game, played mostly with empty space. The supertalls in this volume were built fair and square with AOR and through municipally decreed changes in zoning codes.

But the city's byzantine, 1,300-page zoning resolution on air rights has more loopholes than Swiss cheese. For example, 432 Park was allowed to build taller than its total gross floor area (or GFA) would normally allow, because its mechanical floors were not counted as part of the overall height. Excluding mechanical floors from the overall floor count is a bone of contention between preservationist groups like the Municipal Art Society (MAS) and structural engineers trying to work within the demands of superslender towers. The MAS sees it as a loophole to sneak in extra height; engineers argue that small floor plates require more stacking of mechanical equipment, resulting in additional floors.

Viñoly's exquisitely proportioned 432 Park Avenue of 2015 (eighty-seven floors; 1,397 feet / 426 meters), with a slenderness ratio of 1:15, is an essay in Euclidean geometry, despite mounting bad press for eerily creaking concrete walls, groaning steel partitions, massive flooding, stalled elevators,

(above) Architect Portzamparc aimed for a "Klimt effect" with One57's tessellated blue glass skin, but it became the supertall's most critically reviled feature.

(opposite) The minimalist, gridded cement armature, executed in white Portland cement, of Rafael Viñoly's 432 Park both supports the supertall and defines its silhouette.

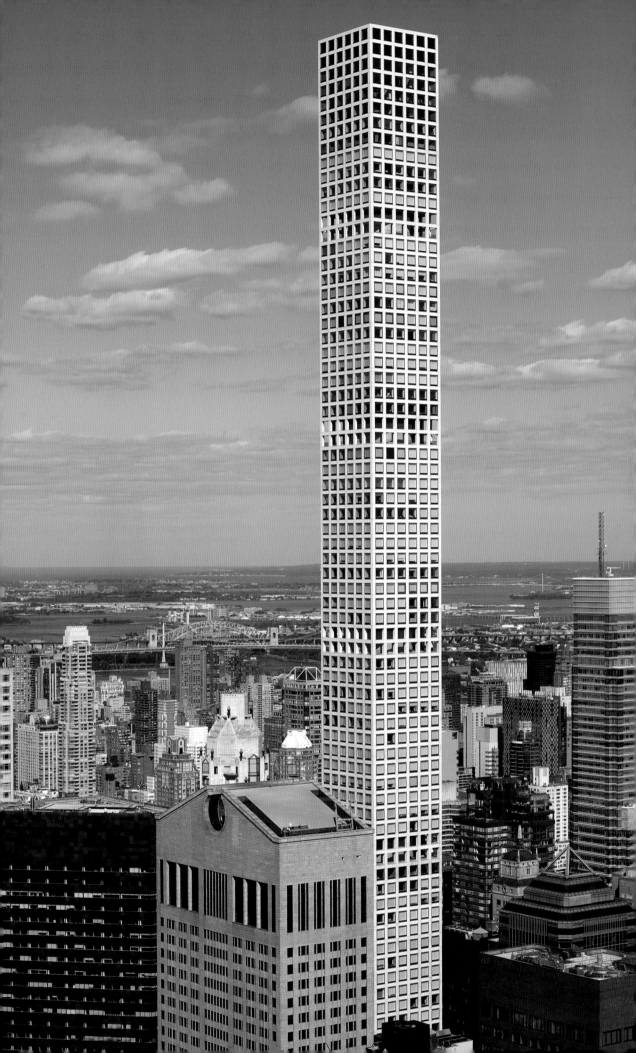

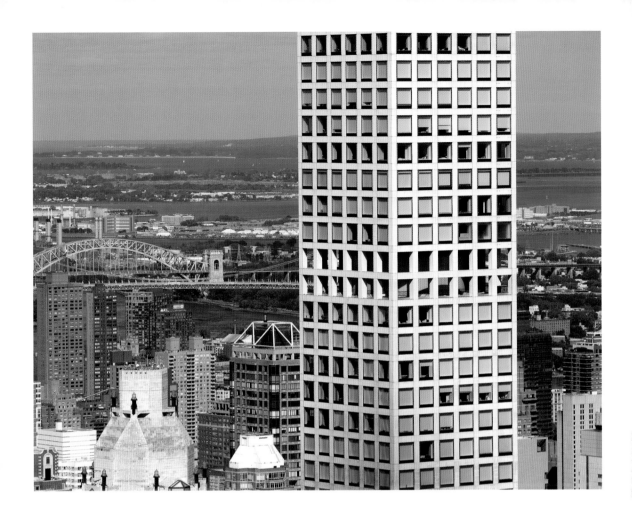

(opposite) The modest footprint of 432 Park meets the sidewalk unobtrusively in a landscaped plaza, a prime example of how a supertall can integrate itself into the city fabric.

(above) 432 Park's openwork, double-height mechanical floors, set every twelve stories, counteract wind shear and punctuate the supertall's height so that it does not feel overwhelming.

garbage chutes that resound like howitzers, skyrocketing fees, and feuding residents, straight out of the anomie of J. G. Ballard's prescient 1975 novel of class struggle, *High-Rise*.[16] But if one wants to live in a work of art, maybe one has to expect such sacrifices? Frank Lloyd Wright's clients tolerated leaky roofs and unforgiving built-in furniture.[17]

Viñoly's tower supremely reveals its structure—the exterior concrete window grid serves as an armature or exoskeleton to help support the weight of the building. Its footprint is a perfect 93-foot by 93-foot / 9-meter by 9-meter square.[18] Like a doll's shoe, the footprint is set in a small, landscaped plaza. Its matter-of-fact columns meet the ground head-on, allowing the tower to stand almost unnoticed streetside.

Each facade is a grid of square windows, 10 feet / 3 meters per side, echoic of the square base. Unlike the glitzy wrappers of the other billionairesses, Viñoly's structure is clad in plain white Portland cement, an unusual choice for a luxury building.[19]

The architect and structural engineers came up with a clever way to cope with wind shear. Their solution was to place open, double-height mechanical floors every twelve floors to allow the wind to blow *through* the building, rather than buffet it. The open floors essentially carve the elevation

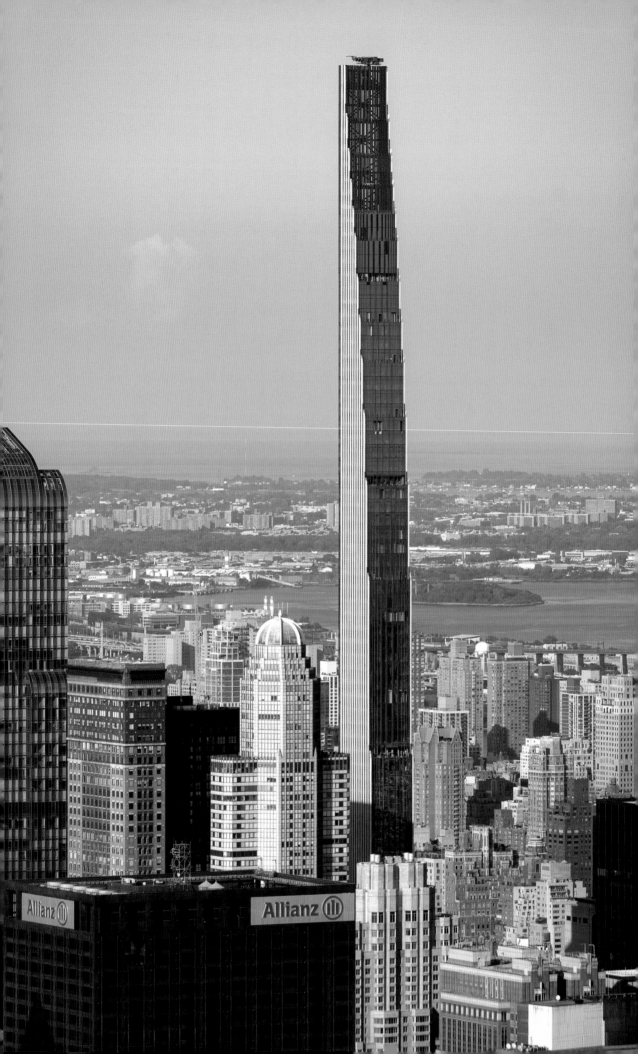

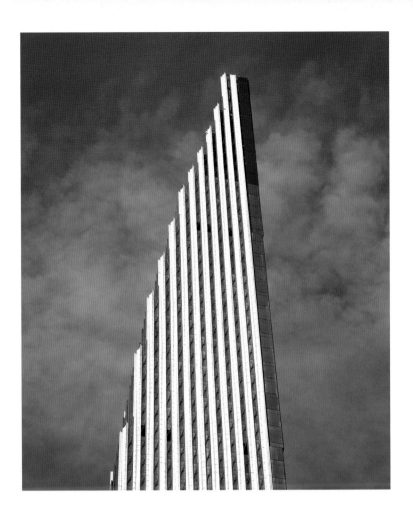

into six large chunks, so that its height does not overwhelm. A drum-shaped, concrete-covered spine runs through the center of the tower, visible at the open floors, containing elevators and mechanical equipment like plumbing, electrical lines, fire stairs, and regular staircases, according to the structural engineering firm wSP.[20] Notably, a circular shape diffuses wind vortices better than a blunt wall.

SHoP Architects' wafery 111 West 57th Street is touted as the world's skinniest skyscraper. Completed in 2020, the ninety-one-story, 1,428-foot / 435-meter supertall is better known as Steinway Tower because it urbanely incorporates Warren & Wetmore's Beaux-Arts sixteen-story Steinway Hall of 1925, with its limestone frieze of swags and bas-reliefs of classical composers.[21] To make this possible, engineers tunneled a foundation *underneath* the existing building, daringly cantilevering the new tower from a subterranean platform.

Feathery setbacks evanesce into the sky, terminating in a 170-foot / 52-meter open steel latticework superstructure that completes the gesture.[22] The former Steinway Hall at the base features luxe residences, while the tower offers contemporary floor-through residences and duplexes.

Supporting concrete walls to the east and west, necessary to fortify such radical height and slenderness, are clad in one

(opposite) SHoP Architects' Steinway Tower, the slenderest skyscraper in the world, slices like a straight razor across the Midtown skyline.

(above) The east–west supporting walls of the Steinway Tower are solid concrete, clad in elaborate terra-cotta patterns chased with bronze, a tribute to the city's great art deco tradition.

The Boulevard of Billionaires

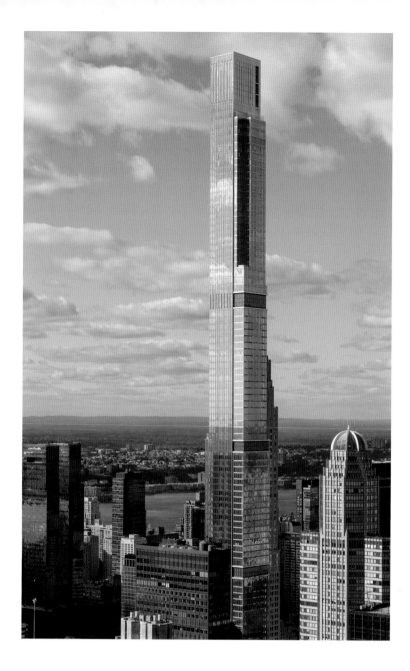

of New York's earliest tall building materials—terra-cotta, popular for ornamentation at the end of the nineteenth century. The Steinway employs twenty-six patterns of cream-colored terra-cotta, as well as art deco–inspired bronze detailing.[23] But all that lavish, expensive detailing is lost on the man in the street, because the tower hides so reticently behind Steinway Hall.

Central Park Tower at 217 West 57th Street (1,550 feet / 472 meters), designed by Adrian Smith + Gordon Gill Architecture, is currently the world's tallest residential building—and the tallest in the Western Hemisphere by roof height.[24] It holds all the charm of a pair of bundled cartons. The developers were disingenuous about the strict definition of all-residential: it is actually mixed-use, because the waviform glass podium five stories above ground, and extending floors below grade, is the Nordstrom flagship

(above) Central Park Tower does not qualify as a purely residential tower, because the Nordstrom flagship makes up its base, so its claim to fame as the tallest residential building in the world is somewhat misleading.

(opposite) Spectacular atmospherics at spectacular prices: Central Park Tower's triple-story penthouse debuted with an asking price of $250 million.

Supertalls

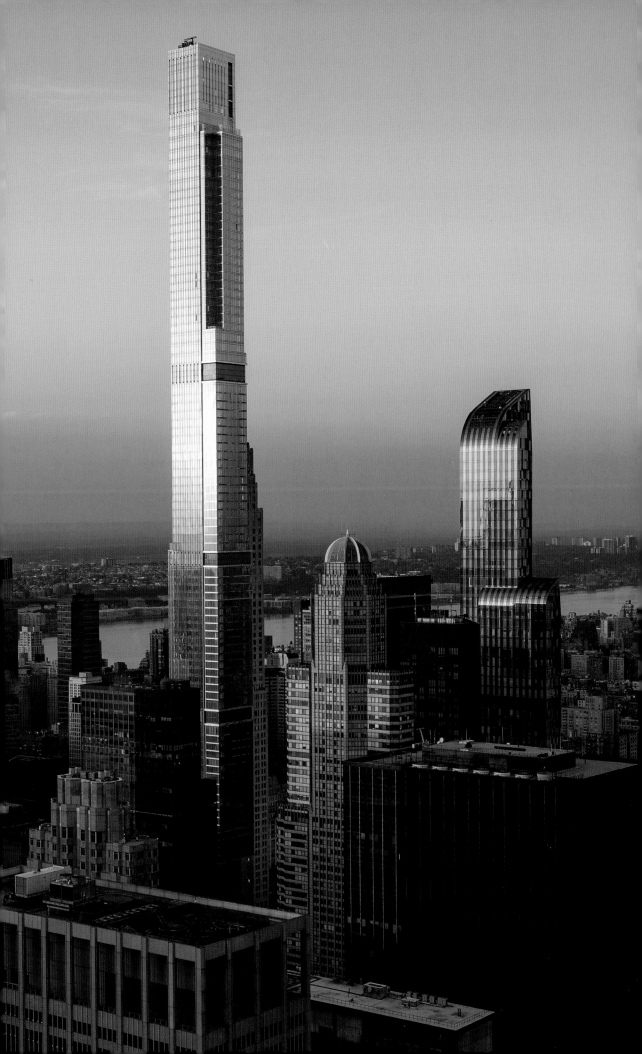

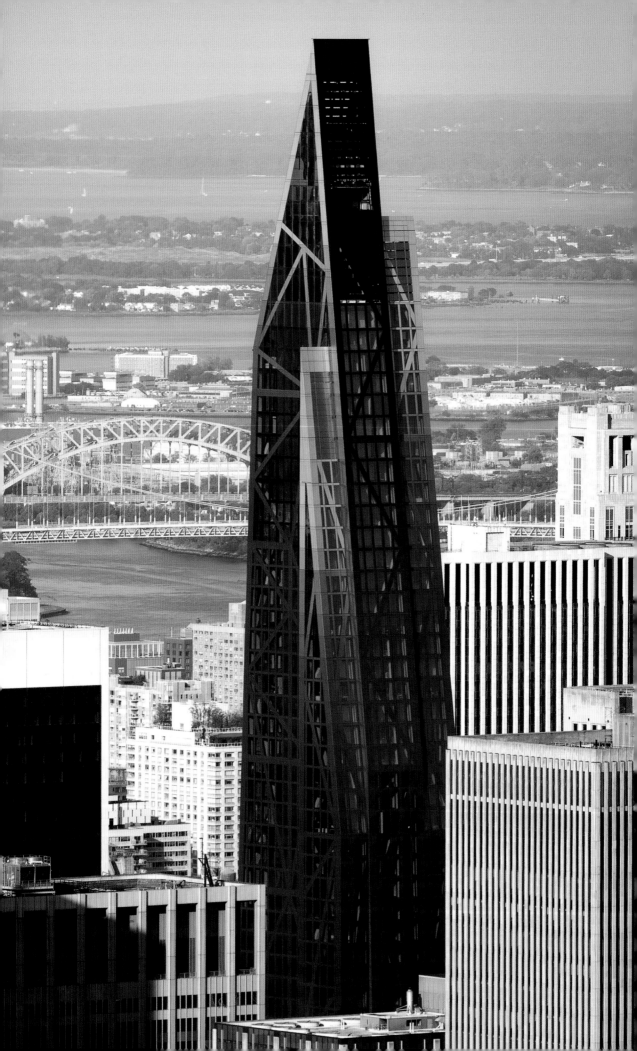

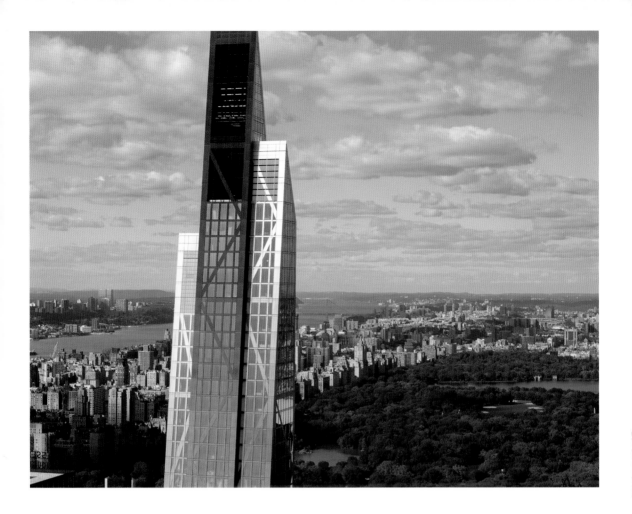

(unless you consider that to be just extra closet space for residents, or perhaps Junkspace).[25]

A full fifth of the building's height is unoccupied vanity height: of 131 floors, ninety-eight are residential.[26] The reflective glass–skinned tower boasts a cigar bar on the one hundredth floor for masters of the universe to blow their own clouds above the clouds.[27]

To add more rooms with a view, a lopsided five-bay cantilever juts out 30 feet / 9 meters from the eastern facade, like a motorcycle sidecar in a Marx Brothers' movie. The goal was to leverage views of Central Park while preserving airspace above Henry Janeway Hardenbergh's palatial, five-floor townhouse, the Art Students League of New York, originally the American Fine Arts Society Building (1892), but the add-on resembles unrestrained parasite construction.

Supertalls can be more than a rich man's plaything—the developer Extell bought the air rights from the Art Students League for $31.8 million dollars; this went a long way to keep the venerable art institution afloat, which charges next to nothing for its courses.[28] This being New York, people still complained.[29]

Jean Nouvel's slender, tapered, black steel-and-glass stalagmite of a tower at 53 West 53rd Street, also known as 53W53, a stone's throw from Billionaire's Row, which in real

(opposite) Jean Nouvel's black glass-and-steel 53W53 creates a shard-like profile. The borders of Billionaire's Row are expanding, much like the metastasis of the Flatiron District.

(above) For those with an anti-supertall mindset, 53W53 succeeds at all levels, as a gorgeous addition to the skyline and a companionable neighbor on the street.

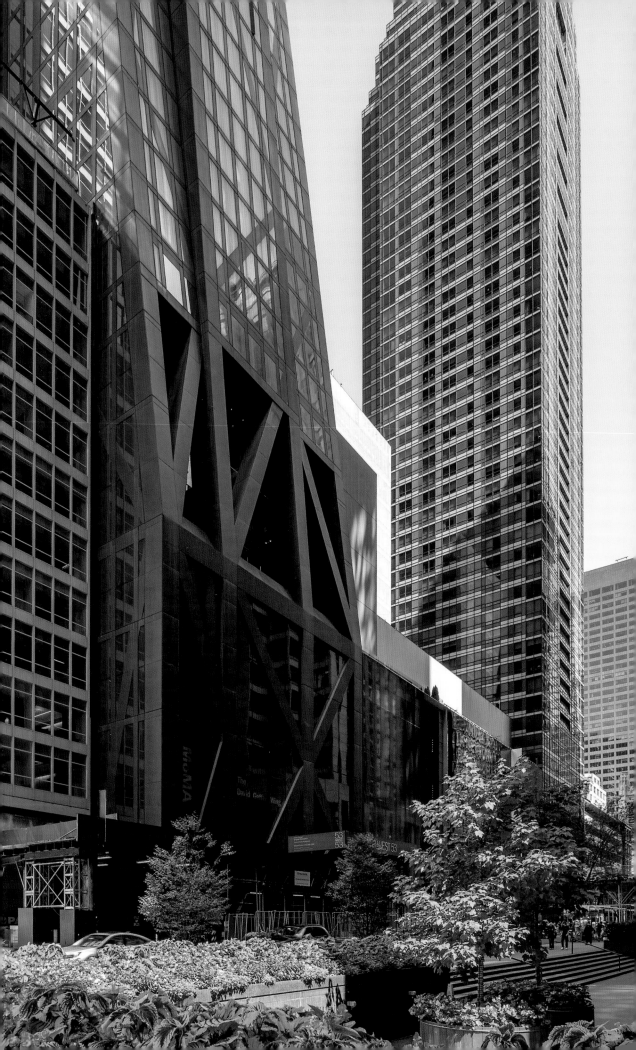

estate terms is metastasizing into a district, like the Flatiron District, seventy-seven floors (eighty-two for marketing purposes—don't ask) and 1,050 feet / 320 meters, completed in 2021, is so seamlessly integrated into the cityscape that it not only adjoins the Museum of Modern Art but affords it three extra floors of permanent gallery space.[30] The zigzag-braced, double-peaked tower is sophisticated, unobtrusive to the street line, respectfully contextual, and tectonically innovative—a welcome addition to the skyline and a cogent counterpoint to the view that supertalls have no place in New York City.

Nouvel's novel solution to the setback requirements involved tapering the setbacks from a podium that blends in with the *rue corridor* (a traditional urban block in which building edges define the street) rather than employing the traditional steplike setback. Giant exterior braces in crazy-quilt patterns affirm the septuagenarian, Pritzker Prize–winning French architect's sense of playfulness. The concatenation of exposed beams in the lobby is a joy.[31]

53W53 is so well integrated into the *rue corridor* that its base contains three floors of gallery space for the neighboring MoMA.

One57
(157 West 57th Street)
75 floors
1,004 feet
306 meters

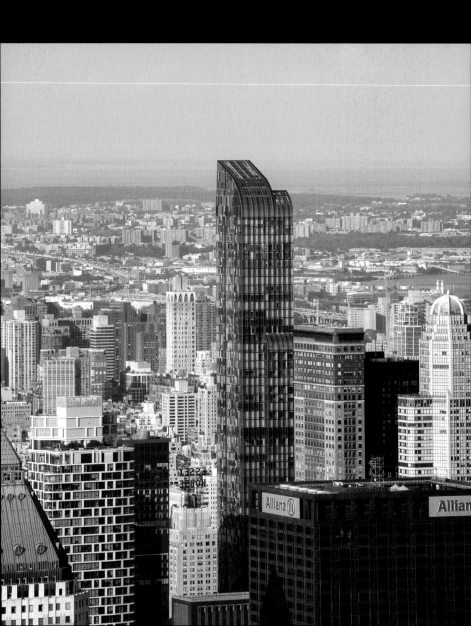

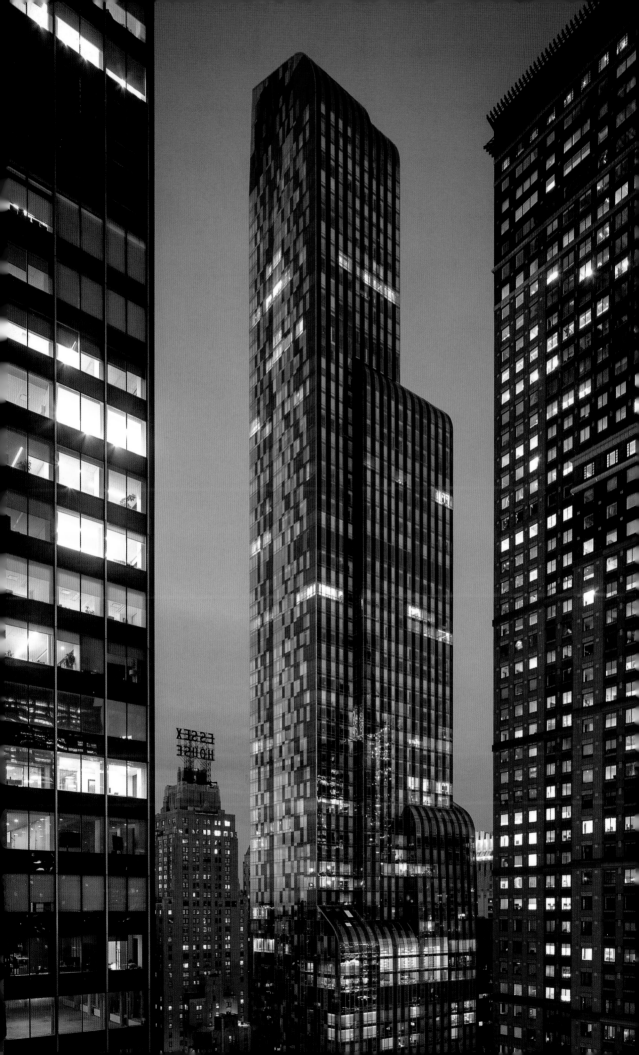

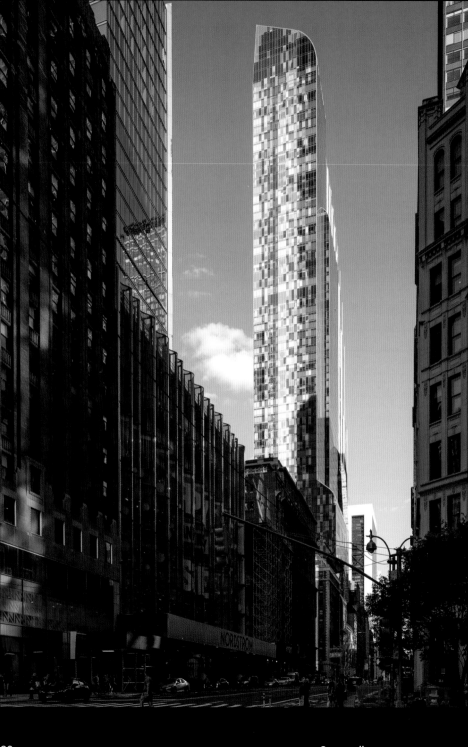

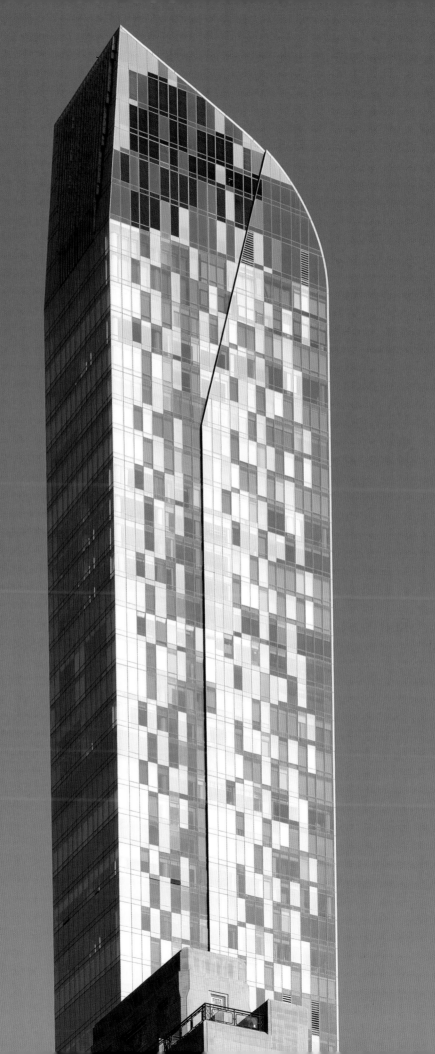

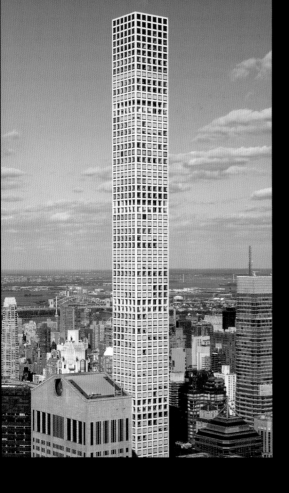
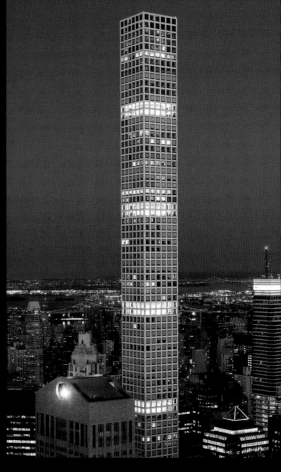

Supertalls

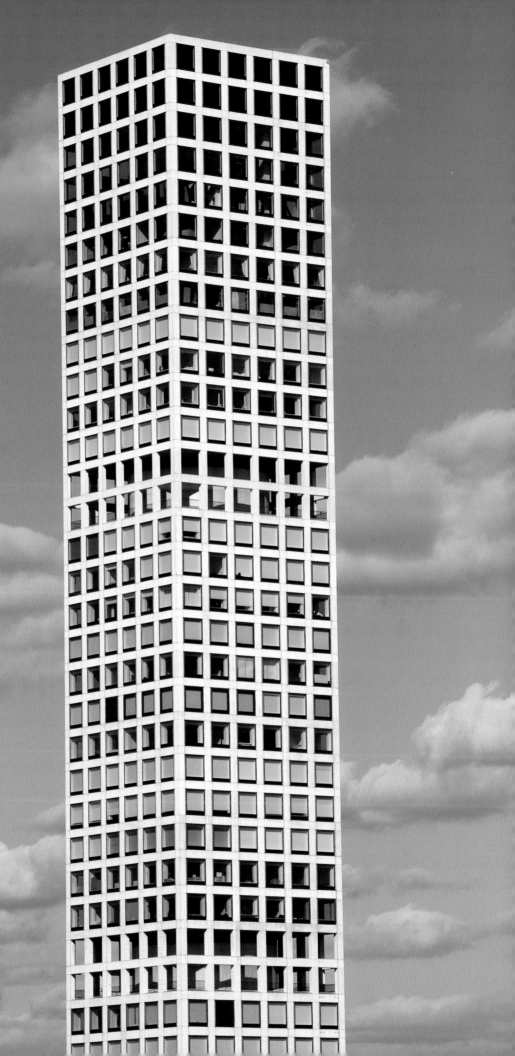

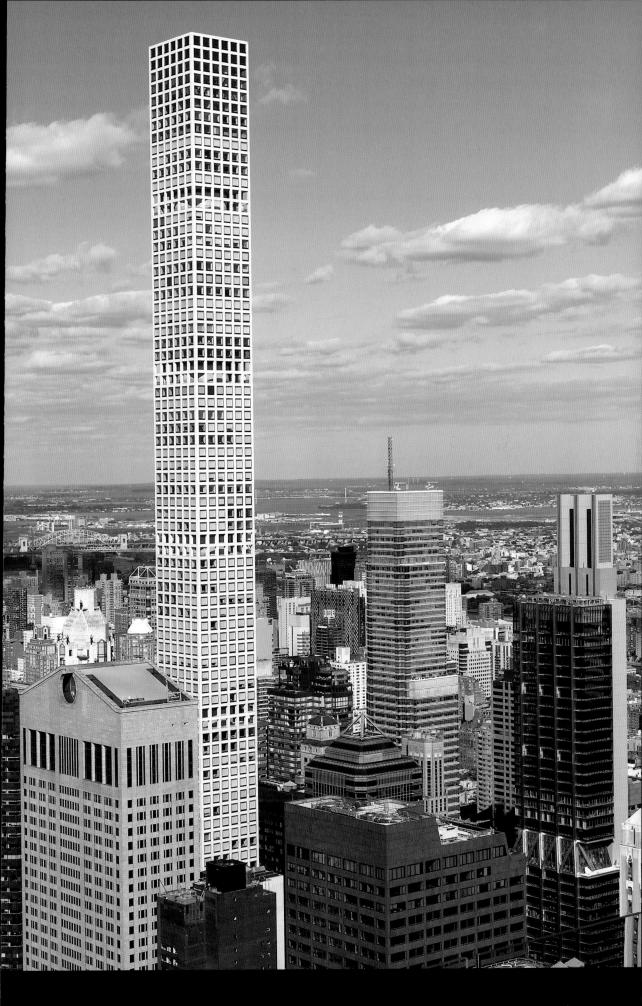

432 Park Avenue

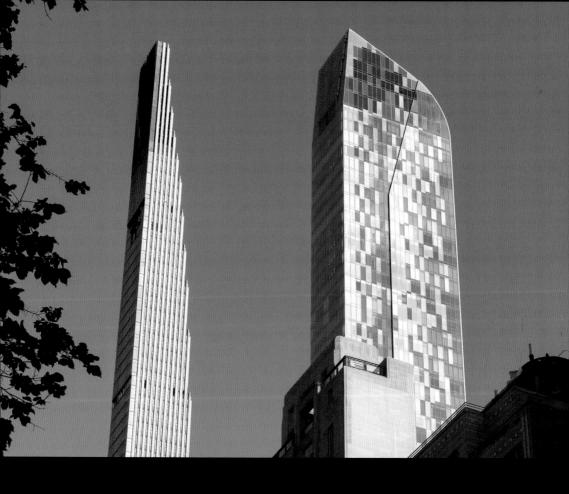

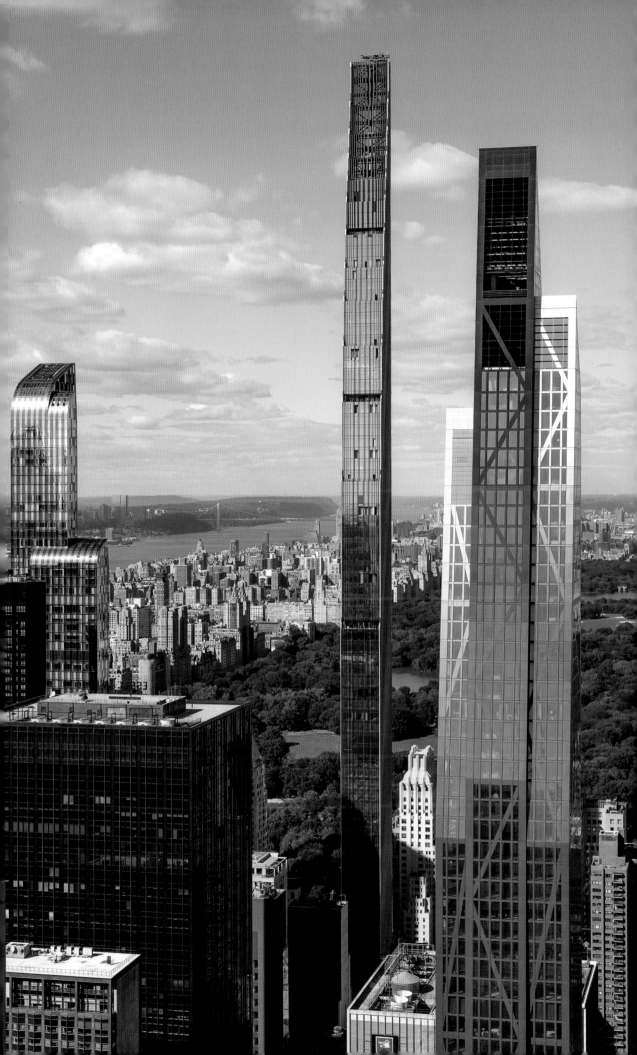

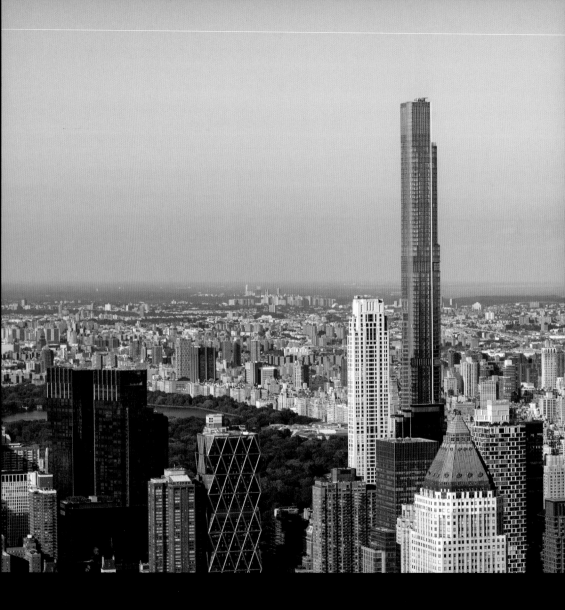

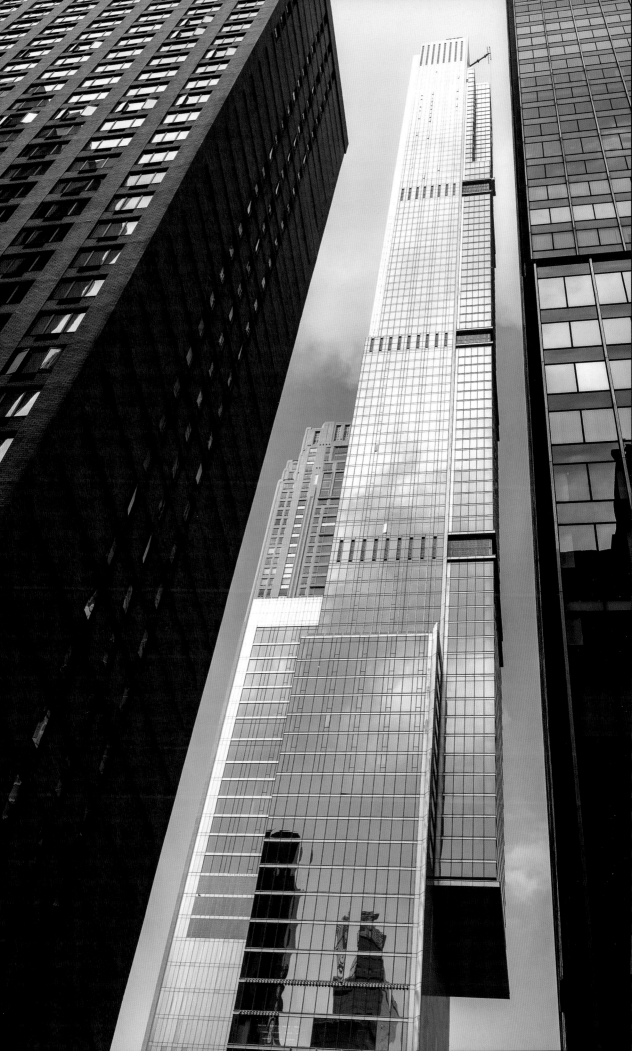

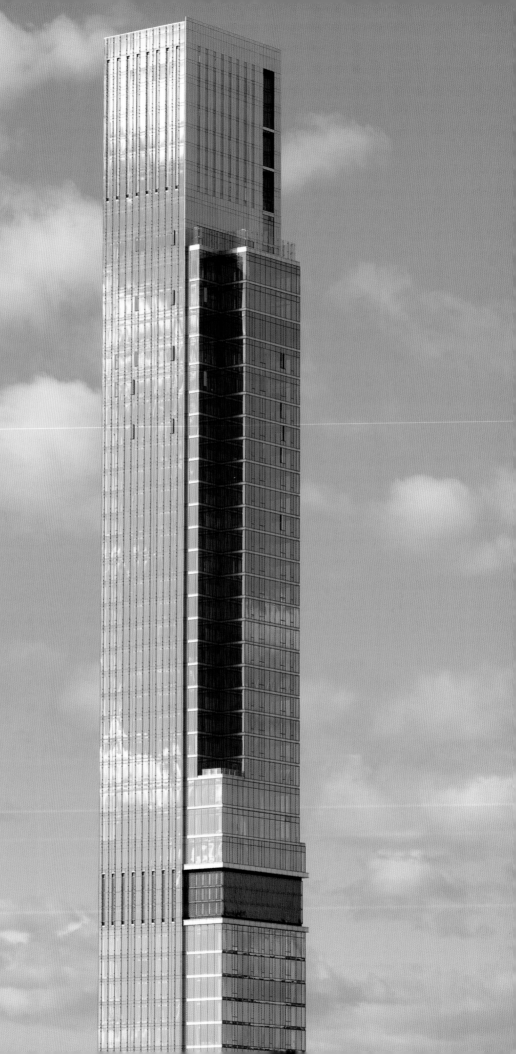

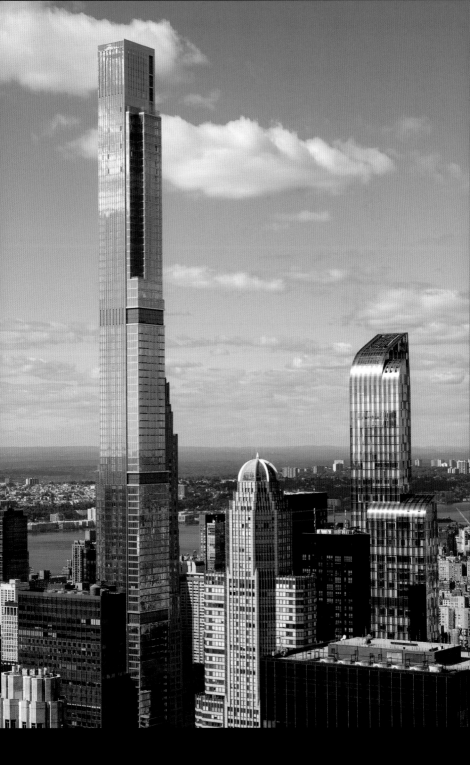

53W53
(53 West 53rd Street)
77 floors
1,050 feet
320 meters

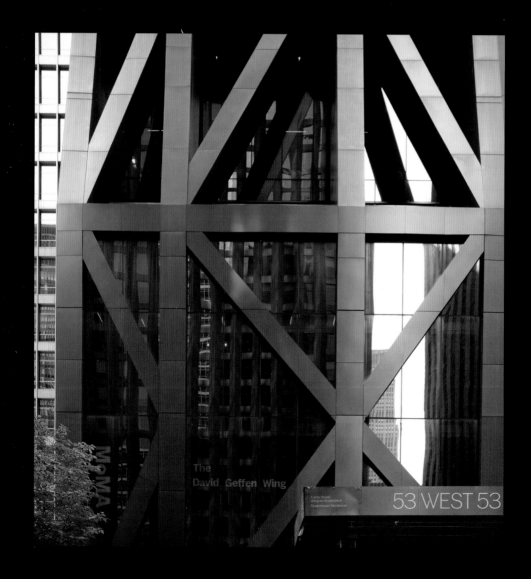

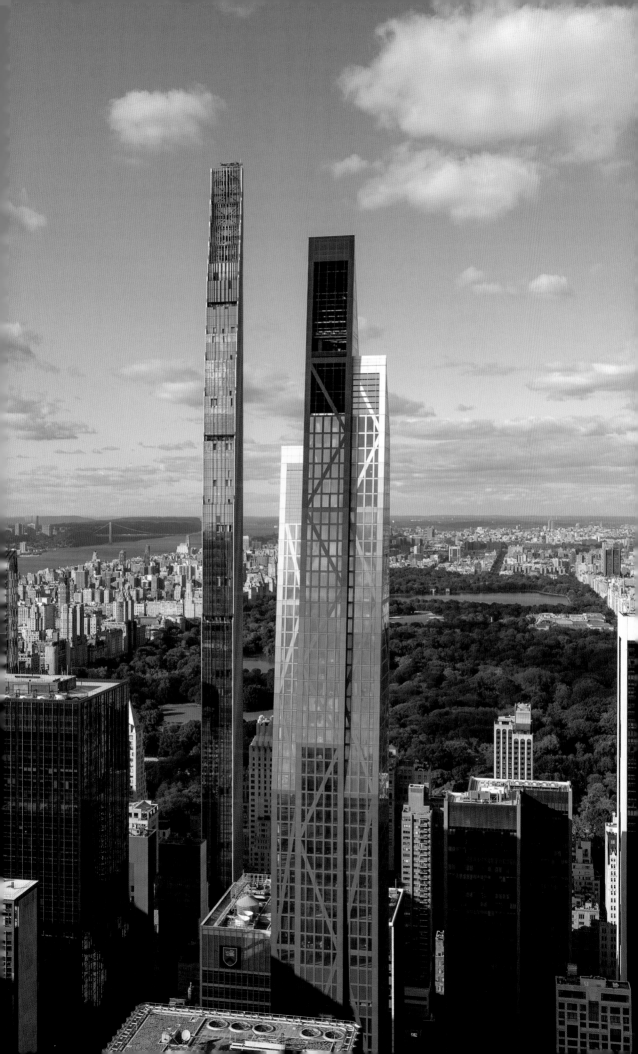

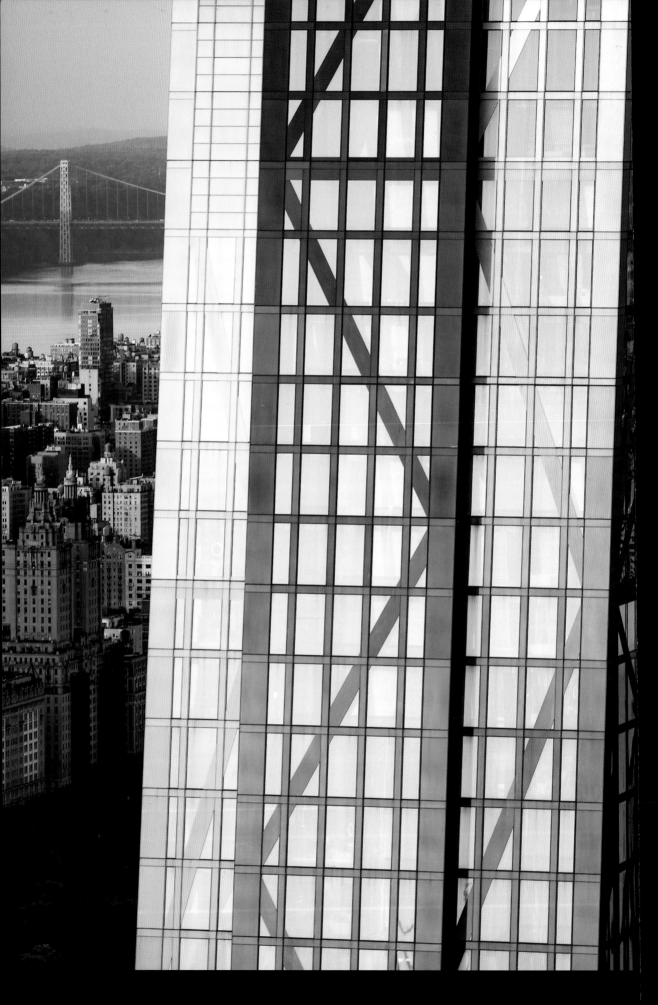

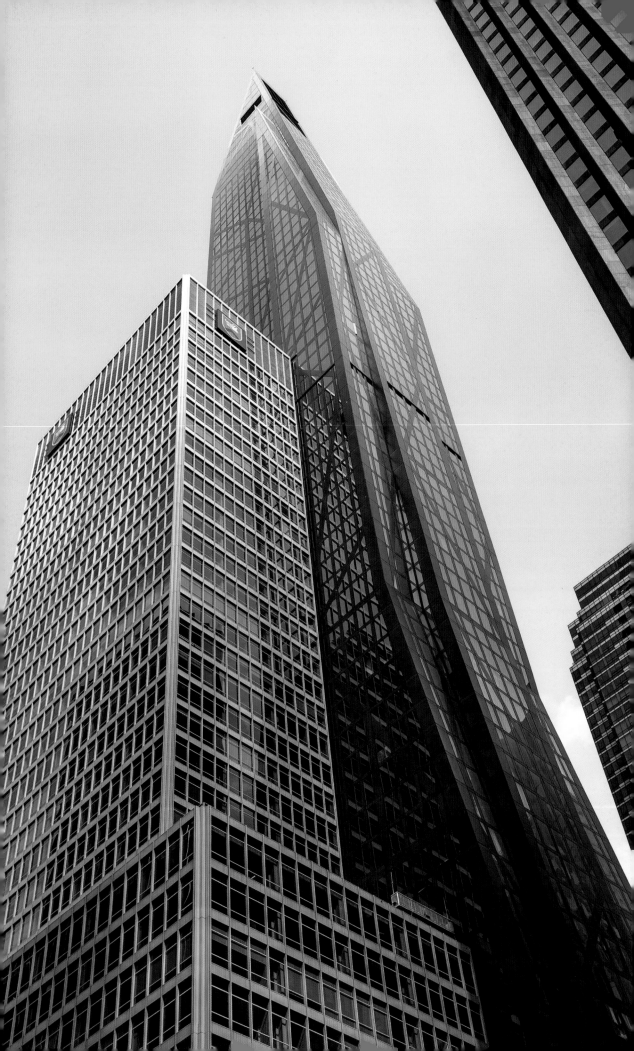

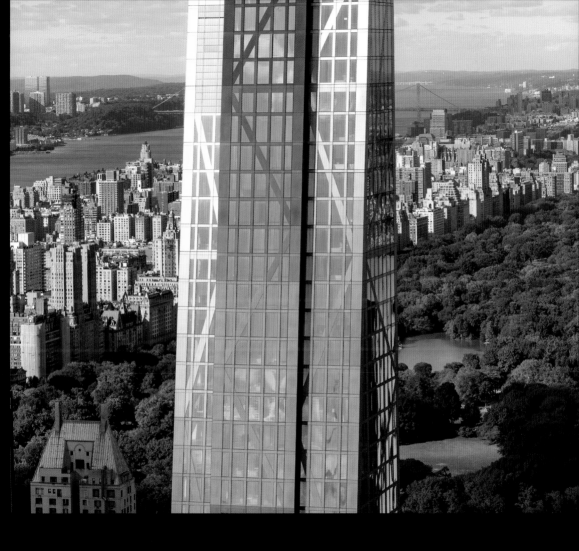

8
If You Build It (Hopefully, Eventually, Maybe) They Will Come

Like with the bubble just before the 1929 stock market crash, developers have been madly overbuilding city office space in the twenty-first century. A downturn in the economy caused by COVID-19, the advent of remote work, or simply the cyclical boom-and-bust nature of capitalism could leave empty space for years to come.

The Empire State Building was mocked as the "Empty State Building" for its lack of tenants and did not turn a profit until 1950, nearly two decades after it opened.[1] Canny John D. Rockefeller Jr. filled his empty showpiece 30 Rock by "papering the house" with subsidiaries brought in from his Standard Oil Company in New Jersey. The more lighthearted Raymond Hood treated his kids to roller-skating parties in the empty, resounding corridors of his McGraw-Hill Building.[2]

The burgeoning 1,401-foot / 427-meter One Vanderbilt, which overshadows Grand Central Terminal, designed in 2020 by James von Klemperer, president and design principal of Kohn Pedersen Fox (KPF), is the objective correlative of the Equitable Building as far as density.[3] The developers benefited from Mayor Bill de Blasio's expansion of the Greater East Midtown Zoning, approved by the City Council in 2017, which allowed for far greater density in the area.[4]

The Municipal Art Society has already condemned the gargantuan, seventy-eight-block expansion plan as "deficient" in almost every urban aspect, like public plazas, blocking views of historic buildings, mixed usage, and inevitable residential conversion.[5] One Vanderbilt's contextual gestures toward its stately neighbor Grand Central Terminal are rudimentary, an afterthought at best—shards of faux-Guastavino tiling in its awning and a hop, skip, and jump courtyard centered around bedraggled flowerpots.

One thing can be said about One Vanderbilt: it's big. The sixty-seven-story tower contains 1.8 million square feet / 167,225 square meters of office space.[6] Pre-COVID,

Illuminated at night, One Vanderbilt adds a contemporary touch of romance to the Midtown skyline.

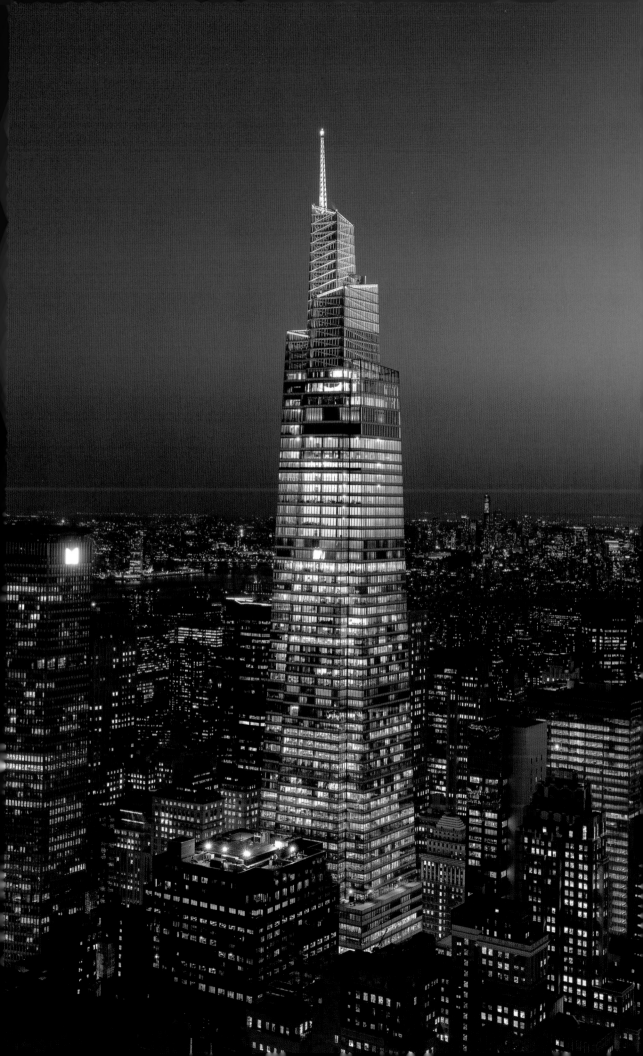

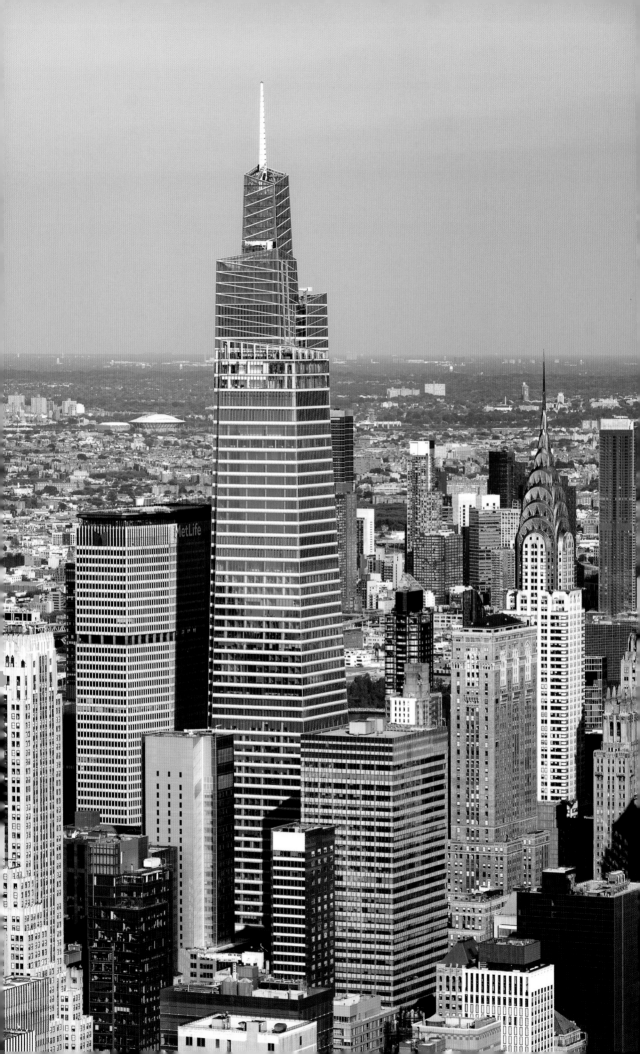

Manhattan was home to some of the world's largest central business districts.[7]

The future is less clear. While many workers began returning to the office after COVID vaccines became available in 2021, the city's three largest employers—Barclays, JP Morgan Chase, and Morgan Stanley—reported that it was doubtful their tens of thousands of workers would return in full force.[8]

In all likelihood, some hybrid system will evolve, with executives going to the office each week and remote workers attending Zoom meetings, or vice versa. Daily office workers supported a vast secondary economy involving everything from food trucks to shoe repair shops, an ecology now as fragile as a coral reef.

Who, exactly, is expected to fill all the new office space? Although One Vanderbilt is already 80 percent leased, the historian Frederick Lewis Allen's observation from 1932 is just as true of Hudson Yards today: "Where will [the] tenants come from? Not out of the dauntless expansion of business—not to-day, at least. They will mostly come out of other buildings."[9]

Half a block long at its base, One Vanderbilt telescopes as it rises, in tribute to the golden age of New York skyscrapers. The slanted pinnacle, which looks like the conning tower of a submarine, dominates the Midtown skyline like an exclamation point. Von Klemperer has likened it to an unfolding rose petal, and noted, "As a rectangular-plan, tapered-point skyscraper, its prominent top joins the Empire State and Chrysler Buildings on the skyline."[10]

Like circling sharks, developers scent blood in the water with the valuable properties surrounding the new Moynihan Train Hall expansion at Pennsylvania Station.[11] Plans for a grandiose business district in the environs were approved under former New York Governor Andrew Cuomo just as he was leaving office in the shadow of a sexual harassment scandal; so far, Governor Kathy Hochul has not delivered her final ruling.[12]

(opposite) One Vanderbilt joins the spired art deco towers of Midtown, the Chrysler and the Empire State Buildings.

(overleaf) The architects of Hudson Yards rarely conferred. The result imparts a sense of randomness rather than order.

Supertalls

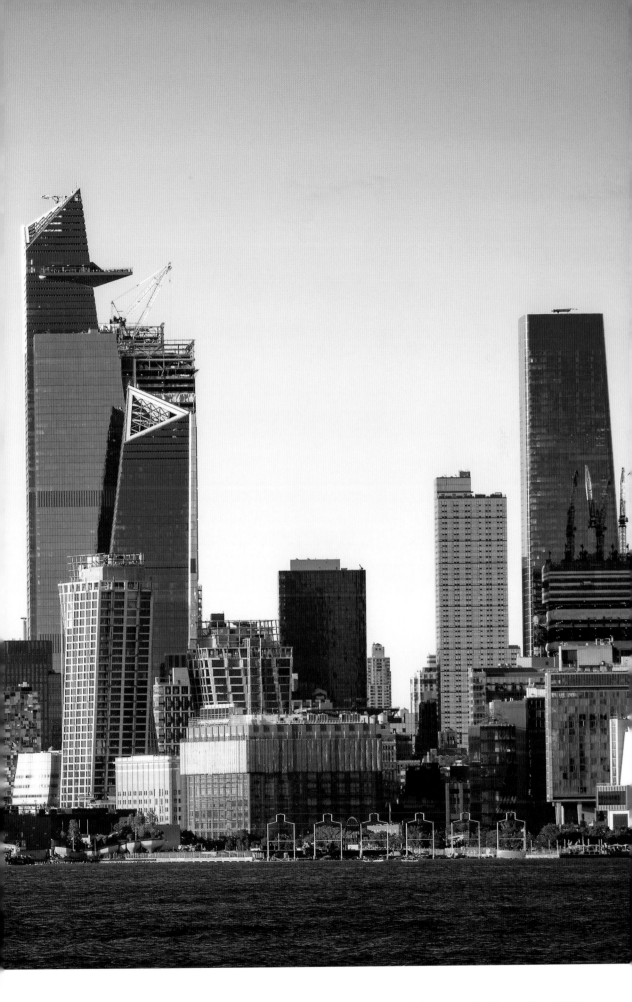

If You Build It (Hopefully, Eventually, Maybe) They Will Come

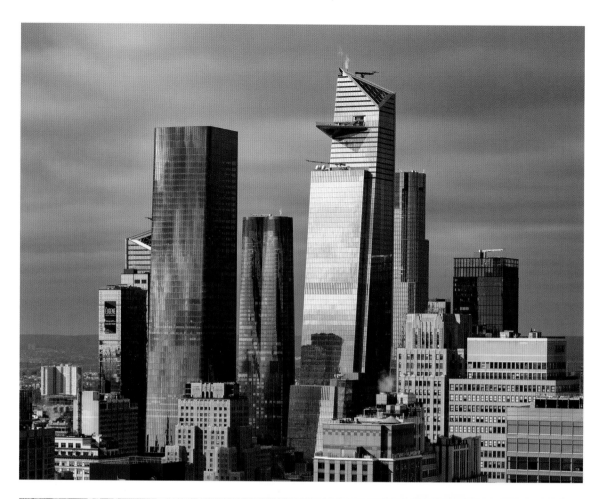

Supertalls

Hudson Yards, seen from the path of the High Line, a park built on a historic elevated rail line, looks like it was lifted straight from Dorothy tripping down the Yellow Brick Road to the Emerald City in *The Wizard of Oz* (1939). The parallels are too great to be happenstance.

Though lacking a coherent master plan like Rockefeller Center, Hudson Yards is an extraordinary feat of engineering and developing ingenuity that turned a rusting, underused piece of Midtown property into a crystalline, consumerist city-within-a-city, with a daily working population of 125,000 people and a residential community of 25,000.[13] It's a Robert Moses–scale piece of empire-building, like stapling the equivalent of the entire hamlet of Baldwin, New York, onto Midtown West.[14]

But the naked profit motive shines through the glitz. Even billionaire developer Stephen Ross, whom *New York* magazine dubbed "the man behind the curtain in this Oz," let the cat out of the bag when he admitted the real purpose of Hudson Yards was to sell apartments.[15]

Hudson Yards is as ersatz a New York experience as the New York–New York Hotel & Casino in Las Vegas, with its "stunning recreations of famous Landmarks including the Manhattan Skyline."[16] As French *philosophe* Guy Debord wrote, "Everything that was directly lived has moved away into representation."[17]

Aesthetically, Hudson Yards resembles a random assortment of chess pieces. Each building's architect more or less built what they liked, without regard to what anyone else was doing. The symbolic centerpiece is Thomas Heatherwick's *Vessel*—a hollowed-out, 150-foot/46-meter shawarma-shaped sculptural staircase with alarmingly low rails, which developers vainly hoped would become the symbol of New York, much like the Statue of Liberty. After three people leapt from it to their deaths, the owners did not alter the railings but instead adopted a buddy system, with more hypervigilance about those likely to be at risk—typical of the plaza's methods of hypersurveillance, one of the things that make it different

(opposite top) Hudson Yards appears like a vision of the Emerald City of Oz as seen from the Yellow Brick Road of the High Line.

(opposite bottom) Thomas Heatherwick's permanent installation *Vessel*, seen here from the glassy lobby of the Shops at Hudson Yards, is the focal point of the complex.

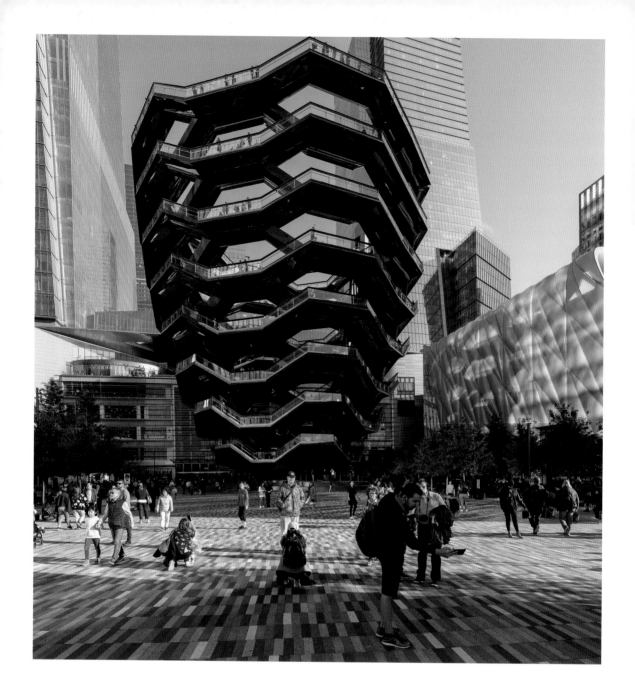

(above) With a price tag of $200 million, Heatherwick's Escher-like, copper-colored stainless-steel staircase *Vessel* may be the world's most expensive hunk of contemporary public art.

(opposite) The brilliantly engineered decking that supports Hudson Yards was constructed by the firm Thornton Tomasetti. A second phase will cover the trainyard in the foreground and feature another supertall.

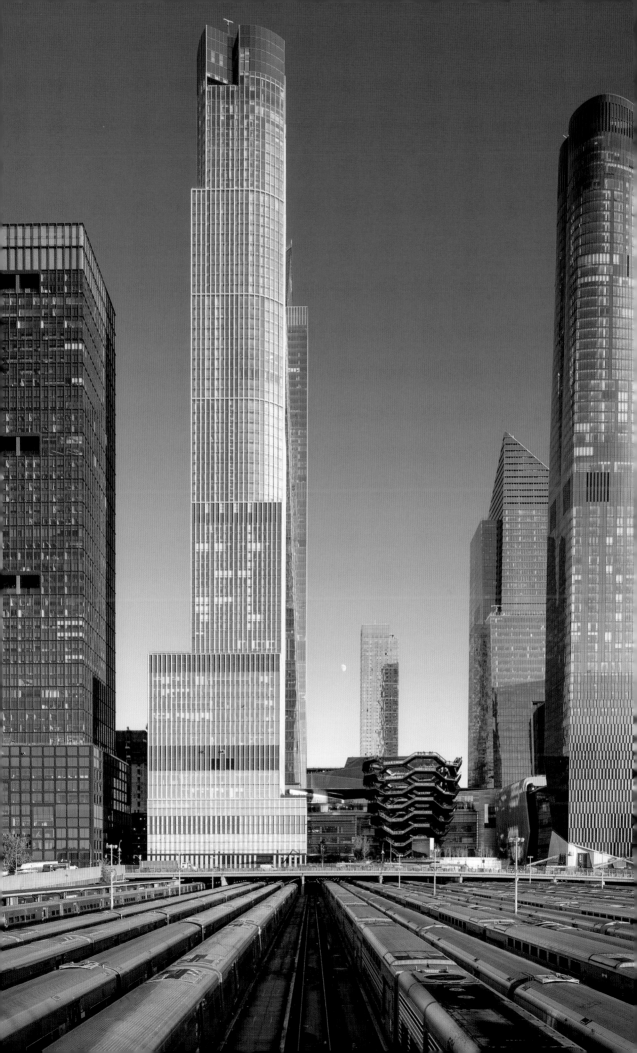

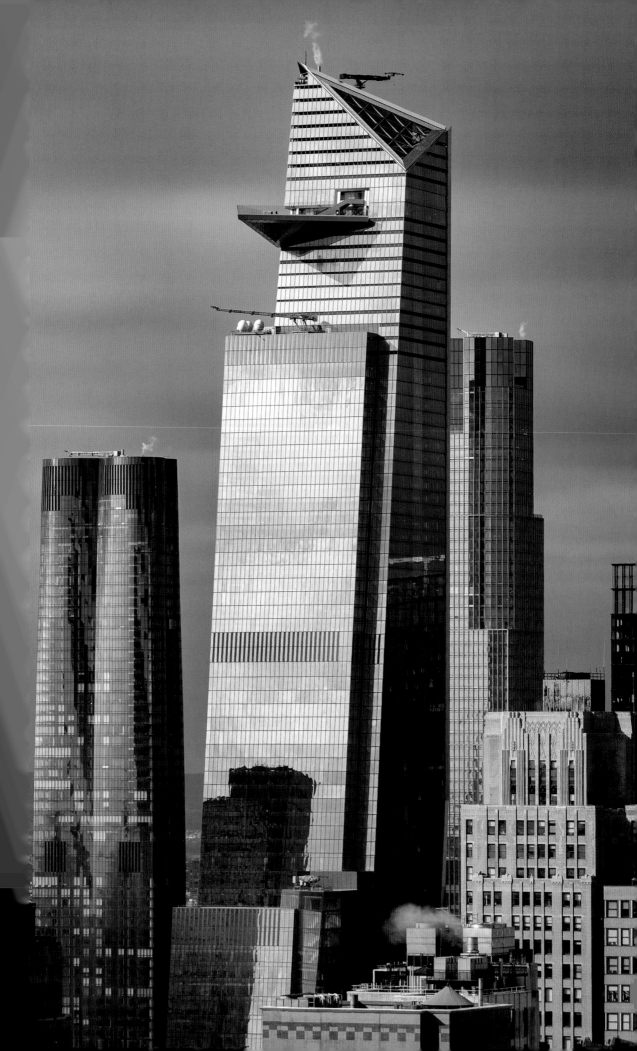

(opposite) The venality
behind Hudson Yards
as a moneymaking venture
shows through: it lacks
the architectural integrity
and cohesion of the city's
great complexes, such as
Lincoln Center, Rockefeller
Center, and the World
Trade Center.

(above) Supertall 30 Hudson
Yard's observation deck
literally puts you close to
the Edge, the highest open-
air observation deck in the
Western Hemisphere.

from ordinary public space. Following a fourth suicide, the staircase was shut indefinitely in the summer of 2021.[18]

KPF's supertall 30 Hudson Yards (seventy-three floors; 1,270 feet / 387 meters), designed by lead architect Bill Pedersen and completed in 2020, is the king piece of this haphazard chessboard.[19] Edge, the delta-shaped observation deck on the 100th floor, at 1,131 feet / 345 meters, is the highest open-air observation deck in the Western Hemisphere.[20] The Empire State Building's upper observation deck is slightly higher, on the 102nd floor, at 1,050 feet / 320 meters, but is enclosed.[21]

Edge's beak-like protrusion is truly an edgy experience. The triangular deck juts out 80 feet / 24 meters from the facade and features a glazed, triangular floor piece to look straight down at the street—an experience not for the acrophobic or faint of heart. On a clear day you can see forever: not only the city skyline, but also up to eighty miles into New York State and New Jersey.[22]

Completed in 2020, SOM's hotel-cum-residences at 35 Hudson Yards, designed by the ubiquitous David Childs, squeak by as a supertall at 1,009 feet / 308 meters, in obligatory "lick-and-stick" limestone cladding, connoting that "touch of class" high-end residents demand. It costs a lot to look this cheap.

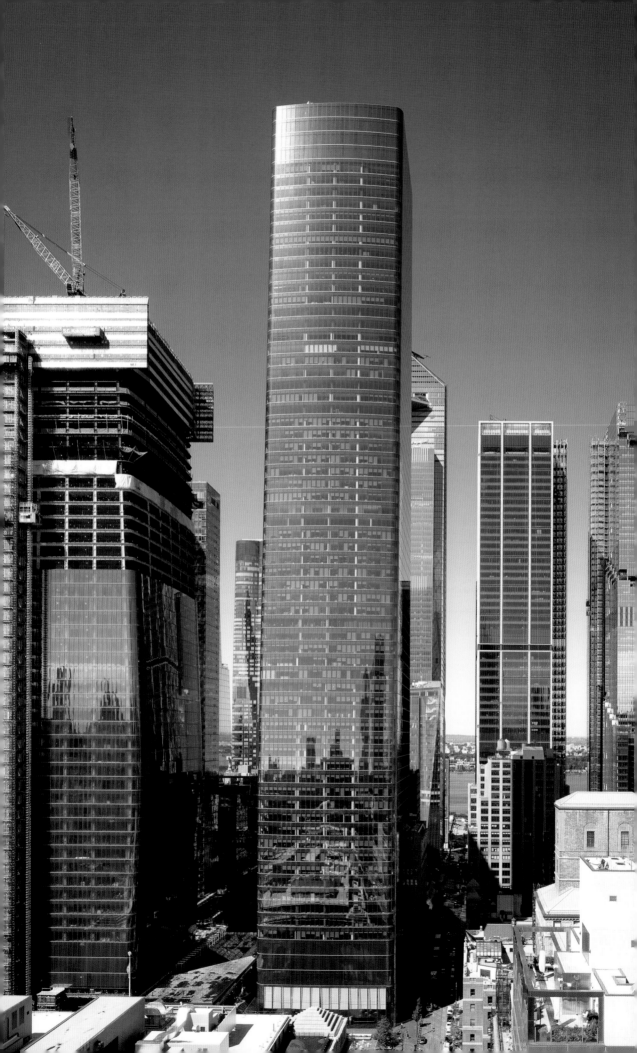

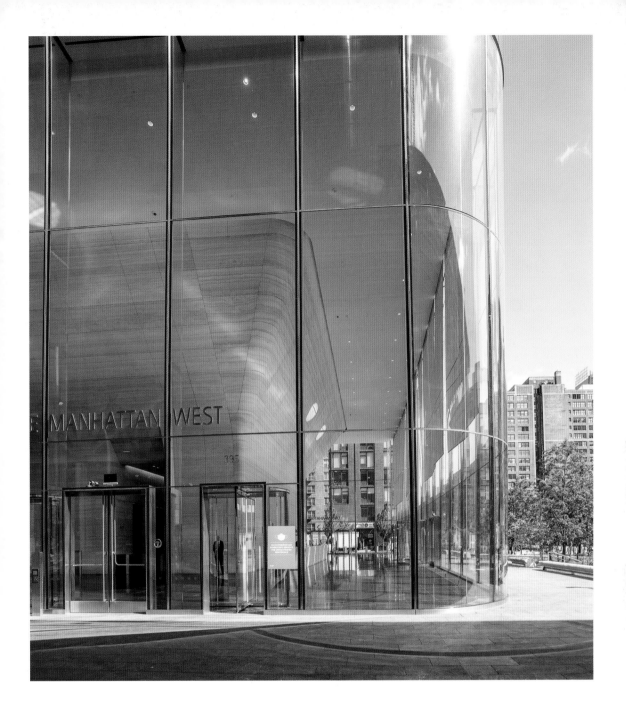

(opposite) At 995 feet /
303 meters, SOM's sleek
but undistinguished One
Manhattan West just
scrapes by as a supertall,
defined as a building
over 984 feet / 300 meters
tall.

(above) One Manhattan
West's massive, glassed-in
central core connects
the tower to bedrock below
the decking.

Another barely supertall is SOM's slouchy, eminently forgettable 995-foot / 303-meter One Manhattan West, completed in 2019 on the easternmost edge of the Yards.[23] The smooth-glass, sixty-seven-story mixed-use office and residential tower has a hunched silhouette, as if it yearns to belong to the Yards. The overall effect is as forlorn as Eeyore, a sagging, upright loaf of art moderne Wonder Bread.

Encased in an aquarium-like lobby, One Manhattan West's flared, 1970s-style, steel-reinforced concrete core is overwhelming, like a gargantuan support of a Saarinen chair, or something out of the movie *Logan's Run* (1976). It has to be: the core anchors the tower to the substratum of the railroad bed below, but you almost expect to see Farrah Fawcett flouncing through the lobby in a sparkly green minidress and feathered curls.

Though Diller, Scofidio + Renfro's shotgun barrel–topped 15 Hudson Yards just misses out on being a supertall at 917 feet / 280 meters—it's a wonder they did not add some doodad vanity for additional height, just for the record—it does feature Skytop, the highest private residential sundeck in the city at more than 900 feet / 274 meters above ground.[24] The privileged can disport themselves like the jeunesse dorée in Fritz Lang's *Metropolis* of 1927 or sunbathe closer to God, like Icarus, until their waxen wings fall off.

Danish-born Bjarke Ingels, founder of Bjarke Ingels Group (BIG), is designing an innovative supertall, the 1,030-foot / 314-meter Spiral, scheduled for completion in late 2022 and thus outside the parameters of this volume.[25] The design for Spiral is a block-wide tower that features tree-lined, zigzagging setback terraces that look like they were cut out with pinking shears. Ingels has said that it "combines the classic ziggurat silhouette of the premodern skyscraper with the slender proportions and efficient layouts of the modern high-rise."[26]

The towers of Hudson Yards do not interact with one another architecturally. KPF was the master planner, but the firms rarely met.

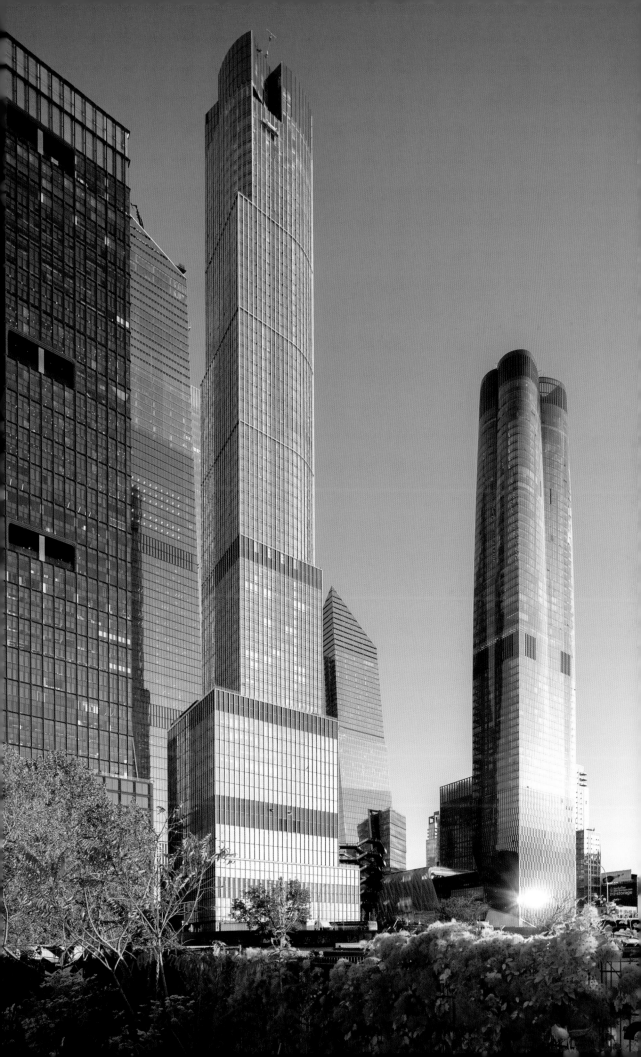

One Vanderbilt
67 floors
1,401 feet
427 meters

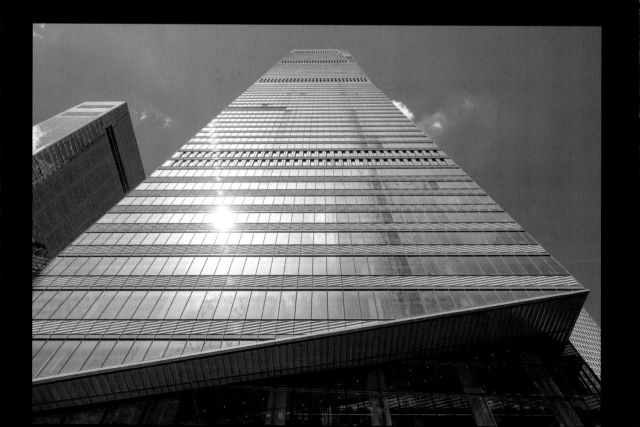

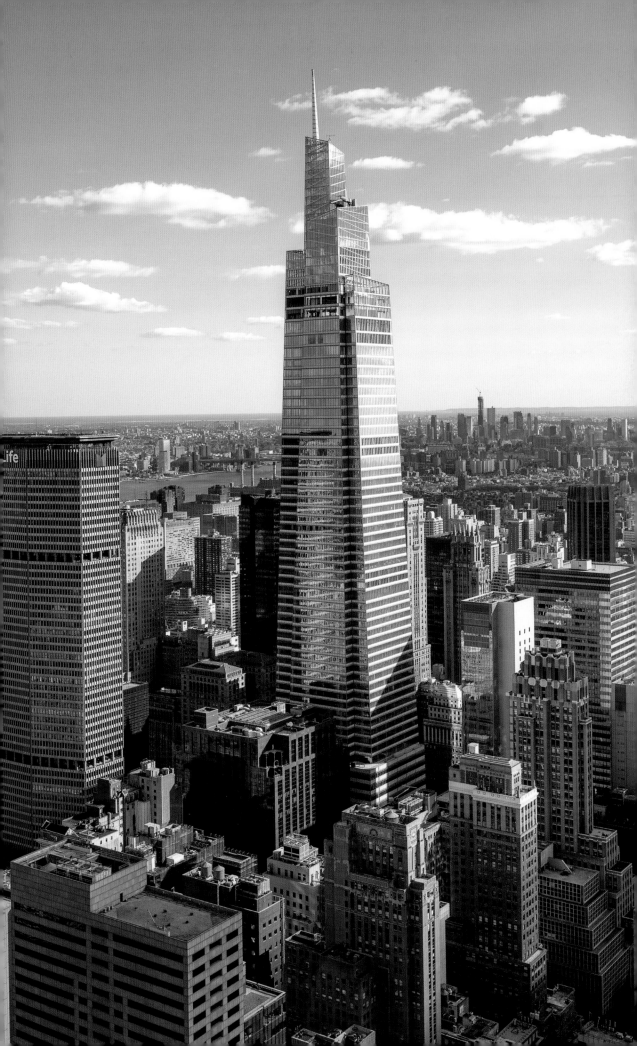

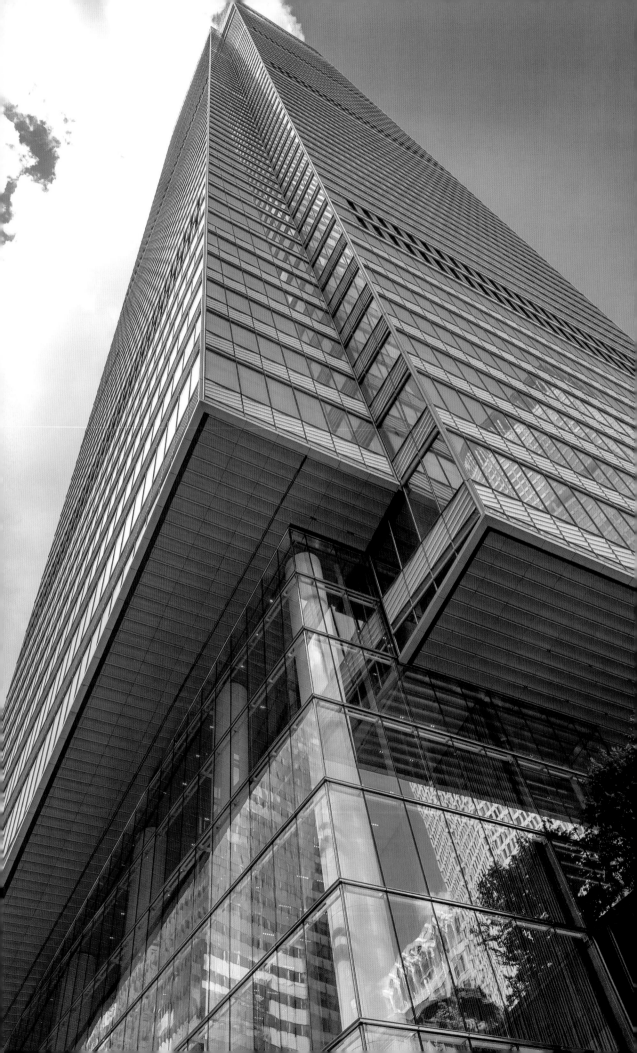

One Vanderbilt

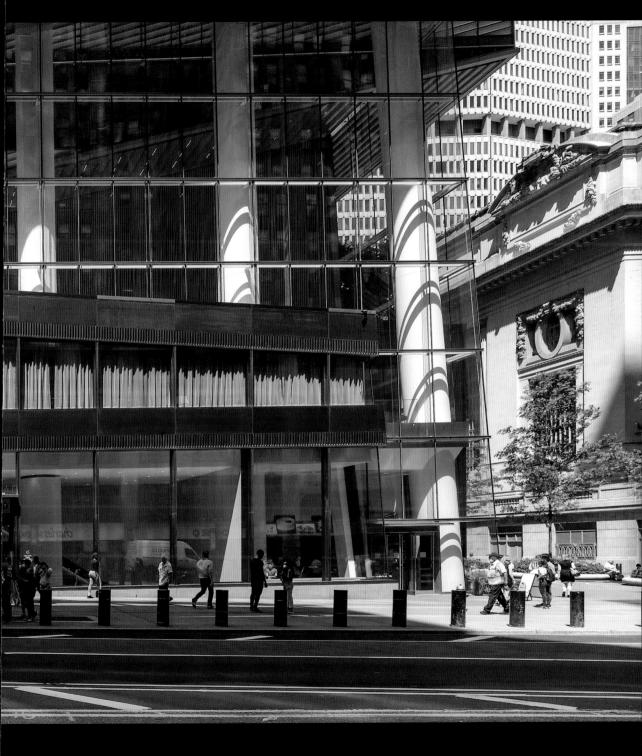

One Vanderbilt

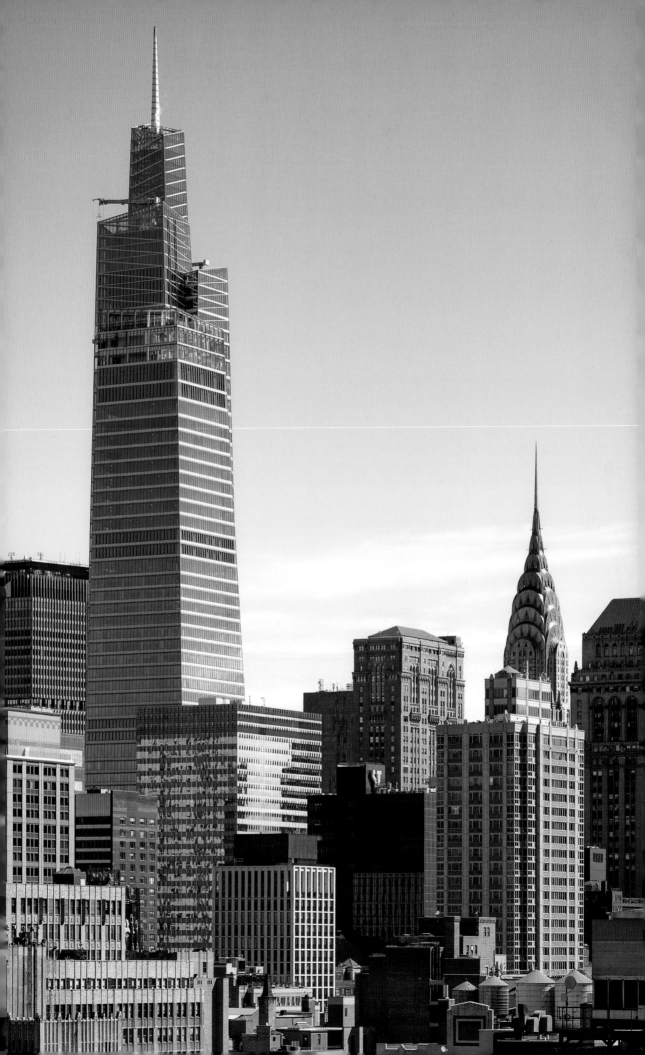

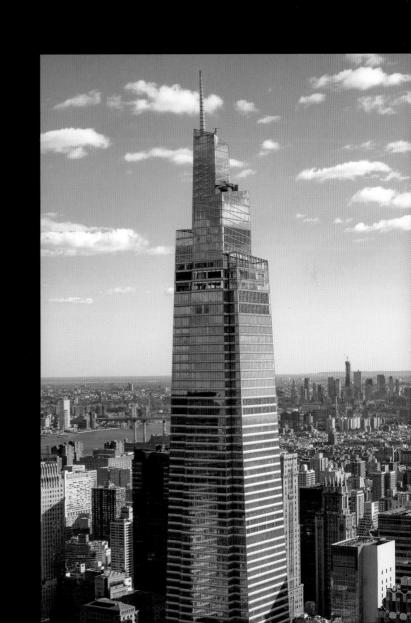

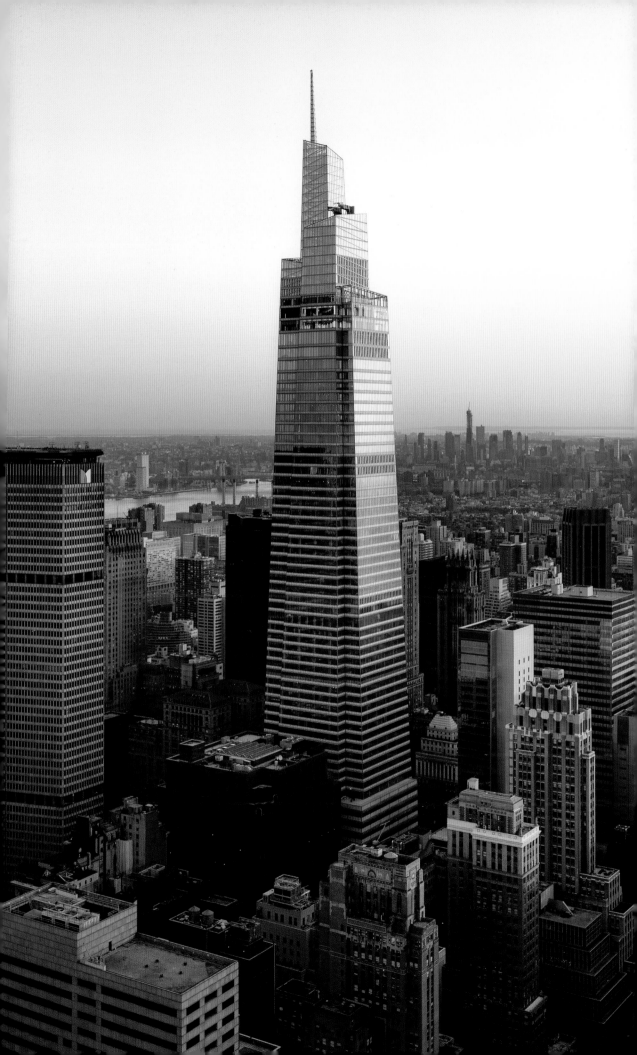

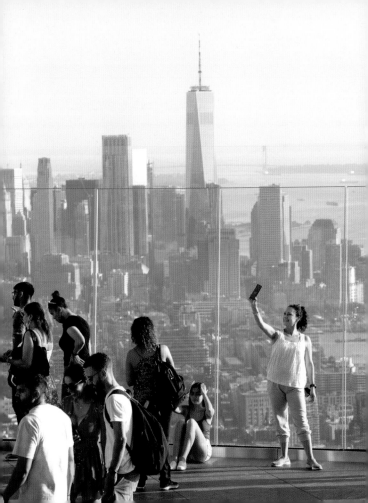

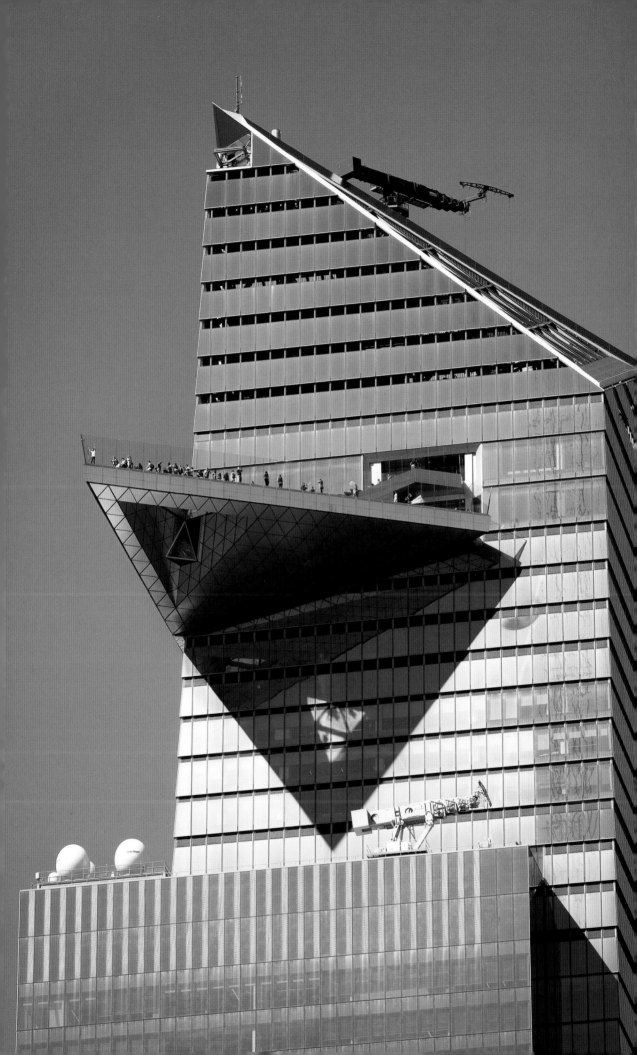

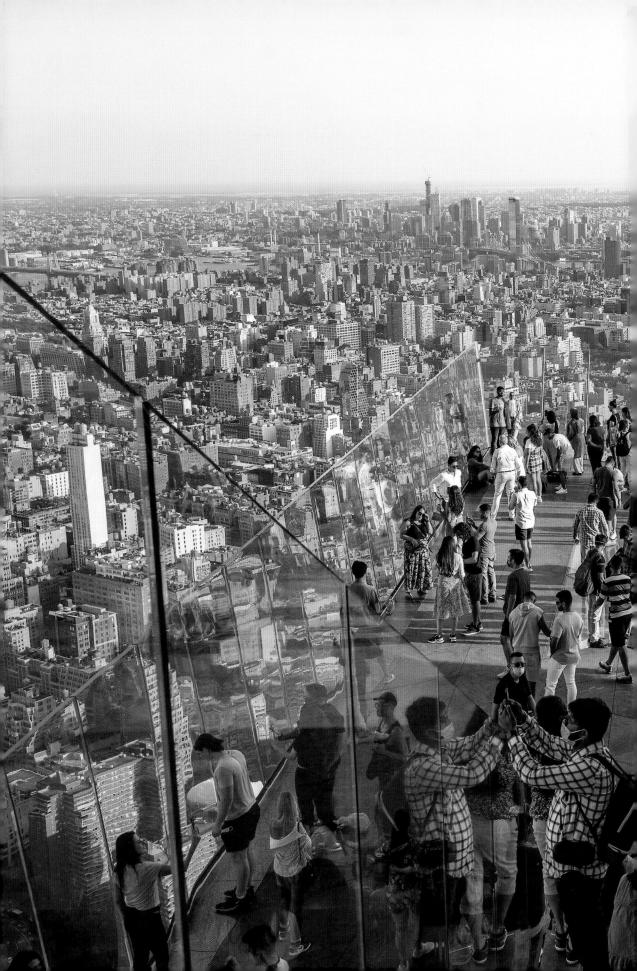

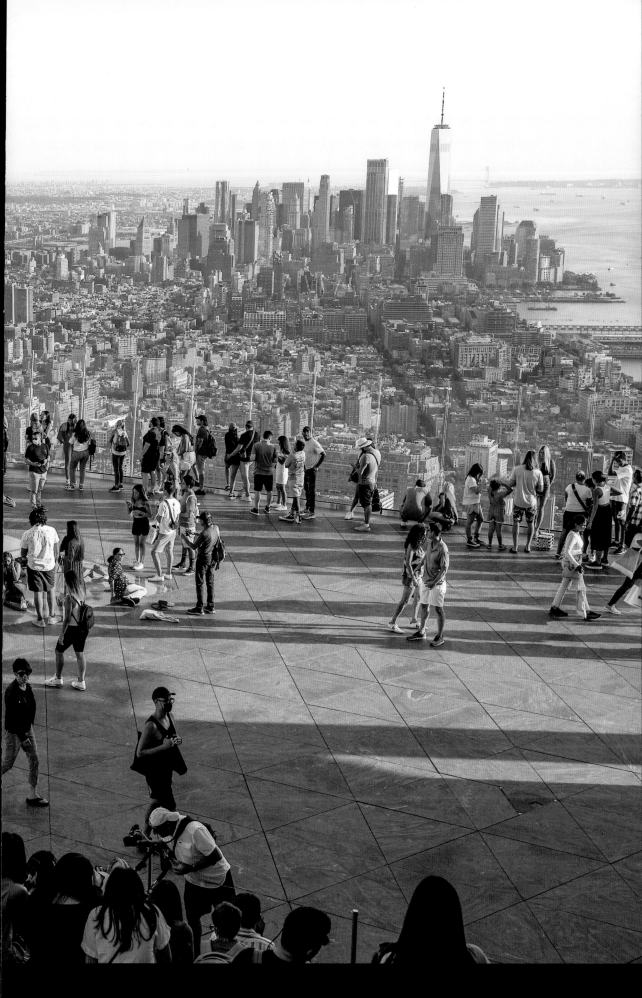

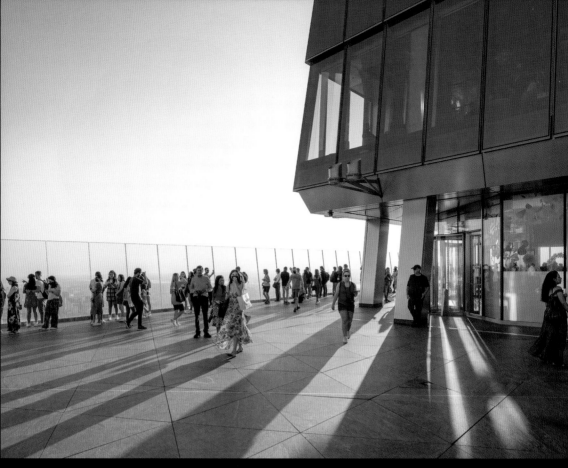

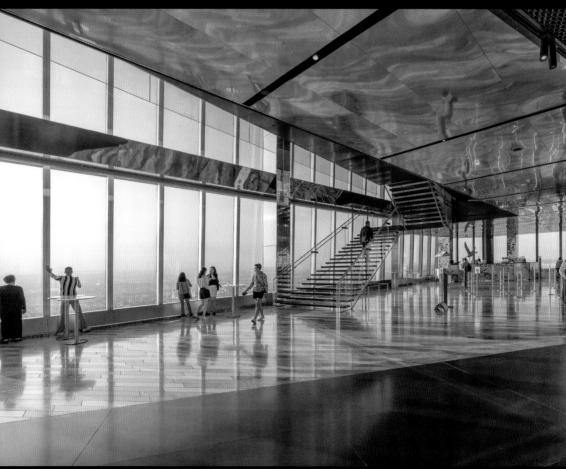

Supertalls

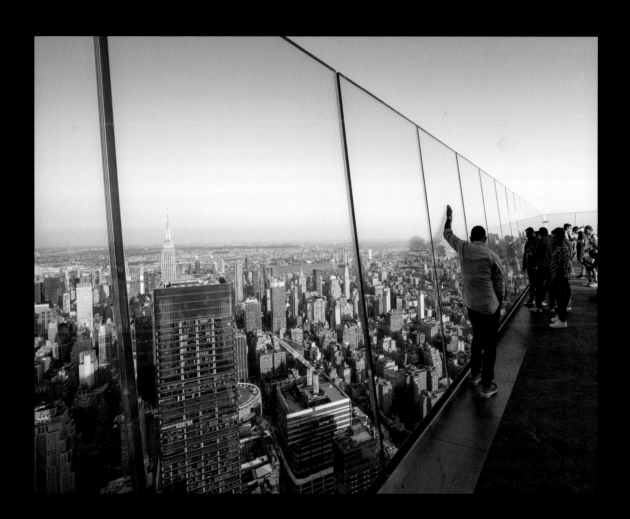

55 Hudson Yards
71 floors
1,009 feet
308 meters

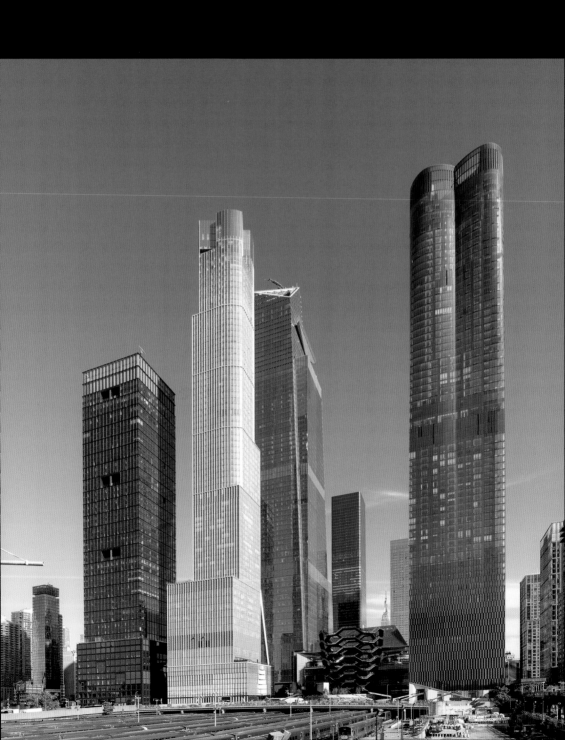

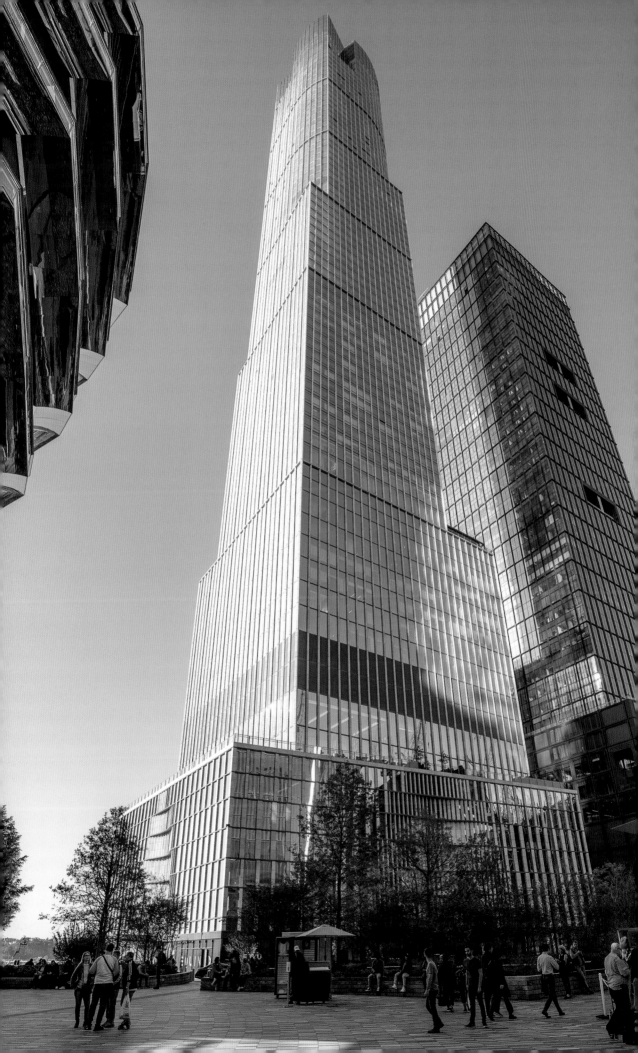

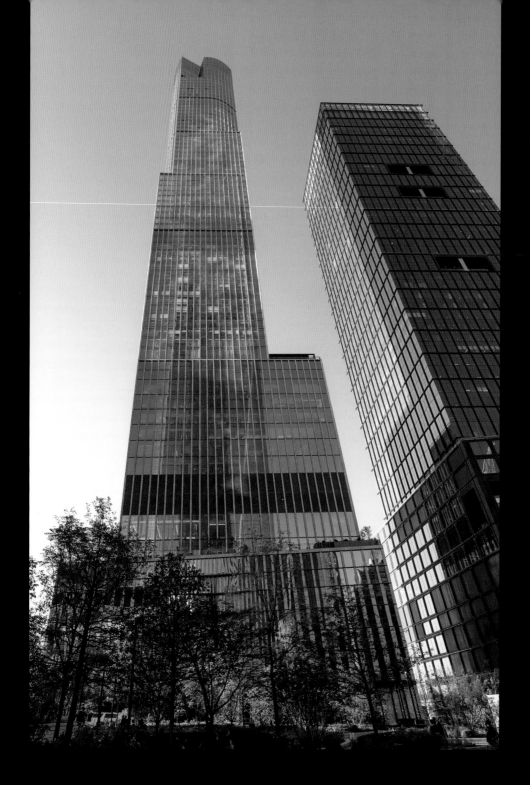

Supertalls

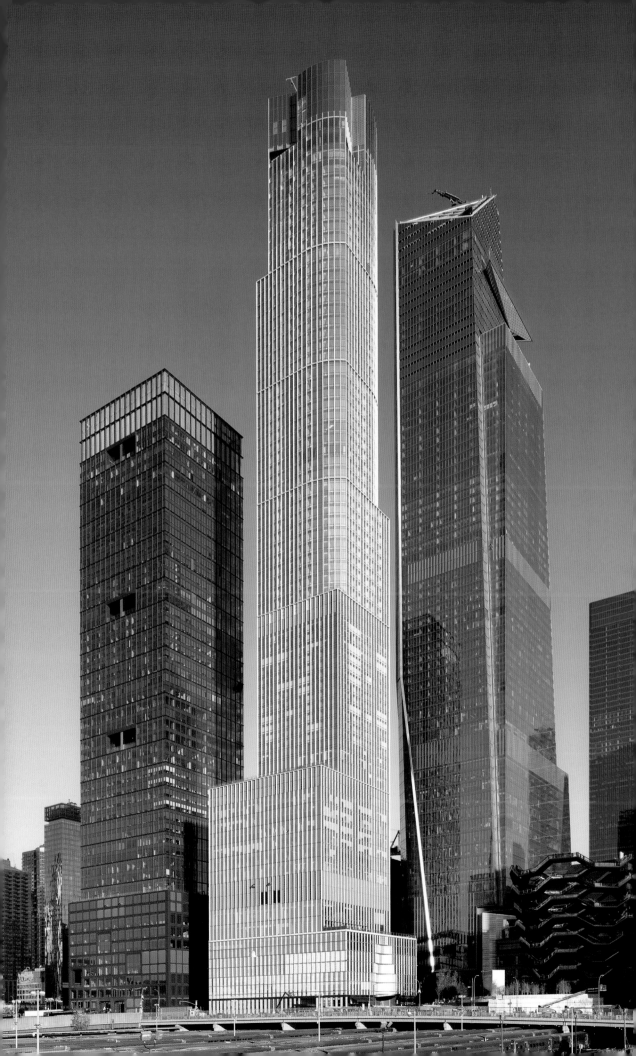

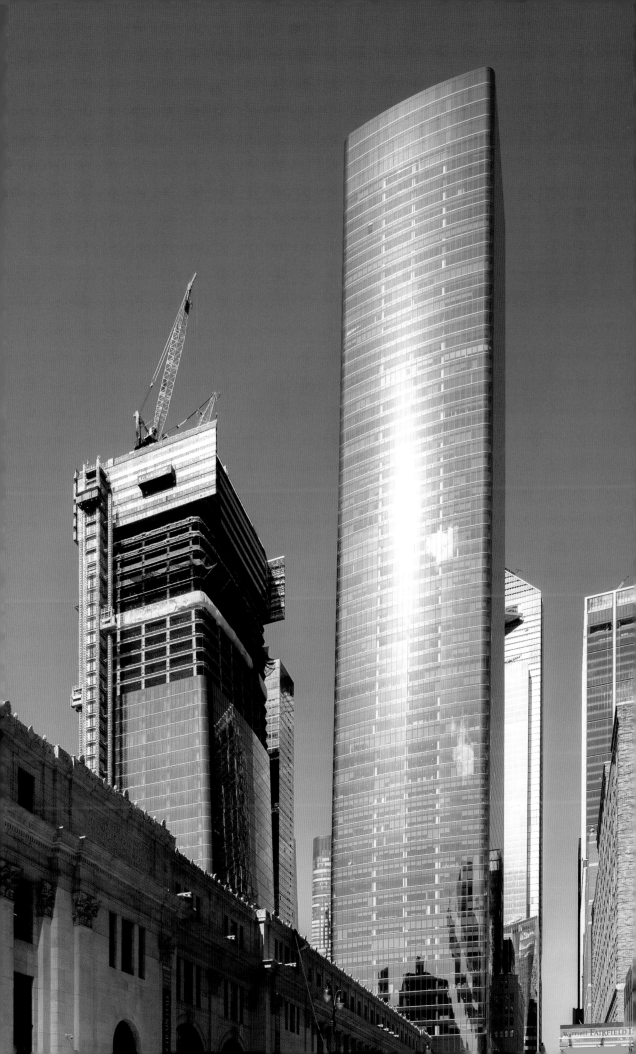

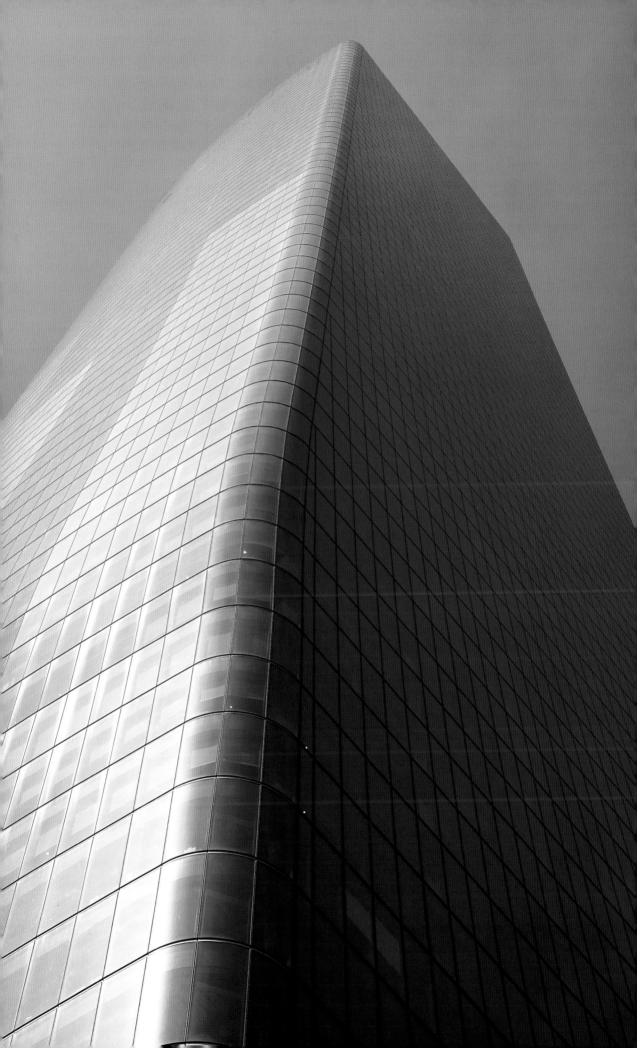

9
At the Corner
of Cheesecake
and Dime

Sited on a delta-shaped block bordered by DeKalb and
Flatbush Avenues and Fleet Street is 9 DeKalb, Brooklyn's
first supertall (ninety-three floors; 1,066 feet / 325 meters),
sandwiched between the Dime Savings Bank and Junior's
Restaurant.[1] SHoP's superattenuated, smoky-glass, hexagonal
spire with bronzed piers soars high above downtown
Brooklyn's newly minted, reflective mid-rises.[2]

It's a conceptual stretch, but the tower's hexagonal shape
is meant to evoke the coffers inside the bank's domed ceiling
and the colors are meant to reflect the bank's interior palette.[3]
But the bronze accents look out of place—the building
could be plunked down in any sun-bleached American city
from Atlanta to Dallas. What is uniquely Brooklyn about
it? Gallingly, for a borough raised on street ball, the tower
features two floors for playing basketball, on the sixty-sixth
and eighty-fifth floors, in addition to what developer Michael
Stern calls "perhaps the world's highest dog run," for the
world's most refined pooches.[4]

Already known as the Brooklyn Tower, even though a
second supertall is slated for the borough, 9 DeKalb utilizes
the landmarked facade and interior of the Pantheon-like
Dime Savings Bank, designed by Mowbray & Uffinger in
1908 and expanded by bank specialists Halsey, McCormack
& Helmer in 1932, as its entrance, in an extraordinary
urbanist gesture, like the Steinway Tower.[5] But the act was
not entirely charitable—purchasing the bank allowed the
developers to add thirty more stories to their tower.[6]

The Beaux-Arts exterior of the original structure was the
first building in the nation to use marble from Greek quarries
that supplied ancient temples.[7] The rotunda is supported
by a dozen red-marble columns that feature Corinthian
capitals inset with silver-colored Mercury dimes, rather than
the Roosevelt dimes we are familiar with, because it was
renovated in 1932, before Roosevelt's death during the War.

Commissioner Frederick Bland of the New York City
Landmarks Preservation Commission deemed 9 DeKalb
"enlightened urbanism at its best."[8]

9 DeKalb, another exemplar
of enlightened urbanism
for supertalls, incorporates
the neoclassical Dime
Savings Bank of New York
as its lobby.

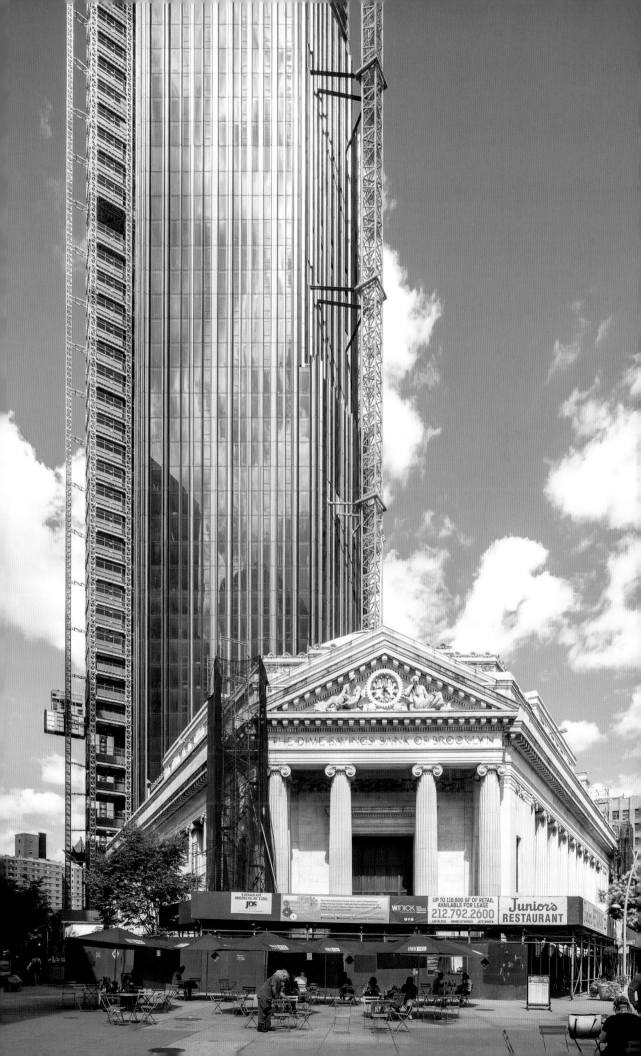

THE DIME SAVINGS BANK OF BROOKLYN

UP TO 118,800 SF OF RETAIL
AVAILABLE FOR LEASE
212.792.2600

WINICK

Junior's
RESTAURANT

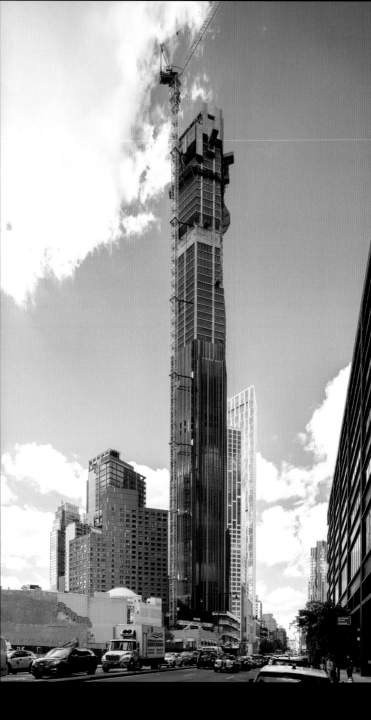

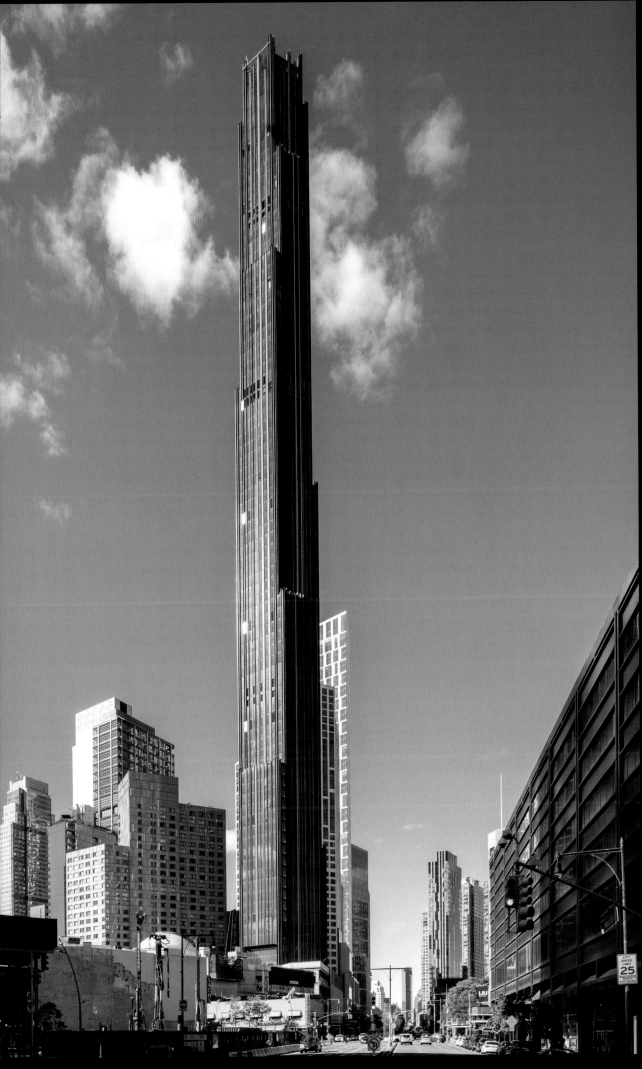

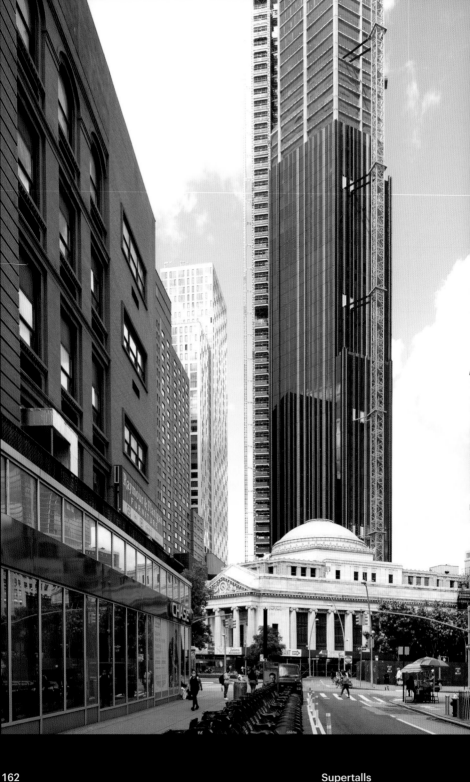

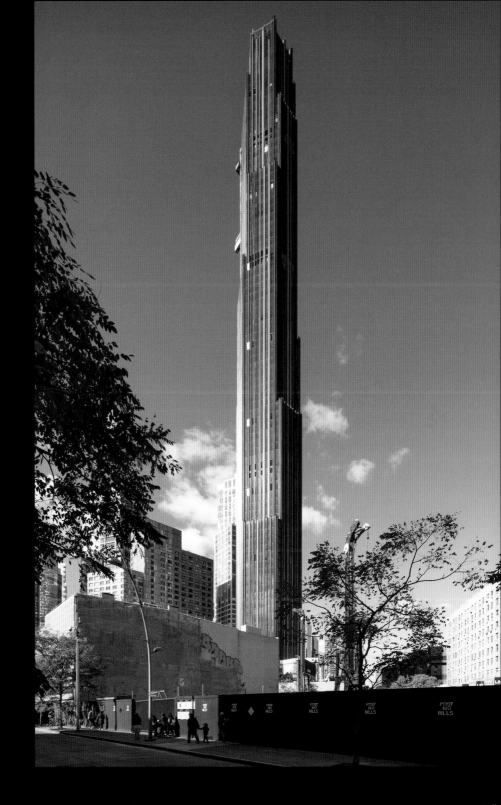

**Part III
Is Bigger Better?**

Part III
Introduction

The only constant in New York, come hell or high water, is accelerating change. Simply put, New York rebuilds. Its very bedrock is a lodestone that attracts steel girders, the young, the ambitious, and those seeking to improve their lot in life. The energy generated by more than eight million inhabitants and the countless millions that preceded them is palpable.

As the Australian art critic Robert Hughes would say: the shock of the new is not new, and nothing stays new for very long.[1] New Yorkers of every generation have been appalled by the increasing height of the city skyline. When Henry James returned from Europe in 1910 to his beloved brownstone city, he remarked on the "thousand glassy eyes of these giants of the mere market."[2]

Older New Yorkers may long for the days when the illuminated, six-story Essex Hotel sign was the biggest intruder on Central Park South, but youngsters playing softball in Central Park's Heckscher Ballfields now will no doubt one day take the supertall skyline for granted. One generation's monstrosity is the next generation's nostalgic *New Yorker* cover.

Supertalls will not transform Manhattan into Dubai on the Hudson. The real question skyscrapers of any height pose is not so much how they affect the skyline, which by and large remains out of sight except from afar, but how they impact the quality of street life. One can walk right past the Empire State Building and not even know it because its base fits in so well with the cornice line of neighboring buildings. Generally the dozen new supertalls in this volume integrate excellently into the city at street level. Those around the Freedom Tower and Hudson Yards are more like towers in cordoned-off courtyards, so they also do not disrupt the urban experience.

Above all, New York remains a city of distinct neighborhoods, one of the world's great cities for walking, like Paris or London, because of its endless variety of streets, shops, parks, architecture spanning three centuries, and the near-mystical street grid itself, conceived by the cartographer John Randel Jr. in 1811.[3]

Is Bigger Better?

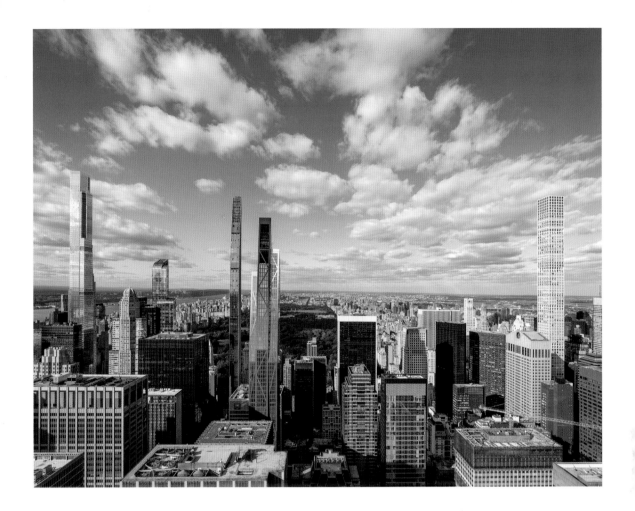

Looking to the future, COVID-19 is likely to become endemic, like the annual flu, instead of pandemic. Most of us will endure our annual shots and forget about it, the way the Spanish flu is buried deep in our cultural subconscious. Social life will go on as usual—baseball games, movies, concerts, theater—until the next disaster strikes, like 9/11 or Hurricane Sandy. The city has a way of serially coping and forgetting and moving on. It is the way of the somnambulist and the survivor.

(above) New York is best read as a skyline city. The sheer scale of supertalls can truly be appreciated only from far vantage points, like the New Jersey entrance to the Midtown Tunnel.

(overleaf) One Vanderbilt's spire is a hit, but its base is a feeble afterthought, meant to acknowledge its splendid Beaux-Arts neighbor, Grand Central Terminal.

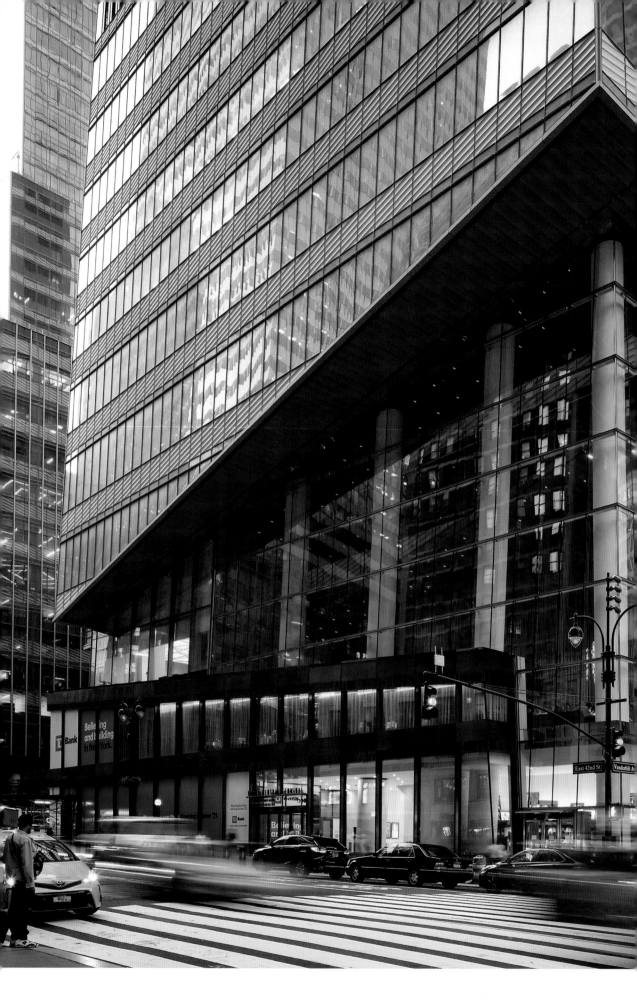

Is Bigger Better?

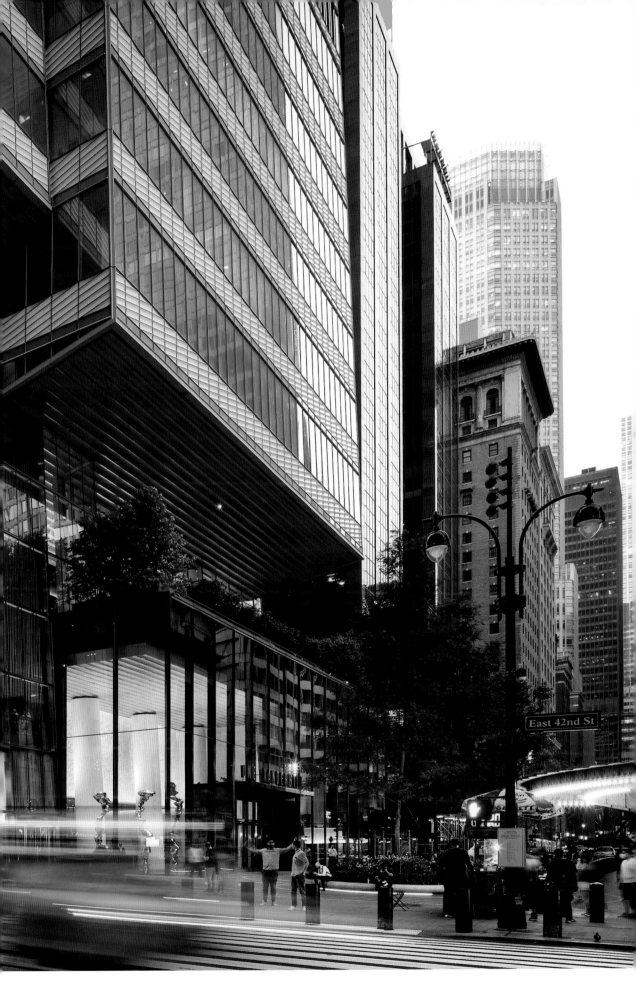

Part III Introduction

10
The View from
Mount Olympus

O! How the diadem of the Chrysler Building must have gleamed as a symbol of all that glitters in capitalism to the teeming masses of the Lower East Side during the Great Depression! As Andy Warhol said of the great deco towers, "These buildings make me think of money."[1]

At night, from the supertalls, the avenues are molten rivers of red and gold seen from hermetic fishbowls. Forget river views—some Manhattan supertalls offer *ocean* views. The possessor arises nude, like Poseidon or Botticelli's Venus, from a bathtub carved from a single block of Carrara marble, with a view of three counties, to greet the rosy-fingered dawn.

From the upper stories of Billionaire's Row, Central Park is reduced to a miniature golf course—the reservoir is a puddle, pedestrians (in both senses of the word) look like ants. Vast views inspire proprietary feelings, as if you are the owner of all you survey. According to self-styled psychogeographer Merlin Coverley, supertalls divide the city into walkers, who experience the street from "down-below," and voyeurs on high. "Looking down upon them from up-above, with a panoptical, godlike view, are the voyeurs who experience the city as a vast totality far removed from any individual perspective."[2] As architectural critic Justin Davidson wrote in another context, "A view is power, a form of majestic surveillance. To gaze is to own."

In *The Theory of the Leisure Class* (1899), sociologist Thorstein Veblen wrote that conspicuous consumption was a measure of maintaining class differences. Not only the height but also the slenderness of supertalls flaunt conspicuous consumption, the way a massive château on Fifth Avenue did for portly millionaires of the nineteenth century. Veblen also identified the lawn as a status symbol, a sign of conspicuous consumption as a holdover from the pastoral. Until long after the Civil War, most Americans could not afford the time or the money to maintain a proper front lawn.[3]

Today's aspirational hosts can offer their guests a view of a front lawn stretching more than fifty city blocks to

The Chrysler's marvelous, absurd, oneiric spire is the aspirational essence of Manhattanism.

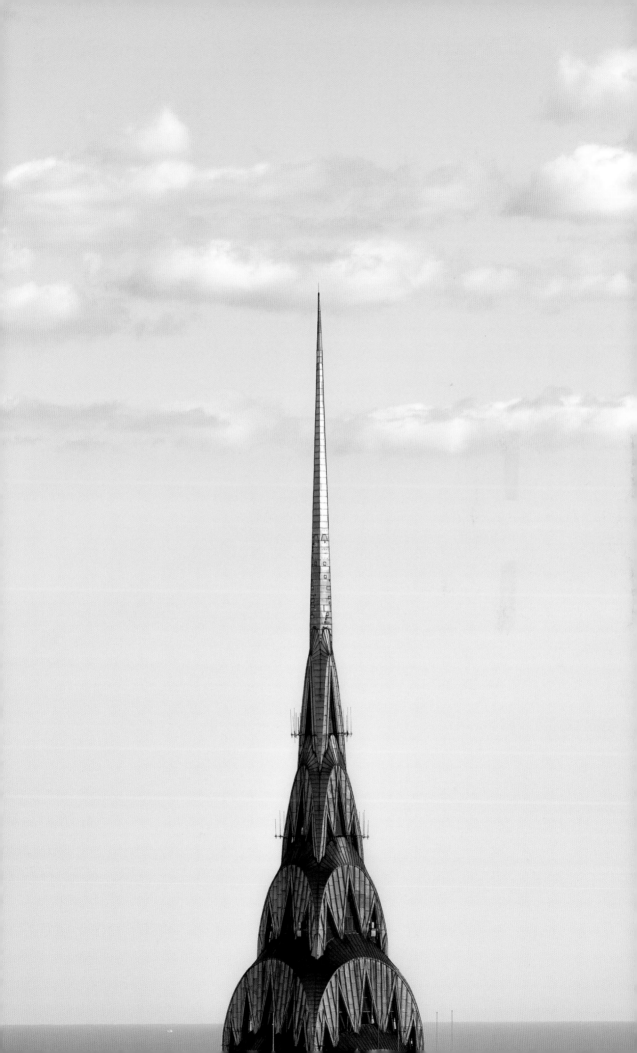

the Harlem Meer, a *tapis vert* worthy of the Sun King, 843 acres, larger than the Principality of Monaco.[4] Promotional material for Central Park Tower presumptuously lays claim, proclaiming the park "your majestic front lawn," as if it were just another of the tower's private amenities.[5]

(above) Once you accustom yourself to their scale, supertalls can be appreciated for their abstract, crystalline beauty.

(opposite) River views are so old hat; from Central Park Tower, at left, you can see the *ocean*.

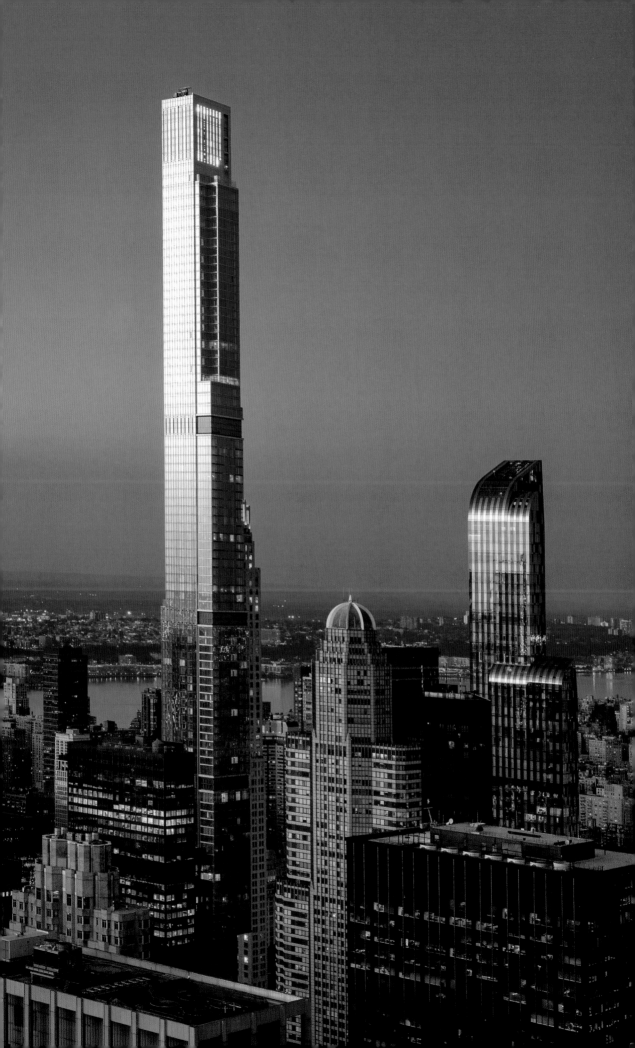

11
Supersize Me

Although supertalls are time-consuming to develop, and costs of building above the fiftieth floor are prohibitive, they persist. A preliminary rendering has been submitted by OMA (Office for Metropolitan Architecture, founded by the ever-inventive Dutch architect Rem Koolhaas) for 47 West 57th Street. The 1,100-foot / 335-meter supertall is planned to be completed in 2026, neighboring the superskinny Steinway Tower, if Turkish developer Sedesco can wrangle floor area bonuses in exchange for subway improvements.[1]

The most critical, and often criticized, role the city government plays in development is in incentives and tax abatements for supertalls. For better or worse, the city, especially under former Mayor Michael Bloomberg, has shamelessly pandered to the one percent instead of aiding the public with low-cost housing, the exact opposite of what Mayor Fiorello La Guardia did during the most dire times of the Great Depression.[2]

In response to criticism when supertalls were becoming an issue of public concern, Bloomberg flippantly remarked, "If we can find a bunch of billionaires around the world to move here, that would be a godsend." He dug himself in deeper, "because that's where the revenue comes to pay for everybody else."[3] Then they could all play golf with him in Bermuda on weekends, while the homeless sleep on the sidewalks.

As a parting shot in one of his last acts in office, Mayor Bill de Blasio, a supporter of tenants' rights and aiding unhoused people, approved a homeless shelter in the former Park Savoy Hotel, next to an entrance of One57, just to thumb his nose at the rich.[4]

Hudson Yards received outrageous tax abatements and incentives from the city. The city invested $3.5 billion in public infrastructure in Hudson Yards, of which $2.1 billion was squandered developing the dinky extension of the 7 train line from Times Square to Hudson Yards. The cost per track foot is unfathomable, for what amounts to a private commuter line for the workers and residents of the Yards.

Fusty New Yorkers from Henry James to renowned 1930s architectural critic Lewis Mumford have been appalled by the city's advancing height. Supertalls are the shape of things to come.

Is Bigger Better?

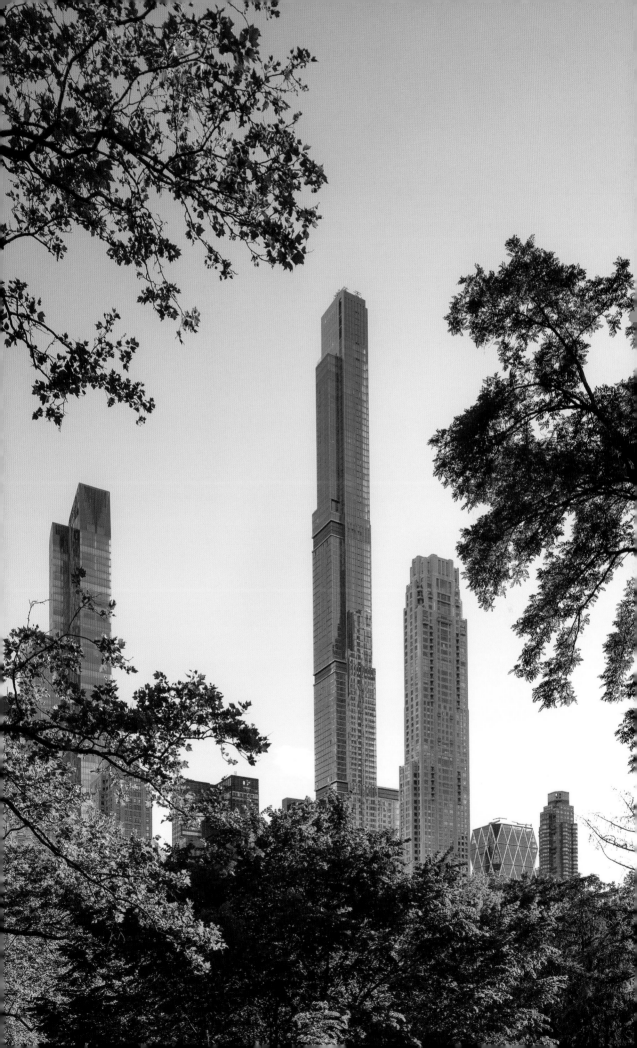

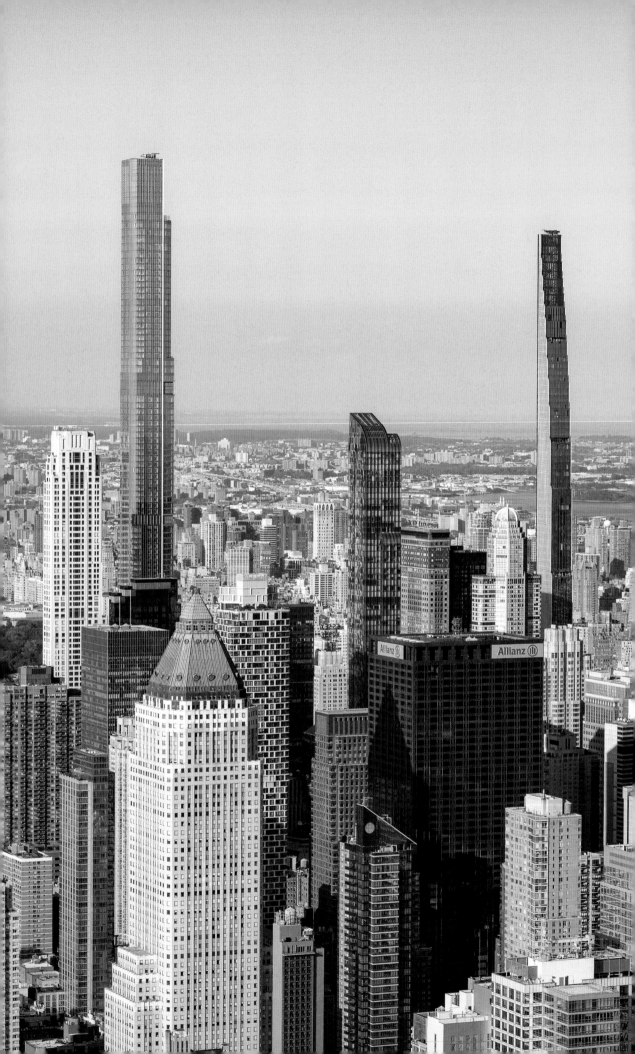

Not only that, the tunnels leak.[5] Normally, 80 percent of such a tab is picked up by the state, but Bloomberg prioritized the project, so that the monies were paid fully out of city coffers.[6]

But that's peanuts compared to a total of $6 billion in tax breaks and other government subsidies indiscriminately awarded to this billionaire's playground.[7] These are deliberate, politically motivated choices to allocate precious resources to the one percent rather than to raise up the Common Man of the New Deal era. As urban theorist Mark Gottdiener writes: "Urban planning in *every* society is a façade for power."[8]

Unscrupulous developers sometimes try to abuse zoning rules by stitching together Frankenstein-like pieces of air rights. In one infamous case that was denied, at 200 Amsterdam Avenue, the developer proposed a gerrymandered thirty-nine-sided parcel, running up and down several streets and avenues like a jigsaw puzzle.[9] Hudson Yards is like Dubai in that it was zoned as a freewheeling, free-enterprise district to encourage economic development. Floor area ratios were maximized and setback limitations made more flexible. Usually, the developer throws in a sop of moderate-income units in a much larger luxury project, or public amenities like public spaces and improved subway access, while recouping enormous benefits. Critics call it "socialism for billionaires."

Seen aerially, Manhattan forms a congested thicket of towers, but the experience is much different down at sidewalk level, where pedestrians negotiate the city.

Supersize Me

12
Who Owns the Streets?

What impact do supertalls have on street life? One of the most creative architects working today, Elizabeth Diller of Diller Scofidio + Renfro, feels that the problem with supertalls is that they are dictated by the market rather than by urban planning. "Every property developer is in it for themselves, building into outer space," she said of buildings like 432 Park and Steinway Tower. "They damage the city fabric."[1]

But in the same breath, Diller, whose firm built the wildly popular High Line, which catalyzed an entire district of the city, seems to contradict herself: she believes Hudson Yards successfully introduces supertalls.[2] But again, she flip-flops: "In a progressively privatized city, the defense of public space, the production of new public space, and saving what is public really for the public is very important. Before we know it, everything is going to be consumed by the dollar."[3]

Hudson Yards is nothing if not completely consumed by the dollar. The High Line and Hudson Yards are by no means the same kind of public space. The High Line is a public park. Everyone loves a well-designed park. Paris was built on its boulevards and *jardins*. Hudson Yards, however, the largest private development in the history of the United States, is the unacceptable face of quintessential capitalist production of space.[4] Urbanist Edward Soja noted, "Space is not an empty void. It is always filled with politics, ideology, and other forces shaping our lives and challenging us to engage in struggles over geography."[5]

Cities designed from the top down like Hudson Yards emit a decaying whiff of totalitarianism. For one thing, they are not spaces designed for public protest. Furthermore, cities designed from the street up offer the fresh air of "anonymity, variety, and conjunction," according to author and critic Rebecca Solnit.[6]

Architect Sir Norman Foster optimistically opined that his glassy supertall office building at 50 Hudson Yards—still underway but projected to reach fifty-eight stories and

If supertalls are to be faulted, it is on economic grounds. Billions in public funds were lavished on Hudson Yards, including Mayor Bloomberg's boondoggle of extending the subway line with municipal monies instead of from Albany.

Is Bigger Better?

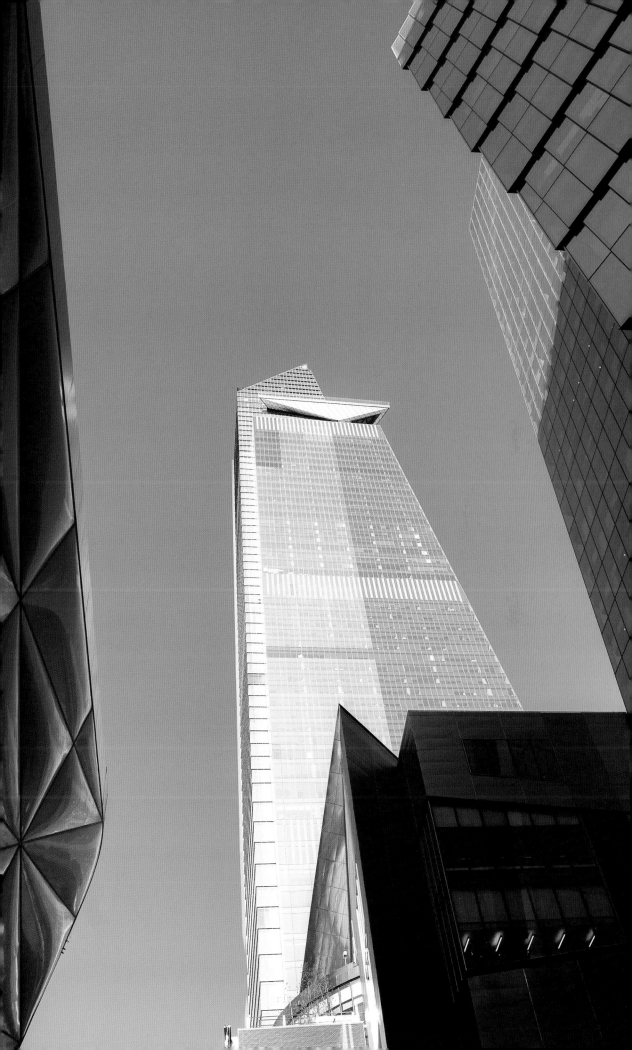

1,011 feet / 308 meters when it is completed in 2023 — will be a "key part of a larger vision that integrates places to live and work within a dense, walkable urban neighborhood."[7] But, as any good flâneur would ask, is it an interesting walk? No, except to satisfy a kind of morbid curiosity about the latest frontier of capitalism.

To understand how Hudson Yards differs from vital public space, we need to reference Harvard economist Shoshana Zuboff's definition of surveillance capitalism: "a new economic order that claims human experience as free raw material for hidden commercial practices of extraction, prediction, and sales…a parasitic economic logic in which the production of goods and services is subordinated to a new global architecture of behavioral modification."[8] In this Disneyland for billionaires, those who do not appear to belong, who are not there to gawk or consume or take snapshots — the homeless, the poor, the oddballs — are discreetly hustled out of sight by crewcut, earphone-wearing security guards. It's like being tailed by Mickey Mouse.

In *The Production of Social Space*, French social critic Henri Lefebvre is particularly pointed regarding sanitized spaces like Hudson Yards, which shows

> the inability of capitalism to produce a space other than capitalist space and its efforts to conceal that production as such, to erase any sign of the maximization of profit. Are there spaces which fail to signify anything? Yes — some because they are neutral or empty, others because they are overburdened with meaning. The former fall short of signification; the latter overshoot it. Some "over-signifying" spaces serve to scramble all messages and make any decoding impossible. Thus certain spaces are so laden with signs — signs of well-being, happiness, style, art, riches, power, prosperity, and so on — that not only is their primary meaning (that of profitability) effaced but meaning disappears altogether.[9]

Is Bigger Better?

Hudson Yards not only
creates a dystopian
public space, it subsidizes
housing for the wealthy
at a time of an escalating
homeless crisis and a
crying need for affordable
housing.

Who Owns the Streets?

13
Giant Steps

By century's end, New York will boast many more supertalls but ultimately may not look much different from the city of today. What counts is maintaining the mix. Many low-rise neighborhoods like the West Village in Manhattan and Brooklyn Heights are protected from high-rise development by zoning and landmarking. Neighborhoods far from commuting distance to central business districts, like Bensonhurst in Brooklyn and Jackson Heights in Queens, are in little danger of superdevelopment.

A new generation of architects like Bjarke Ingels are already responding creatively to the new high-rise ethos, not only with his Spiral supertall at Hudson Yards but also with his innovative, pyramid-like "courtscraper," VIA 57 West. Located near the banks of the Hudson River, it combines elements of a mid-rise skyscraper with the intimacy of a European apartment building, surrounding a central court.[1]

But superdevelopers can't help thinking supersize, because it maximizes their profit margins and satisfies their kingly egos. Developer Harry Macklowe's grandiose ninety-six-story, 1,556-foot / 474-meter Tower Fifth, proposed directly north of St. Patrick's Cathedral in Midtown, would become the tallest in the city by roof height. The tower's pedestal sits atop colossal paired, 400-foot / 122-meter pillars, which alone outstrip the cathedral spires (330 feet / 101 meters). In renderings, St. Patrick's is framed perfectly in Tower Fifth's lobby window, the way Milan's Galleria Vittorio Emanuele II frames Il Duomo.[2]

"The days of restrictions on buildings are really over," Macklowe magisterially proclaimed to the *New York Times*. "This is a building that's never been built before, a 21st-century building."[3] He may be right, and he may not be. Developers aren't known for their modesty or restraint.

Supertalls and near-supertalls are being proposed all over the city, like the invasion in the 1957 science-fiction cheesefest *The Monolith Monsters*. (No need to worry about them shattering; tall buildings present no greater risks than mid-rises if they are engineered properly.) The real problems

Is Bigger Better?

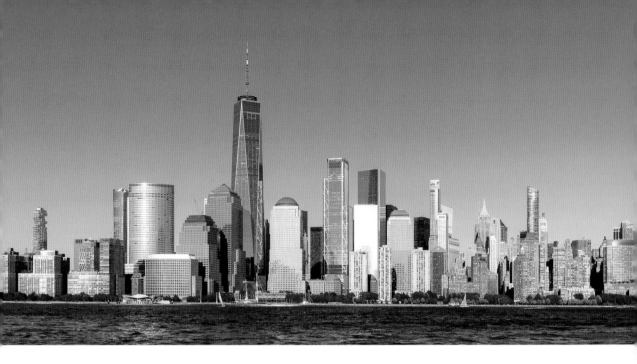

are not height but building beyond what the market can bear, so that there are too many empty stores and offices, a lack of good design, and a paucity of attractive, affordable housing. Urban density makes it easier to walk, use public transportation, and ride bikes, which is why property close to the transit hubs of Grand Central and the World Trade Center is so valuable.

Supertall projects are built on shifting sands, of course, but every city wants to pierce the clouds to prove its status as a hub of world capital. According to the CTBUH, one hundred supertalls are underway or under review in cities as far-flung as Tokyo, Toronto, Dubai, Kuala Lumpur, Bangkok, Jakarta, Warsaw, Mumbai, and Cairo, as well as in more than a score of cities in China.[4] Even Miami, long considered superrisky because of its hurricane-force winds, is already marketing its first supertall: the Waldorf Astoria Residences at one hundred floors and 1,049 feet / 320 meters by Sir Norman Foster, with other projects in the works.[5]

A megatall in Manhattan remains the stuff that dreams are made of due to the web of zoning and air rights needed to stitch together such a structure. There is just no place to parcel together the air rights, at least for now. However, if the urban theory of multinodal cities rather than central business districts holds true, a megatall could arise in some outlying borough or business exurb, like Stamford, Connecticut, just to put it on the map. But barring superbugs even graver than COVID-19 or biblical floods that technology cannot stem, Manhattan will continue to be, in Kurt Vonnegut's words, "Skyscraper National Park."[6]

Congestion was the bugbear of midcentury planners like Robert Moses, who tried to solve every problem by paving it over with asphalt. But according to urbanist William H.

New York perforce is a vertical city; supertalls are simply the next iteration. In the long view, there is an abstract, minimalist beauty in the apposition of the city's horizontality and the sheer verticality of its towers.

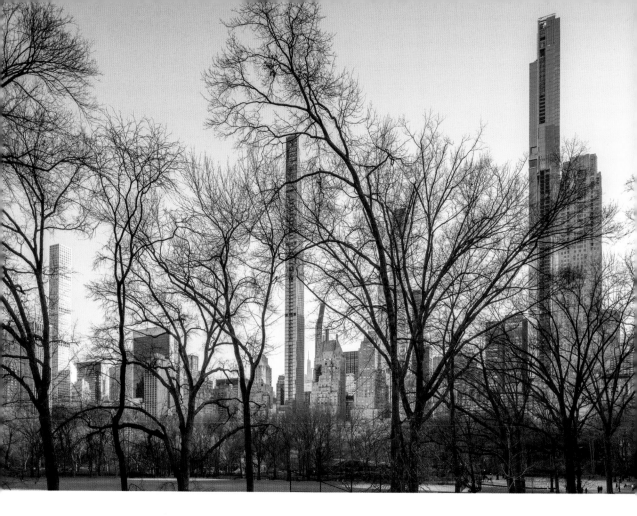

Whyte, who went so far as to observe New York street behavior with a movie camera and a stopwatch, there's no such thing as too much congestion.[7] As long as people have decent, affordable housing, Whyte wrote, the best thing about cities is the chance for people to bump into each other.[8] The art of schmoozing is how business is done, and a reason cities have existed as far back as Nineveh. Today's urban planners can intelligently plan for density in a way that benefits the greatest number of people. "Congestion is good," skyscraper architect Raymond Hood affirmed nearly a century ago. "It's the best thing we have in New York. The glory of the skyscraper is that we have provided for it so well."[9]

Welfare policies in the 1960s led to panic about New York devolving into a "behavioral sink" (a term popularized by a rat ethologist to describe the effects of overcrowding, and "white flight" to the suburbs).[10] During the fiscal crisis of the mid-1970s whole neighborhoods cratered, like the South Bronx and Lower Manhattan's Alphabet City. But New York always seems to bounce back like a fresh, pink Spaldeen handball.

One way to look at the influx of supertalls is that they're just another phase in the city's history, a new tier of the skyline, like what was achieved in the 1920s. Manhattan is

A new generation will grow up calling this skyline home—one generation's shock is the next generation's nostalgia.

　　　　　Is Bigger Better?

in essence a vertical city, and supertalls are simply a logical extension. The majority of the new supertalls harmonize with the street environment, which is the most critical element, and some are things of beauty in themselves. Blame for the city's problems should not be placed on the slim shoulders of supertalls, prominent as they are, but rather on political, social, and budgetary policies that favor the superrich over needs for quality mass-housing and infrastructure repair.

During the Depression, political titans like Mayor Fiorello La Guardia and President Franklin Delano Roosevelt accomplished near miracles with an enlightened coalition of urban and federal resources: schools, parks, humane slum clearance, and the very first public housing in the nation.[11] The Great Depression was an era of low buildings and high ideals; we now live in a time of sky-high buildings and leaders of little pith.

No doubt future boulevardiers will become as inured to supertalls, even Harry Macklowe's monstrosity, as we are to our built environment of art deco, modern, and postmodern skyscrapers. They may glance up from their iPhones occasionally, exclaim, "Ye gods! What is *that*?" snap it, and go about their business. As German sociologist Georg Simmel observed in his 1903 essay "The Metropolis and Mental Life," the "blasé attitude" *is* the urban condition.[12]

Notes

**Part I
A Short History of the Tall Building
in New York City**

Introduction

1 Council on Tall Buildings and Urban Habitat (CTBUH) (website), accessed April 25, 2022, https://www.ctbuh.org/.

2 The Eiffel Tower (website), accessed April 25, 2022, https://www.toureiffel.paris/en.

3 Fareed Zakaria, *Ten Lessons for a Post-Pandemic World* (New York: W. W. Norton, 2020), 103–5, 125–26.

4 Ibid., 18–19.

5 David Wallace-Wells, *The Uninhabitable Earth: Life After Warming* (New York: Tim Duggan Books, 2019), 5.

6 Ibid., 59.

7 Emporis (website), a global skyscraper database, accessed April 25, 2022, https://www.emporis.com/; "List: Skyscrapers Under Construction or Planned in New York," The Tower Info, accessed April 25, 2022, https://thetowerinfo.com/nyc-skyscrapers-under-construction-proposed/.

8 CTBUH.

9 "China," The Skyscraper Center, CTBUH, accessed April 25, 2022, https://www.skyscrapercenter.com/country/china/.

10 "MEXICO CITY | Torre Santander—Reforma Colón," Proposed Supertalls, Skyscraper City, accessed April 25, 2022, https://www.skyscrapercity.com/threads/mexico-city-torre-santander-reforma-col%C3%B3n-316m-1037ft-72-fl-181m-162m-prep.1806511/page-7/.

11 CTBUH; Matt Shaw, "10 Facts About Jeddah Tower, the Soon-to-Be Tallest Building in the World," Architizer, accessed April 25, https://architizer.com/blog/inspiration/industry/kingdom-tower-10-facts/.

12 Roger Vincent and Alexandra Zavis, "An Arrest in Saudi Arabia Could Be Felt as Far as Silicon Valley and Wall Street," *Los Angeles Times*, November 5, 2017, https://www.latimes.com/world/middleeast/la-fi-alwaleed-bin-talal-backgrounder-20171105-story.html/.

13 Emporis.

14 Ibid.

15 Alexander W. Allison et al., eds., *The Norton Anthology of Poetry.* (New York: W. W. Norton, 1983), 335.

16 CTBUH; Emporis.

17 Patrick Sisson, "The Engineering Tricks behind the World's Super Tall and Super Slender Skyscrapers," Curbed, September 24, 2015, https://archive.curbed.com/2015/9/24/9917752/the-engineering-tricks-behind-building-slender-taller-towers-and/.

18 CTBUH.

19 Ibid.; Emporis.

20 "Central Park Tower," Extell Development, accessed April 25, 2022, https://extell.com/portfolio/central-park-tower.

21 Jenna McKnight, "Wave of Super-Tall Towers in Manhattan Sparks Protests over Shadows," *Dezeen*, November 11, 2015, https://www.dezeen.com/2015/11/11/supertall-skinny-skyscrapers-towers-manhattan-new-york-shop-architects-robert-stern-rafaely-vinoly-jean-nouvel-portzamparc-controversy-protest/.

22 Scott Heins, "Behold Central Park's Dark & Shadowy Future," *Gothamist*, July 27, 2016, https://gothamist.com/news/behold-central-parks-dark-shadowy-future.

23 CTBUH.

24 Ibid.; "7 Figure Drawing Proportions to Know," The Drawing Source, accessed April 25, 2022, https://www.thedrawingsource.com/figure-drawing-proportions.html/.

25 CTBUH; Emporis.

26 "One World Trade Center," World Trade Center, accessed April 25, 2022, https://www.wtc.com/about/buildings/1-world-trade-center.

27 Ibid.; CTBUH.

28 CTBUH.

29 Ibid.

1
The Eclectic Era

1 Andreas Bernard, *Lifted: A Cultural History of the Elevator* (New York: NYU Press, 2014), 2.
2 Ibid.
3 Ibid.
4 Jason Goodwin, *Otis: Giving Rise to the Modern City* (Chicago: Ivan R. Dee, 2001), 7.
5 Margot Gayle and Edmund V. Gillon Jr., *Cast-Iron Architecture in New York: A Photographic Survey* (New York: Dover Publications, 1974), 142; Council on Tall Buildings and Urban Habitat (CTBUH) (website), accessed April 25, 2022, https://www.ctbuh.org/; Barbaralee Diamonstein, *The Landmarks of New York II* (New York: Harry N. Abrams, 1993), 122.
6 Dennis Hevesi, "When Computer Store Meets Historic District," *New York Times*, August 3, 2005, https://www.nytimes.com/2005/08/03/technology/when-computer-store-meets-historic-district.html; Diamonstein, *Landmarks of New York II*, 464.
7 Hevesi, "When Computer Store Meets Historic District."
8 Christian Wolmar, "*Cathedrals of Steam: How London's Great Stations Were Built and How They Transformed the City.*" (London: Atlantic Books, 2020).
9 Stefan Muthesius, "The 'Iron Problem' in the 1850s," *Architectural History* 13 (1970): 58–63, 128–31; Sigfried Giedion, *Building in France, Building in Iron, Building in Ferroconcrete* (Santa Monica, CA: Getty Center for the History of Art and the Humanities, 1995); John Gloag and Derek Bridgwater, *A History of Cast Iron in Architecture* (London: George Allen and Unwin, 1948).
10 Gayle and Gillon Jr., *Cast-Iron Architecture in New York*, x–xiii.
11 Ibid.
12 Marc Gordon, "The Distinctive Cast Iron Architecture of NYC's SoHo," Untapped New York, November 2, 2021, https://untappedcities.com/2021/11/02/cast-iron-arc/.
13 Gayle and Gillon Jr., *Cast-Iron Architecture in New York*, vi.
14 W. Knight Sturges, "Cast in Iron: New York's Structural Heritage," *Architectural Review*, October 6, 1953, https://www.architectural-review.com/archive/cast-in-iron-new-yorks-structural-heritage.
15 Gayle and Gillon Jr., *Cast-Iron Architecture in New York*, viii.
16 "Cast Iron vs Cast Steel," Reliance Foundry, accessed April 25, 2022, https://www.reliance-foundry.com/blog/cast-iron-vs-cast-steel/.
17 Gordon, "Distinctive Cast Iron Architecture of NYC's SoHo."
18 Ibid.
19 Ibid.
20 Roger Shepherd, ed., *Skyscraper: The Search for an American Style 1891–1941* (New York: McGraw-Hill, 2003), 7.
21 CTBUH; Shepherd, *Skyscraper*, 7.
22 Robert Twombly, *Louis Sullivan: His Life and Work* (New York: Viking, 1986), 49; Diamonstein, *Landmarks of New York II*, 236, 260; CTBUH; Roxanne Kuter Williamson, *American Architects and the Mechanics of Fame* (Austin: University of Texas Press, 1991), 36.
23 Diamonstein, *Landmarks of New York II*, 260.
24 Joseph J. Korom Jr., *Skyscraper Façades of the Gilded Age: Fifty-One Extravagant Designs, 1875–1910* (Jefferson, NC: McFarland, 2013).
25 Louis H. Sullivan, "The Tall Office Building Artistically Considered," *Lippincott's Magazine* 339 (March 1896): 403–9.
26 "Cast Iron vs Cast Steel."
27 Ibid.

2
Ever Upward

1 "New York State Emblems," New York Department of State, accessed April 25, 2022, https://dos.ny.gov/new-york-state-emblems/.

2 Robert A. M. Stern, Gregory Gilmartin, and John Massengale, *New York 1900: Metropolitan Architecture and Urbanism, 1890–1915* (New York: Rizzoli International Publications), 146–47; Council on Tall Buildings and Urban Habitat (CTBUH) (website), accessed April 25, 2022, https://www.ctbuh.org/; Emporis (website), accessed April 25, 2022, https://www.emporis.com/; The Skyscraper Museum (website), accessed April 25, 2022, https://www.skyscraper.org/.

3 Stern, Gilmartin, and Massengale, *New York 1900*, 171; CTBUH; Emporis; Barbaralee Diamonstein, *The Landmarks of New York II* (New York: Harry N. Abrams, 1993), 415.

4 Diamonstein, *Landmarks of New York II*, 415; "Campanile di San Marco," Civitatis Venice, accessed April 25, 2022, https://www.introducingvenice.com/campanile-san-marco.

5 Diamonstein, *Landmarks of New York II*, 308; Donald Martin Reynolds, *The Architecture of New York City: Histories and Views of Important Structures, Sites, and Symbols* (New York: Macmillan, 1984), 168–79; CTBUH; Emporis.

6 Diamonstein, *Landmarks of New York II*, 308.

7 Reynolds, *Architecture of New York City*, 179.

8 Reynolds, *Architecture of New York City*, 169, 179.

9 Alexander Braun, *Winsor McCay: The Complete Little Nemo, 1910–1927* (Cologne, Germany: Taschen Books, 2019); George Perry and Alan Aldridge, *The Penguin Book of Comics* (Harmondsworth, UK: Penguin Books, 1967), 108, 111.

10 Robert A. M. Stern, Gregory Gilmartin, and Thomas Mellins, *New York 1930: Architecture and Urbanism between the Two World Wars* (New York: Rizzoli, 2009), 31; CTBUH; Emporis.

11 Stern, Gilmartin, and Mellins, *New York 1930*, 31.

12 "Shadows Cast by Skyscrapers," *Buildings and Building Management* 18 (November 1918): 38.

3
Art Deco Days (and Nights)

1 Robert A. M. Stern, Gregory Gilmartin, and Thomas Mellins, *New York 1930: Architecture and Urbanism between the Two World Wars* (New York: Rizzoli, 2009), 31.

2 Barbaralee Diamonstein, *The Landmarks of New York II* (New York: Harry N. Abrams, 1993), 341; Council on Tall Buildings and Urban Habitat (CTBUH) (website), https://www.ctbuh.org/; Emporis (website), https://www.emporis.com/.

3 Stern, Gilmartin, and Mellins, *New York 1930*, 213; CTBUH; Emporis.

4 Stern, Gilmartin, and Mellins, *New York 1930*, 213.

5 Diamonstein, *Landmarks of New York II*, 347.

6 Pergamonmuseum, Staatliche Museen zu Berlin Preussicher Kultur Besitz (website), accessed April 25, 2022, https://www.smb.museum/en/museums-institutions/pergamonmuseum/home/.

7 Susan Tunick, *Terra-Cotta Skyline* (New York: Princeton Architectural Press, 1997), 79–80.

8 Peter Pennoyer and Anne Walker, *New York Transformed: The Architecture of Cross & Cross* (New York: Monacelli, 2014), 10–11, 190–203; CTBUH; Emporis.

9 CTBUH; Emporis.

10 Diamonstein, *Landmarks of New York II*, 353; CTBUH; Emporis.

11 Diamonstein, *Landmarks of New York II*, 353.

12 Ibid.

13 Norval White and Elliot Willensky with Fran Leadon, *AIA Guide to New York City*, 5th ed. (New York: Oxford University Press, 2010), 8; CTBUH; Emporis; Rem Koolhaas, *Delirious New York: A Retroactive Manifesto for Manhattan* (New York: Monacelli, 1978), 10.

14 Koolhaas, *Delirious New York*, 156–59.

15 Ibid., 157.

16 Stern, Gilmartin, and Mellins, *New York 1930*, 222–25; CTBUH; Emporis.

17 Stern, Gilmartin, and Mellins, *New York 1930*, 222–25.

18 Ibid., 603–15.

19 Ibid., 605; CTBUH; Emporis.

20 Stern, Gilmartin, and Mellins, *New York 1930*, 605; CTBUH; Emporis.

21 Empire State Building (website), accessed April 25, 2022, https://www.esbnyc.com/.

22 Ibid.

23 Ibid.

24 Quoted in Neil Bascomb, "For the Architect, a Height Never Again to Be Scaled," *New York Times*, May 26, 2005, https://www.nytimes.com/2005/05/26/garden/for-the-architect-a-height-never-again-to-be-scaled.html.

25 Bret Stevens, "New York as Skyscraper," *Wall Street Journal*, August 2, 2008, https://www.wsj.com/articles/SB121762156747405585.

26 Christopher Gray, "Streetscapes/William Van Alen; An Architect Called the 'Ziegfeld of His Profession'," *New York Times*, March 22, 1998, https://www.nytimes.com/1998/03/22/realestate/streetscapes-william-van-alen-an-architect-called-the-ziegfeld-of-his-profession.html/.

27 Carol Willis, *Form Follows Finance: Skyscrapers and Skylines in New York and Chicago* (New York: Princeton Architectural Press, 1995).

28 Ibid., 83.

29 Ibid.

30 Ibid.

31 Ibid., 96.

32 Anthony Flint, *Modern Man: The Life of Le Corbusier, Architect of Tomorrow* (Boston: New Harvest, 2014); Fiona MacCarthy, *Gropius: The Man Who Built the Bauhaus* (Cambridge, MA: Belknap Press of Harvard University Press, 2019); Antonio Román, *Eero Saarinen: An Architecture of Multiplicity* (New York: Princeton Architectural Press, 2003).

33 Walter H. Kilham Jr., *Raymond Hood, Architect: Form through Function in the American Skyscraper* (New York: Architectural Book Publishing, 1973).

34 Diamonstein, *Landmarks of New York II*, 363; CTBUH; Emporis.

35 Diamonstein, *Landmarks of New York II*, 363.

36 Ibid., 367; CTBUH; Emporis.

37 Le Corbusier, *Towards a New Architecture*, trans. Frederick Etchells (New York: Dover, 1986).

38 Daniel Okrent, *Great Fortune: The Epic of Rockefeller Center* (New York: Viking, 2003).

39 Diamonstein, *Landmarks of New York II*, 369; CTBUH; Emporis.

40 Okrent, *Great Fortune*, 432.

4
Looking through a Glass Onion

1 Roberto Schezen, Kenneth Frampton, and Joseph Rosa, *Adolf Loos: Architecture, 1903–1932* (New York: Monacelli, 2009); Magadena Droste, *The Bauhaus, 1919–1933: Reform and Avant-Garde* (Cologne, Germany: Taschen, 2006; Gabriele Fahr-Becker, *Wiener Werkstätte*, ed. Angelika Taschen (Cologne, Germany: Taschen, 2008); Lucius Burckhardt, ed., *The Werkbund: History and Ideology, 1907–1933* (Woodbury, NY: Barron's, 1977); Sean Reynolds, "Neue Sachlichkeit," *A Dictionary of Modern Architecture* (blog), University of Chicago, November 16, 2015, https://voices.uchicago.edu/201504arth15709-01a2/2015/11/16/neue-sachlichket/.

2 Le Corbusier, quoted at Brainy Quote, accessed April 29, 2022, https://www.brainyquote.com/quotes/le_corbusier_115262/.

3 Victoria Newhouse, *Wallace K. Harrison, Architect* (New York: Rizzoli, 1989), 117–28.

4 Robert A. M. Stern, Thomas Mellins, and David Fishman, *New York 1960: Architecture and Urbanism between the Second World War and the Bicentennial* (New York: Monacelli, 1997), 617.

5 Council on Tall Buildings and Urban Habitat (CTBUH) (website), accessed April 25, 2022, https://www.ctbuh.org/; Emporis (website), accessed April 25, 2022, https://www.emporis.com/.

6 Anthony Flint, *Modern Man: The Life of Le Corbusier, Architect of Tomorrow* (Boston: New Harvest, 2014), 66; Stern, Mellins, and Fishman, *New York 1960*, 618.

7 Stern, Mellins, and Fishman, *New York 1960*, 339; CTBUH; Emporis.

8 Stern, Mellins, and Fishman, *New York 1960*, 339; Norval White and Elliot Willensky with Fran Leadon, *AIA Guide to New York City*, 5th ed. (New York: Oxford University Press, 2010), 320; Jan Cigliano Hartman, ed., *The Women Who Changed Architecture* (New York: Princeton Architectural Press, 2022), 90.

9 Franz Schulze, introduction to Ezra Stoller, *The Seagram Building* (New York: Princeton Architectural Press, 2000), 1, 12; CTBUH; Emporis; Barbaralee Diamonstein, *The Landmarks of New York II* (New York: Harry N. Abrams, 1993), 434.

10 "Less Is More: Mies van der Rohe, a Pioneer of the Modern Movement," *ArchDaily*, March 27, 2021, https://www.archdaily.com/350573/happy-127th-birthday-mies-van-der-rohe/; Philip C. Johnson, *Mies van der Rohe* (New York: Museum of Modern Art, 1947).

11 "1961 New York City Zoning Resolution," accessed April 29, 2022, https://www.nypap.org/preservation-history/1961-new-york-city-zoning-resolution/.

12 "The 3rd Avenue Elevated," accessed April 29, 2022, https://www.nycsubway.org/wiki/The_3rd_Avenue_Elevated/.

5
Beyond Modernism

1 Eric P. Nash, "Modernism: A Love Hate Affair," *New York Times*, April 10, 1994. https://www.nytimes.com/1994/04/10/magazine/modernism-a-love-hate-affair.html

2 Michel Foucault, *Discipline & Punish: The Birth of the Prison* (New York: Vintage Books, 1995); Mark Wigley, *The Architecture of Deconstruction: Derrida's Haunt* (Cambridge, MA: MIT Press, 1995); Hélène Frichot and Stephen Loo, eds., *Deleuze and Architecture* (Edinburgh: Edinburgh University Press, 2013); Shane Waggoner, "Jean-Francois Lyotard, Defining the Postmodern," *Modernism and Postmodernism* (course blog), January 3, 2015, https://ph240.wordpress.com/2015/01/03/jean-francois-lyotard-defining-the-postmodern/; Jacques Derrida, *Adesso l'architettura* (Milan: Libri Scheiwiller, 2008); John Shannon Hendrix, *Architecture and Psychoanalysis: Peter Eisenman and Jacques Lacan* (New York: Peter Lang, 2016).

3 Henry-Russell Hitchcock and Philip Johnson, *The International Style* (New York: W. W. Norton, 1995).

4 Robert A. M. Stern, David Fishman, and Jacob Tilove, *New York 2000: Architecture and Urbanism between the Bicentennial and the Millennium* (New York: Monacelli, 2006), 493, 494; Council on Tall Buildings and Urban Habitat (CTBUH) (website), accessed April 25, 2022, https://www.ctbuh.org/; Emporis (website), accessed April 25, 2022, https://www.emporis.com/; Norval White and Elliot Willensky with Fran Leadon, AIA *Guide to New York City*, 5th ed. (New York: Oxford University Press, 2010), 334, 493.

5 Ada Louise Huxtable, "Architecture View," *New York Times*, December 31, 1978. https://www.nytimes.com/1978/12/31/archives/architecture-view-towering-achievements-of-78-architecture-view.html; Paul Goldberger, "Major, Monument of Post-Modernism," *New York Times*, March 31, 1978, https://www.nytimes.com/1978/03/31/archives/a-major-monument-of-poshmodernism-planned-att-tower-is-already.html.

Part II
Supertalls

Introduction

6 Paul Goldberger, *Up From Zero: Politics, Architecture, and the Rebuilding of New York* (New York: Random House, 2004); Eric P. Nash, *Manhattan Skyscrapers* (New York: Princeton Architectural Press, 1999), 133.

7 CTBUH; Emporis.

8 Ibid.

9 Peter Lobner, "Tall and Skinny in New York City and Miami," Lyncean Group of San Diego, May 23, 2016, https://lynceans.org/all-posts/tall-and-skinny-in-new-york-city-and-miami/.

1 Matthew Soules, *Icebergs, Zombies, and the Ultra Thin: Architecture and Capitalism in the Twenty-First Century* (New York: Princeton Architectural Press, 2021).

2 Davide Ponzini and Michele Nastasi, *Starchitecture: Scenes, Actors and Spectacles in Contemporary Cities* (New York: Monacelli, 2016); Soules, *Icebergs, Zombies, and the Ultra Thin*; "Housing," Steven Holl Architects, accessed May 1, 2022, http://stevenholl.com/project.php?type=housing; Bjarke Ingels Group, *Formgiving: An Architectural Future History* (Cologne, Germany: Taschen, 2020); Elizabeth Fazzare, "Santiago Calatrava Explains How He Designed the Oculus for Future Generations," *Architectural Digest*, October 24, 2017, https://www.architecturaldigest.com/story/santiago-calatrava-explains-designed-oculus-for-future-generations/.

3 India Block, "Visual Shows Supertall Skyscraper Designed by OMA for Billionaire's Row in New York," *Dezeen*, July 8, 2021, https://www.dezeen.com/2021/07/08/oma-41-47-west-57th-street-supertall-skyscraper-new-york/; Rem Koolhaas, "Beijing Manifesto," *Wired*, June 2003, 124.

4 Steven Holl, "In New York, Architecture with a Sense of Social Purpose Is Becoming Increasingly Rare," *Dezeen*, May 22, 2015, https://www.dezeen.com/2015/05/22/opinion-steven-holl-new-york-skyscrapers-profane/.

5 Ibid.

6 Richard Wood, "'Core-First' Construction Technique Cuts Costs, Saves Time on NYC High-Rise Project," Building Design + Construction Network, December 27, 2014, https://www.bdcnetwork.com/core-first-construction-technique-cuts-costs-saves-time-nyc-high-rise-project/.

7 Council on Tall Buildings and Urban Habitat (CTBUH) (website), accessed April 25, 2022, https://www.ctbuh.org/.

8 Dennis Ayemba, "Jeddah Tower the Tallest Building in the World That Has Never Been Completed," Construction Review Online, updated March 1, 2022, https://constructionreviewonline.com/project-timelines/jeddah-tower-project-timeline-and-all-you-need-to-know/.

9 "Kingdom Tower Cheaper to Build than Burj Khalifa," Arabian Business, August 4, 2011, https://www.arabianbusiness.com/industries/construction/kingdom-tower-cheaper-build-than-burj-khalifa-414170/.

10 Harvard Natural Sciences Lecture Demonstrations, "Vortex Shedding in Air," accessed April 25, 2022, https://sciencedemonstrations.fas.harvard.edu/presentations/vortex-shedding-ai.

11 CTBUH; "20 Fun Facts about the John Hancock Center (875 North Michigan Avenue)," uploaded by jonesrmi, YouTube, May 6, 2020, https://www.youtube.com/watch?v=Z9Cz1mPZx5g/.

12 "Poltergeist III (1988) Filming & Production," IMDb, https://www.imdb.com/title/tt0095889/locations/.

13 Eric Limer, "How a Skyscraper Stays Upright in a Typhoon," *Popular Mechanics*, August 10, 2015, https://www.popularmechanics.com/technology/design/a16819/tapei-101-mass-damper-record/.

14 Wood, "'Core-First' Construction Technique Cuts Costs."

15 Tony Whitehead, "Three New York Skyscrapers That Wouldn't Exist Without High-Strength Concrete," The Possible, July 2017, https://www.the-possible.com/three-new-york-skyscrapers-wouldnt-exist-without-high-strength-concrete/.

6
Phoenix from the Ashes

1 Meg Green, "Three Insurers Win Ruling That WTC Disaster Was One Event," AM Best Information Services, September 25, 2002, https://news.ambest.com/newscontent.aspx?refnum=52954&altsrc=13/; Nikola Krastev, "U.S.: Polish-Born American Architect Wins World Trade Center Design Competition," Radio Free Europe / Radio Liberty, February 28, 2003, https://www.rferl.org/a/1102371.html/; SOM (website), accessed May 1, 2022, https://www.som.com/; "World Trade Center Oculus," Port Authority of New York and New Jersey, accessed June 2, 2022, https://www.officialworldtradecenter.com/en/local/learn-about-wtc/oculus-transportation-hub.html/.

2 Studio Libeskind (website), accessed May 1, 2022, https://libeskind.com/; Michelle Young, "The NYC That Never Was: 1 WTC and the Competition for the World Trade Center Site," Untapped New York, November 4, 2014, https://untappedcities.com/2014/11/04/the-nyc-that-never-was-1-wtc-and-the-competition-for-the-world-trade-center-site/; "World Trade Center Master Plan," Studio Libeskind, accessed May 1, 2022, https://libeskind.com/work/ground-zero-master-plan/.

3 "The Man Behind the Rebuilding of 9/11's Ground Zero," Reuters, September 1, 2021, https://www.reuters.com/world/us/man-behind-rebuilding-911s-ground-zero-2021-09-01/; Blair Golson, "Two Architects Whip Up Tower in Mad Frenzy," *Observer*, December 1, 2003, https://observer.com/2003/12/two-architects-whip-up-tower-in-mad-frenzy/.

4 Touropia, "27 Top Tourist Attractions in New York City," updated October 14, 2021, https://www.touropia.com/tourist-attractions-in-new-york-city/.

5 Judith Dupré, *One World Trade Center: Biography of the Building* (New York: Little, Brown, 2016).

6 Ibid., 70.

7 WSP (website), accessed May 1, 2022, https://www.wsp.com/en-US.

8 G. Roger Denson, "Michael Arad's 9/11 Memorial 'Reflecting Absence': More Than a Metaphor or a Monument," HuffPost, updated December 6, 2017, https://www.huffpost.com/entry/michael-arads-911-memoria_b_955454/.

9 Council on Tall Buildings and Urban Habitat (CTBUH) (website), accessed April 25, 2022, https://www.ctbuh.org/; "More Than a Building," 3WTC, accessed June 5, 2022, https://3wtc.com/building/.

10 "More Than a Building."

11 Elizabeth Fazzare, "Santiago Calatrava Explains How He Designed the Oculus for Future Generations," *Architectural Digest*, October 24, 2017, https://www.architecturaldigest.com/story/santiago-calatrava-explains-designed-oculus-for-future-generations/; Nicholas Foulkes, *Louis Vuitton Manufactures* (New York: Assouline, 2022).

12 Rem Koolhaas and Hal Foster, *Junkspace with Living Room* (London: Notting Hill Editions, 2013), 3.

13 Fazzare, "Santiago Calatrava Explains How He Designed the Oculus for Future Generations."

14 Henry Grabar, "NYC's $4 Billion Oculus Is a Shopping Mall Disguised as a Train Station," *Gothamist*, March 8, 2016, https://gothamist.com/news/nycs-4-billion-oculus-is-a-shopping-mall-disguised-as-a-train-station/.

15 Vera Haller, "World Trade Center Transit Hub Over Budget, Past Schedule—and Odd-Looking, Many Say," *Los Angeles Times,* March 3, 2016, https://www.latimes.com/nation/la-na-world-trade-center-hub-20160303-story.html/.

7
The Boulevard of Billionaires

1 Clement Greenberg, "Art," *The Nation*, April 7, 1945, 397–98.

2 The Eiffel Tower (website), accessed April 25, 2022, https://www.toureiffel.paris/en.

3 Brad Smithfield, "Guy de Maupassant Ate Lunch at the Base of the Eiffel Tower, because That Was the Only Place in Paris from Which He Could Not See It…," *Vintage News*, September 20, 2016, https://www.thevintagenews.com/2016/09/20/priority-french-writer-ate-lunch-everyday-base-eiffel-tower-place-paris-not-see-2/.

4 Paul Goldberger, *The City Observed: A Guide to the Architecture of Manhattan* (New York: Random House, 1979), 10–11.

5 James Glanz and Eric Lipton, *City in the Sky: The Rise and Fall of the World Trade Center* (New York: Times Books, 2003).

6 Paul Goldberger, "'Sliver' Apartment Houses (and Tempers) Going Up in City: An Appraisal," *New York Times*, February 8, 1982, https://www.nytimes.com/1982/02/08/nyregion/sliver-apartment-houses-and-tempers-going-up-in-city-an-app-raisal.html/.

7 Council on Tall Buildings and Urban Habitat (CTBUH) (website), accessed April 25, 2022, https://www.ctbuh.org/.

8 Eric P. Nash, *Manhattan Skyscrapers*, 3rd ed. (New York: Princeton Architectural Press, 2010), 162–63.

9 Christopher Hawthorne, "How New York's Trend of Rising 'Supertall' Towers Looks from the 92nd Floor," *Los Angeles Times,* June 15, 2017, https://www.latimes.com/entertainment/arts/la-ca-cm-building-type-needle-towers-20170618-htmlstory.html.

10 "Sky High & the Logic of Luxury," Skyscraper Museum, accessed June 7, 2022, https://old.skyscraper.org/EXHIBITIONS/SKY_HIGH/one57.php/.

11 Matt Chaban, "Christian de Portzamparc Channeled Not Just Waterfalls but Gustav Klimt for One57," *Observer*, June 11, 2012, https://observer.com/2012/06/christian-de-portzamparc-channeled-not-just-waterfalls-but-gustav-klimt-for-one57/; Rainer Metzger, *Vienna 1900* (Cologne, Germany: Taschen, 2018), 11.

12 Pavel Bendov, *New Architecture New York* (Munich: Prestel, 2017), 192–96.

13 Michael Kimmelman, "Seeing a Need for Oversight of New York's Lordly Towers," *New York Times*, December 22, 2013, https://www.nytimes.com/2013/12/23/arts/design/seeing-a-need-for-oversight-of-new-yorks-lordly-towers.html.

14 Jennifer Gould, "Developer Says 'Penis Envy' Is Fueling City's Tower Obsession," *New York Post*, May 8, 2016, https://nypost.com/2016/05/08/architect-admits-that-the-tallest-residential-tower-in-america-is-flawed/.

15 Katherine Clarke and Candace Taylor, "The Man Behind Billionaire's Row Battles to Sell the World's Tallest Condo," *Wall Street Journal*, January 17, 2019, https://www.wsj.com/articles/the-man-behind-billionaires-row-battles-to-sell-the-worlds-tallest-condo-11547739897/.

16 CTBUH; Stefanos Chen, "The Downside to Life in a Supertall Tower: Leaks, Creaks, Breaks," *New York Times*, updated September 23, 2021, https://www.nytimes.com/2021/02/03/realestate/luxury-high-rise-432-park.html/; J. G. Ballard, *High-Rise* (New York: Holt, Rinehart, and Winston, 1975).

17 Hugh Howard, "Find Out Which Renowned Homes Were Practically Uninhabitable," Bob Vila, updated February 22, 2020, https://www.bobvila.com/articles/famous-houses-leaky-roofs/; "Usonian," Frank Lloyd Wright Foundation, February 4, 2017, https://franklloydwright.org/style/usonian/.

18 432 Park Avenue (website), accessed June 7, 2022, https://www.432parkavenue.com/#residences/.

19 Matt Ball, "Concrete Was Key in Engineering of 432 Park Avenue," *Informed Infrastructure: The Magazine for Civil & Structural Engineers*, April 18, 2016, https://informedinfrastructure.com/21844/concrete-was-key-in-engineering-of-432-park-avenue/.

20 WSP (website), accessed May 1, 2022, https://www.wsp.com/en-GL/projects/432-park-avenue/.

21 CTBUH; Norval White and Elliot Willensky with Fran Leadon, AIA *Guide to New York City*, 5th ed. (New York: Oxford University Press, 2010), 305.

22 CTBUH.

23 Ibid.

24 Ibid.; Central Park Tower (website), accessed June 7, 2022, https://centralparktower.com.

25 Central Park Tower.

26 Ibid.

27 Ibid.

28 Barbaralee Diamonstein, *Landmarks of New York II* (New York: Harry N. Abrams, 1993), 206.

29 Tom Mashberg and Colin Moynihan, "At Art Students League, Air Rights and Airing Grievances," *New York Times*, January 17, 2016, https://www.nytimes.com/2016/01/18/arts/design/at-art-students-league-air-rights-and-airing-grievances.html/.

30 "53W53," Emporis, accessed June 7, 2022, https://www.emporis.com/buildings/315691/53w53-new-york-city-ny-usa/; CTBUH; Anna Winston, "Jean Nouvel's First New York Skyscraper Will Include Three Floors of MoMA Gallery Space," *Dezeen*, May 20, 2015, https://www.dezeen.com/2015/05/20/jean-nouvel-53w53-skyscraper-new-york-moma-gallery-space-three-floors/.

31 "Jean Nouvel," Britannica, accessed June 7, 2022, https://www.britannica.com/biography/Jean-Nouvel/.

8
If You Build It (Hopefully, Maybe, Eventually) They Will Come

1 Jonathan Glancey, "The Empire State Building: American Icon," BBC, October 21, 2014, https://www.bbc.com/culture/article/20130613-empire-state-towering-ambition/.

2 Walter H. Kilham Jr., *Raymond Hood, Architect: Form through Function in the American Skyscraper* (New York: Architectural Book Publishing, 1973), 172.

3 Council on Tall Buildings and Urban Habitat (CTBUH) (website), accessed April 25, 2022, https://www.ctbuh.org/; Kohn Pedersen Fox (website), accessed June 7, 2022, https://www.kpf.com/.

4 "Greater East Midtown," NYC Department of City Planning, updated August 9, 2017, https://www1.nyc.gov/site/planning/plans/greater-east-midtown/greater-east-midtown.page/.

5 "MAS Comments Regarding the Greater East Midtown Proposal," The Municipal Art Society of New York, February 1, 2017, https://www.mas.org/news/mas-comments-regarding-the-greater-east-midtown-proposal/.

6 One Vanderbilt (website), accessed June 7, 2022, https://www.onevanderbilt.com/.

7 "New York City's CBDs (Central Business Districts)," New York Offices, October 9, 2014, https://www.ny-offices.com/nycity/new-york-citys-cbds-central-business-districts/.

8 Matthew Haag, "Manhattan Faces a Reckoning if Working from Home Becomes the Norm," *New York Times*, updated May 13, 2020, https://www.nytimes.com/2020/05/12/nyregion/coronavirus-work-from-home.html/.

9 Frederick Lewis Allen, "Radio City: Cultural Center?," *Harper's*, April 1932, 540–41.

10 "KPF-Designed One Vanderbilt Opens in Midtown Manhattan," KPF, September 14, 2020, https://www.kpf.com/pt/current/news/one-vanderbilt-opens-in-midtown/.

11 Eliot Brown, "Roth Still Interested in Smaller Moynihan Plan," *Observer*, April 8, 2008, https://observer.com/2008/04/roth-still-interested-in-smaller-moynihan-plan/.

12 Rachel Holliday Smith and Gabriel Poblete, "The Penn Station Area Is on the Verge of Redevelopment. Here's What We Know About the Looming Transformation," The City, July 27 2022, https://www.thecity.nyc/manhattan/2022/7/13/23211836/penn-station-redevelopment-project

13 "About Hudson Yards" (press kit), Hudson Yards New York, March 12, 2019, https://www.hudsonyardsnewyork.com/sites/default/files/2019-03/HY_PressKit_NEW_031219_web_final.pdf/; Hudson Yards Demographics, https://www.point2homes.com/US/Neighborhood/NY/Manhattan/Hudson-Yards-Demographics.html#Employment.

14 "United States Cities Starting with M," World Population Review, accessed June 7, 2022, https://worldpopulationreview.com/us-cities/starting-with/m/.

15 Carl Swanson, "The Only Man Who Could Build Oz," *New York*, February 18, 2019, https://nymag.com/intelligencer/2019/02/stephen-ross-hudson-yards.html.

16 "New York-New York Hotel & Casino," Tripadvisor, accessed September 2, 2022, https://www.tripadvisor.com/Hotel_Review-g45963-d91904-Reviews-New_York_New_York_Hotel_Casino-Las_Vegas_Nevada.html/.

17 Guy Debord, *Society of the Spectacle* (Detroit: Black & Red, 2016), 2.

18 Ed Shanahan and Kimiko de Freytas-Tamura, "150-Foot Vessel Sculpture at Hudson Yards Closes after 3rd Suicide," *New York Times*, updated July 30, 2021, https://www.nytimes.com/2021/01/12/nyregion/hudson-yards-suicide-vessel.html/; Michael Gold, "The Vessel, a Tourist Draw, to Reopen with Changes after Several Deaths," *New York Times*, May 26, 2021, https://www.nytimes.com/2021/05/26/nyregion/hudson-yards-vessel-reopening.html.

19 CTBUH.

20 Edge (website), accessed June 7, 2022, https://www.edgenyc.com/en/.

21 Empire State Building (website), accessed April 25, 2022, https://www.esbnyc.com/.

22 Edge.

23 Ibid.

24 CTBUH.

25 Bjarke Ingels Group, *Formgiving: An Architectural Future History* (Cologne, Germany: Taschen, 2020).

26 Jenna McKnight, "BIG Unveils Plans for The Spiral Office Tower in New York," *Dezeen*, February 8, 2016, https://www.dezeen.com/2016/02/08/the-spiral-office-tower-big-new-york-conceptual-design-skyscraper-bjarke-ingels/6.

9
At the Corner of
Cheesecake and Dime

1 Council on Tall Buildings and Urban Habitat
(CTBUH) (website), accessed April 25, 2022,
https://www.ctbuh.org/.
2 Ibid.
3 Valeria Ricciulli, "The Brooklyn Skyline Is About
to Change Forever with 9 DeKalb," *Curbed,*
July 15, 2021, https://www.curbed.com/article/9-
dekalb-tallest-building-brooklyn-nyc.html.
4 Stefanos Chen, "New York's First Supertall Tower
Outside Manhattan Rises in Brooklyn," *New
York Times*, March 9, 2022, https://www.nytimes.
com/2022/03/09/realestate/brooklyn-tower-
supertall-condo-nyc.html/.
5 "Dime Savings Bank," accessed July 22, 2022,
http://www.neighborhoodpreservationcenter.org/
db/bb_files/Dime-Savings-Bank.pdf.
6 Chen, "New York's First Supertall Tower Outside
Manhattan Rises in Brooklyn."
7 Lucie Levine, "From Brooklyn's Biggest Bank to
Its Tallest Building: Behind the Scenes at the Dime
Savings Bank," 6sqft, January 7, 2019, https://
www.6sqft.com/tag/dime-savings-bank/.
8 Matt A. V. Chaban, "Proposal for Brooklyn's
Tallest Tower Is Approved," *New York
Times*, April 19, 2016, https://www.nytimes.
com/2016/04/20/nyregion/proposal-for-
brooklyns-tallest-tower-is-approved.html.

Part III
Is Bigger Better?

Introduction

1 Robert Hughes, *The Shock of the New: The
Hundred-Year History of Modern Art, Its Rise,
Its Dazzling Achievement, Its Fall*, 3rd ed. (New
York: Alfred A. Knopf, 1991), 11.
2 Dietmar Schloss, *Culture and Criticism in Henry
James* (Tübingen, Germany: Gunter Narr Verlag,
1992), 69.
3 Gerard Koeppel, *City on a Grid: How New York
Became New York* (Boston: Da Capo, 2015).

10
The View from Mount Olympus

1 Reinhart Wolf, *New York* (Cologne, Germany: Taschen, 2016).
2 Merlin Coverley, *Psychogeography* (Chicago: Oldcastle, 2018), 65.
3 Thorstein Veblen, *The Theory of the Leisure Class* (New York: Dover Thrift Editions, 1994).
4 Central Park Conservancy (website), accessed June 7, 2022, https://www.centralparknyc.org/; "Monaco Statistics Pocket," Monaco Statistics, accessed June 7, 2022, https://www.monacostatistics.mc/IMSEE/Publications/monaco-statistics-pocket/.
5 "Central Park: Your Majestic Front Lawn," Central Park Tower (website), accessed June 7, 2022, https://centralparktower.com/.

11
Supersize Me

1 OMA (website), accessed June 7, 2022, https://www.oma.com/.
2 Mason B. Williams, *City of Ambition: FDR, La Guardia, and the Making of Modern New York* (New York: W. W. Norton, 2013).
3 Michael Kimmelman, "Seeing a Need for Oversight of New York's Lordly Towers," *New York Times*, December 22, 2013, https://www.nytimes.com/2013/12/23/arts/design/seeing-a-need-for-oversight-of-new-yorks-lordly-towers.html/.
4 Rachel Holliday Smith, "Manhattan Billionaire's Row Homeless Shelter Opens after Years-Long Legal Battle," The City, November 10, 2021, https://www.thecity.nyc/housing/2021/11/8/22771214/manhattan-billionaires-row-homeless-shelter-opens-after-legal-battle/.
5 Bridget Fisher and Flávia Leite, "The Cost of New York City's Hudson Yards Redevelopment Project," Working Paper #2, November 2018, Schwartz Center for Economic Policy Analysis and Department of Economics, The New School for Social Research, https://www.economicpolicyresearch.org/images/docs/research/political_economy/Cost_of_Hudson_Yards_WP_11.5.18.pdf.
6 Ibid.
7 Matthew Haag, "Amazon's Tax Breaks and Incentives Were Big. Hudson Yards' Are Bigger," *New York Times*, March 9, 2019, https://www.nytimes.com/2019/03/09/nyregion/hudson-yards-new-york-tax-breaks.html.
8 M. Gottdiener, *The Social Production of Urban Space* (Austin: University of Texas Press, 1985), 18.
9 Matt Pruznick, "200 Amsterdam Ruling Threatens 'Havoc' to New York City Development," New York YIMBY, February 21, 2020, https://newyorkyimby.com/2020/02/200-amsterdam-ruling-threatens-havoc-to-new-york-city-development.html/.

12
Who Owns the Streets?

1 James Brillon, "New York's Supertall Towers 'Damage the City Fabric' Says Elizabeth Diller," *Dezeen,* August 5, 2016, https://www.dezeen.com/2016/08/05/new-york-supertall-towers-damage-city-fabric-elizabeth-diller-interview/.

2 Ibid.

3 Ibid.

4 "Hudson Yards," Related, accessed June 7, 2022, https://www.related.com/our-company/properties/hudson-yards.

5 Edward W. Soja, *Seeking Spatial Justice* (Minneapolis: University of Minnesota Press, 2010), 17.

6 Rebecca Solnit, *Wanderlust: A History of Walking* (London: Granta, 2002), 171.

7 Tanay Walker, "Foster + Partners Will Design 985-Foot Hudson Yards Skyscraper," *Curbed New York,* December 8, 2016, https://ny.curbed.com/2016/12/8/13882640/50-hudson-yards-related-norman-foster/.

8 Shoshana Zuboff, *The Age of Surveillance Capitalism: The Fight for a Human Future at the New Frontier of Power* (London: Profile Books, 2019), frontispiece.

9 Henri Lefebvre, *The Production of Space*, trans. Donald Nicholson-Smith (Oxford, UK: Blackwell Publishing, 2001), 160.

13
Giant Steps

1 Via 57 West (website), accessed June 7, 2022, https://www.via57west.com/.

2 Alexandra Alexa, "Plans for Second-Tallest Building in the Western Hemisphere Move Forward with Demolition Permits," 6sqft, April 15 2019, https://www.6sqft.com/plans-for-second-tallest-building-in-the-western-hemisphere-move-forward-with-demolition-permits/.

3 Charles V. Bagli, "The Empire State Building May Soon Have Another Rival on the Skyline," *New York Times*, January 18, 2019, https://www.nytimes.com/2019/01/18/nyregion/harry-macklowe-skyscraper-nyc.html/.

4 Council on Tall Buildings and Urban Habitat (CTBUH) (website), accessed April 25, 2022, https://www.ctbuh.org/.

5 "The 2022 List of Every Supertall Tower Currently Being Planned in Miami," The Next Miami, March 31, 2022, https://www.thenextmiami.com/the-2022-list-of-every-supertall-tower-currently-being-planned-in-miami/.

6 Kurt Vonnegut, *Breakfast of Champions* (New York: Delacorte, 1973).

7 William H. Whyte, *City: Rediscovering the Center* (Philadelphia: University of Pennsylvania Press, 2009).

8 Ibid.

9 Walter H. Kilham Jr., *Raymond Hood, Architect: Form through Function in the American Skyscraper* (New York: Architectural Book Publishing, 1973), 188.

10 Fredrick Kunkle, "The Researcher Who Loved Rats and Fueled Our Doomsday Fears," *Washington Post*, June 19, 2017, https://www.washingtonpost.com/news/retropolis/wp/2017/06/19/the-researcher-who-loved-rats-and-fueled-our-doomsday-fears/; Leah Boustan, "The Culprits behind White Flight," *New York Times*, May 15, 2017, https://www.nytimes.com/2017/05/15/opinion/white-flight.html.

11 Mason B. Williams, *City of Ambition: FDR, La Guardia, and the Making of Modern New York* (New York: W. W. Norton, 2013).

12 Kurt H. Wolff, ed. and trans., *The Sociology of Georg Simmel* (New York: Free Press, 1950), 413.

Bibliography

Ballard, J. G. *High-Rise*. New York: Holt, Rinehart, and Winston, 1975.

Bascomb, Neil. *Higher: A Historic Race to the Sky and the Making of a City*. New York: Doubleday, 2003.

Bendov, Pavel. *New Architecture New York*. New York: Prestel, 2017.

Bernard, Andreas. *Lifted: A Cultural History of the Elevator*. New York: NYU Press, 2014.

Bjarke Ingels Group. *Formgiving: An Architectural Future History*. Cologne, Germany: Taschen, 2020.

——. *Yes Is More: An Archicomic on Architectural Evolution*. Cologne, Germany: Taschen, 2010.

Braun, Alexander, ed. *Winsor McCay: The Complete Little Nemo, 1910–1927*. Cologne, Germany: Taschen, 2019.

Burckhardt, Lucius, ed. *The Werkbund: History and Ideology, 1907–1933*. Woodbury, NY: Barron's, 1977.

Caro, Robert A. *The Power Broker: Robert Moses and the Fall of New York*. New York: Vintage Books, 1975.

Christin, Pierre, and Olivier Balez. *Robert Moses: The Master Builder of New York City*. London: Nobrow Ltd., 2018.

Chung, Chuihua Judy, Jeffrey Inaba, Rem Koolhaas, and Sze Tsung Leong, eds. *Harvard Design School Guide to Shopping*. Cologne, Germany: Taschen, 2002.

Coverley, Merlin. *Psychogeography*. Chicago: Oldcastle Books, 2018.

Debord, Guy. *Society of the Spectacle*. Detroit: Black & Red, 1983.

Derrida, Jacques. *Adesso l'architettura*. Milan: Libri Scheiwiller, 2008.

Diamonstein, Barbaralee. *The Landmarks of New York II*. New York: Harry N. Abrams, 1993.

Droste, Magadena. *The Bauhaus, 1919–1933: Reform and Avant-Garde*. Cologne, Germany: Taschen, 2006.

Dupré, Judith. *One World Trade Center: Biography of the Building*. New York: Little, Brown, 2016.

Fahr-Becker, Gabriele. *Wiener Werkstätte*. Edited by Angelika Taschen. Cologne, Germany: Taschen, 2008.

Flint, Anthony. *Modern Man: The Life of Le Corbusier, Architect of Tomorrow*. Boston: New Harvest, 2014.

Foucault, Michel. *Discipline & Punish: The Birth of the Prison*. New York: Vintage Books, 1995.

Foulkes, Nicholas. *Louis Vuitton Manufactures*. New York: Assouline, 2022.

Frichot, Hélène, and Stephen Loo, eds. *Deleuze and Architecture*. Edinburgh: Edinburgh University Press, 2013.

Gayle, Margot, and Edmund V. Gillon Jr. *Cast-Iron Architecture in New York: A Photographic Survey*. New York: Dover Publications, 1974.

Giedion, Sigfried. *Building in France, Building in Iron, Building in Ferroconcrete*. Santa Monica, CA: Getty Center for the History of Art and the Humanities, 1995.

——. *Space, Time and Architecture: The Growth of a New Tradition*. Cambridge, MA: Harvard University Press, 1947.

Glanz, James, and Eric Lipton. *City in the Sky: The Rise and Fall of the World Trade Center*. New York: Times Books, 2003.

Gloag, John, and Derek Bridgwater. *A History of Cast Iron in Architecture*. London: George Allen and Unwin, 1948.

Goldberger, Paul. *The City Observed, New York: A Guide to the Architecture of Manhattan.* New York: Random House, 1979.

——. *Up from Zero: Politics, Architecture, and the Rebuilding of New York.* New York: Random House, 2004.

Goodell, Jeff. *The Water Will Come: Rising Seas, Sinking Cities, and the Remaking of the Civilized World.* New York: Little, Brown, 2017.

Goodwin, Jason. *Otis: Giving Rise to the Modern City.* Chicago: Ivan R. Dee, 2001.

Gottdiener, M. *The Social Production of Urban Space.* Austin: University of Texas, 1985.

Hartman, Jan Cigliano, ed. *The Women Who Changed Architecture.* New York: Princeton Architectural Press, 2022.

Hendrix, John Shannon. *Architecture and Psychoanalysis: Peter Eisenman and Jacques Lacan.* New York: Peter Lang, 2016.

Hillier, Bevis. *Art Deco of the 20s and 30s.* London: Studio Vista/Dutton Pictureback, 1972.

Hitchcock, Henry-Russell, and Philip Johnson. *The International Style.* New York: W. W. Norton, 1995.

Hughes, Robert. *The Shock of the New: The Hundred-Year History of Modern Art, Its Rise, Its Dazzling Achievement, Its Fall.* 3rd ed. New York: Alfred A. Knopf, 1991.

Johnson, Philip C. *Mies van der Rohe.* New York: Museum of Modern Art, 1947.

Kanigel, Robert. *Eyes on the Street: The Life of Jane Jacobs.* New York: Knopf Doubleday, 2016.

Kidney, Walter C. *The Architecture of Choice: Eclecticism in America, 1880–1930.* New York: George Braziller, 1974.

Kilham, Walter H., Jr. *Raymond Hood, Architect: Form through Function in the American Skyscraper.* New York: Architectural Book Publishing, 1973.

Koeppel, Gerard. *City on a Grid: How New York Became New York.* Boston: Da Capo, 2015.

Koolhaas, Rem. *Delirious New York: A Retroactive Manifesto for Manhattan.* New York: Monacelli, 1978.

Koolhaas, Rem, and Hal Foster. *Junkspace with Living Room.* London: Notting Hill Editions, 2013.

Korom, Joseph J., Jr. *Skyscraper Façades of the Gilded Age: Fifty-One Extravagant Designs, 1875–1910.* Jefferson, NC: McFarland, 2013.

Landau, Sarah Bradford, and Carl W. Condit. *Rise of the New York Skyscraper: 1865–1913.* New Haven, CT: Yale University Press, 1996.

Le Corbusier. *Towards a New Architecture.* Translated by Frederick Etchells. New York: Dover, 1986.

Lefebvre, Henri. *The Production of Space.* Translated by Donald Nicholson-Smith. Oxford, UK: Blackwell Publishing, 2001.

Leslie, Thomas. *Chicago Skyscrapers: 1871–1934.* Urbana: University of Illinois Press, 2013.

MacCarthy, Fiona. *Gropius: The Man Who Built the Bauhaus.* Cambridge, MA: Belknap Press of Harvard University Press, 2019.

Metzger, Rainer. *Vienna 1900.* Cologne, Germany: Taschen, 2018.

Nash, Eric P. *Manhattan Skyscrapers,* 3rd ed. New York: Princeton Architectural Press, 2010.

Newhouse, Victoria. *Wallace K. Harrison, Architect.* New York: Rizzoli, 1989.

Newman, Oscar. *Design Guidelines for Creating Defensible Space*. Washington, DC: National Institute of Law Enforcement and Criminal Justice, 1976.

Okrent, Daniel. *Great Fortune: The Epic of Rockefeller Center*. New York: Viking, 2003.

Pennoyer, Peter, and Anne Walker. *New York Transformed: The Architecture of Cross & Cross*. New York: Monacelli, 2014.

Perry, George, and Alan Aldridge. *The Penguin Book of Comics*. Harmondsworth, UK: Penguin Books, 1967.

Ponzini, Davide, and Michele Nastasi. *Starchitecture: Scenes, Actors and Spectacles in Contemporary Cities*. New York: Monacelli, 2016.

Raffa, Enzo. *San Gimignano: City of the Beautiful Towers*. San Gimignano, Italy: Boldrini, n.d.

Reynolds, Donald Martin. *The Architecture of New York City: Histories and Views of Important Structures, Sites, and Symbols*. New York: Macmillan, 1984.

Román, Antonio. *Eero Saarinen: An Architecture of Multiplicity*. New York: Princeton Architectural Press, 2003.

Saggio, Antonino. *Louis Sauer: The Architect of Low-Rise High-Density Housing*. 2nd ed. Translated by Christopher Houston. Rome: University of Rome Department of Architecture and Urban Design, 2014.

Schezen, Roberto, Kenneth Frampton, and Joseph Rosa. *Adolf Loos: Architecture, 1903–1932*. New York: Monacelli, 2009.

Schloss, Dietmar. *Culture and Criticism in Henry James*. Tübingen, Germany: Gunter Narr Verlag, 1992).

Schumpeter, Joseph. *Capitalism, Socialism, and Democracy*. New York: Harper & Brothers, 1942.

Shepherd, Roger, ed. *Skyscraper: The Search for an American Style, 1891–1941*. New York: McGraw-Hill, 2003.

Soja, Edward W. *Seeking Spatial Justice*. Minneapolis: University of Minnesota Press, 2010.

Solnit, Rebecca. *Wanderlust: A History of Walking*. London: Granta, 2014.

Soules, Matthew. *Icebergs, Zombies, and the Ultra Thin: Architecture and Capitalism in the Twenty-First Century*. New York: Princeton Architectural Press, 2021.

Stern, Robert A. M., David Fishman, and Jacob Tilove. *New York 2000: Architecture and Urbanism between the Bicentennial and the Millennium*. New York: Monacelli, 2006.

Stern, Robert A. M., Gregory Gilmartin, and John Massengale. *New York 1900: Metropolitan Architecture and Urbanism, 1890–1915*. New York: Rizzoli, 1983.

Stern, Robert A. M., Gregory Gilmartin, and Thomas Mellins. *New York 1930: Architecture and Urbanism between the Two World Wars*. New York: Rizzoli, 2009.

Stern, Robert A. M., Thomas Mellins, and David Fishman. *New York 1880: Architecture and Urbanism in the Gilded Age*. New York: Monacelli, 1999.

——. *New York 1960: Architecture and Urbanism between the Second World War and the Bicentennial*. New York: Monacelli, 1997.

Stoller, Ezra. *The Seagram Building*. New York: Princeton Architectural Press, 2000.

"Tang dynasty." Britannica. Accessed April 25, 2022. https://www.britannica.com/topic/Tang-dynasty.

Torre, Susana, ed. *Women in American Architecture: A Historic and Contemporary Perspective*. New York: Whitney Library of Design, 1977.

Tunick, Susan. *Terra-Cotta Skyline*. New York: Princeton Architectural Press, 1997.

Twombly, Robert. *Louis Sullivan: His Life and Work*. New York: Viking, 1986.

Veblen, Thorstein. *The Theory of the Leisure Class*. New York: Dover Thrift Editions, 1994.

Violette, Zachary J. *The Decorated Tenement: How Immigrant Builders and Architects Transformed the Slum in the Gilded Age*. Minneapolis: University of Minnesota Press, 2019.

Vonnegut, Kurt, *Breakfast of Champions*. New York: Delacorte, 1973.

Wallace-Wells, David. *The Uninhabitable Earth: Life After Warming*. New York: Tim Duggan Books, 2019.

White, Norval, and Elliot Willensky, with Fran Leadon. *AIA Guide to New York City*. 5th ed. New York: Oxford University Press, 2010.

Whyte, William H. *City: Rediscovering the Center*. Philadelphia: University of Pennsylvania Press, 2009.

Wigley, Mark. *The Architecture of Deconstruction: Derrida's Haunt*. Cambridge, MA: MIT Press, 1995.

Williams, Mason B. *City of Ambition: FDR, La Guardia, and the Making of Modern New York*. New York: W. W. Norton, 2013.

Williamson, Roxanne Kuter. *American Architects and the Mechanics of Fame*. Austin: University of Texas Press, 1991.

Willis, Carol. *Form Follows Finance: Skyscrapers and Skylines in New York and Chicago*. New York: Princeton Architectural Press, 1995.

Wojtowicz, Robert, ed. *Sidewalk Critic: Lewis Mumford's Writings on New York*. New York: Princeton Architectural Press, 1998.

Wolf, Reinhart. *New York*. Cologne, Germany: Taschen, 2016.

Wolff, Kurt H., ed. and trans. *The Sociology of Georg Simmel*. New York: Free Press, 1950.

Wolmar, Christian. *Cathedrals of Steam: How London's Great Stations Were Built and How They Transformed the City*. London: Atlantic Books, 2020.

Zakaria, Fareed. *Ten Lessons for a Post-Pandemic World*. New York: W. W. Norton, 2020.

Zuboff, Shoshana. *The Age of Surveillance Capitalism: The Fight for a Human Future at the New Frontier of Power*. London: Profile Books, 2019.

Illustration Credits

All photographs are by Bruce Katz unless noted below.

Page 19 top left: Albert Levering, *The Future of Trinity Church*, 1907, Library of Congress Prints and Photographs Division, https://www.loc.gov/pictures/item/2005694696/

24 top: "Park Row Building, New York, N.Y.," 1901–1907, Miriam and Ira D. Wallach Division of Art, Prints and Photographs: Picture Collection, New York Public Library, https://digitalcollections.nypl.org/items/510d47e2-8e23-a3d9-e040-e00a18064a99

24 bottom: "Metropolitan Life Building, New York," 1908–1914, Miriam and Ira D. Wallach Division of Art, Prints and Photographs: Picture Collection, New York Public Library, https://digitalcollections.nypl.org/items/510d47e2-8da9-a3d9-e040-e00a18064a99

25: Fairchild Aerial Surveys, Inc., *Woolworth Tower in Clouds, New York City*, 1928, Library of Congress Prints and Photographs Division, https://www.loc.gov/pictures/item/96518598/

29: Irving Underhill, *New York Skyscrapers*, 1932, Library of Congress Prints and Photographs Division, https://www.loc.gov/pictures/item/2015647624/

35 and 36: Eric P. Nash

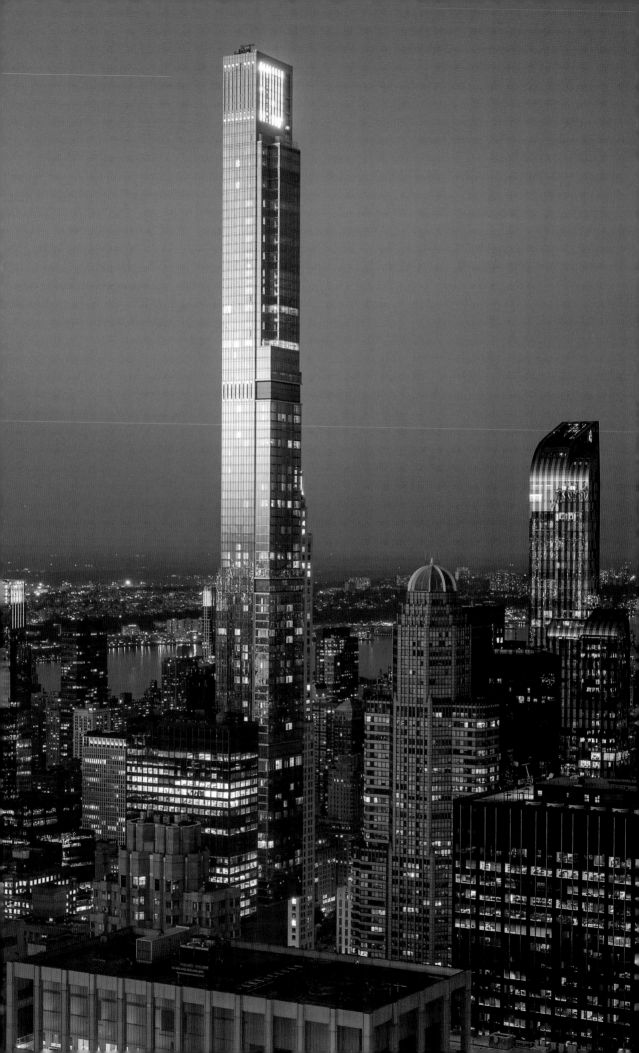

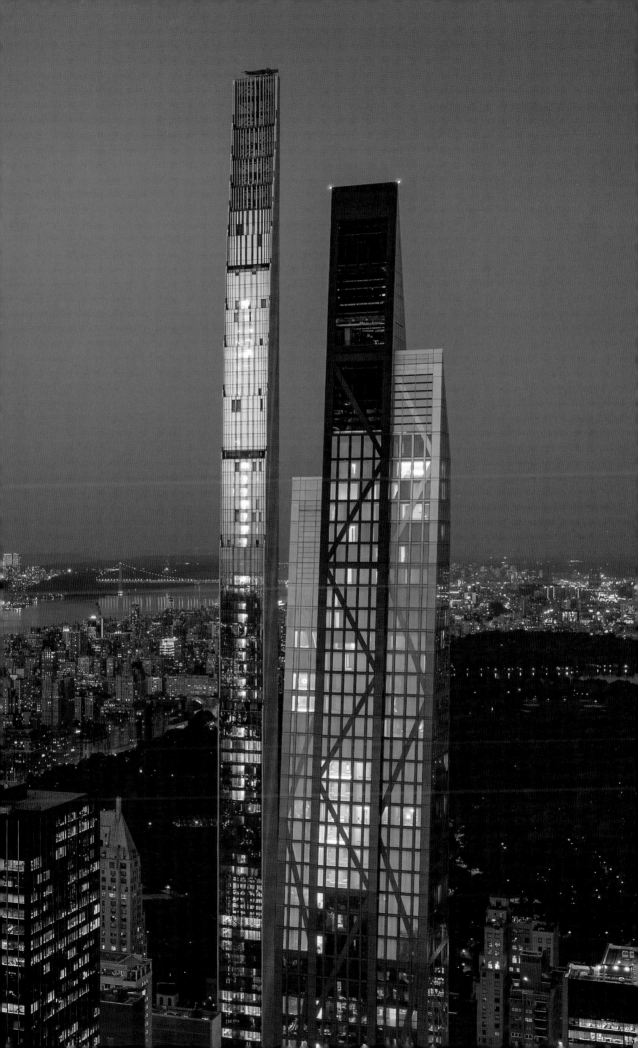

About the Authors

Eric P. Nash was a researcher and writer for the *New York Times* for twenty-five years. He is the author of several books about architecture and design, including *Manhattan Skyscrapers*, *MiMo: Miami Modern Revealed*, and *New York's 50 Best Skyscrapers*, and an architectural tour guide in New York City.

Bruce Katz is an architectural photographer whose work has appeared in *Architectural Digest*, *New York Magazine*, *Landscape Architecture*, and the *Washington Post*. He has taught at the International Center of Photography, and several of his images were recently acquired by the New-York Historical Society.